Drawing Anime Faces and Feelings

Drawing Anime Faces and Feelings

Impact Books
An imprint of Penguin Random House LLC
penguinrandomhouse.com

Copyright © 2015 by Studio Hard, Mynavi Publishing Corporation
DEJITARUTSURU DE KAKU! KANJO GA AFURE DERU KYARA NO HYOJO NO KAKIKATA
Original Japanese edition published in Japanese language by Mynavi Publishing
Corporation, Tokyo, Japan
English language rights, translation & production by World Book Media, LLC
Translation rights arranged with Mynavi Publishing Corporation through Timo
Associates, Inc., Tokyo

Author: Studio Hard Deluxe
Designers: Yu Ishimoto, Fuka Okazawa (Studio Hard Deluxe)
Editors: Yuta Ishikawa, Masaki Sasaguchi, Maho Omura (Studio Hard Deluxe)
English Language Editor: Beth Erikson
Translator: Kyoko Matthews
English Edition Cover Designer: Vikki Chu
English Edition Interior Design: WBM Design

Printed in China
10 9 8 7 6 5 4 3

ISBN: 978-1-4403-0111-7

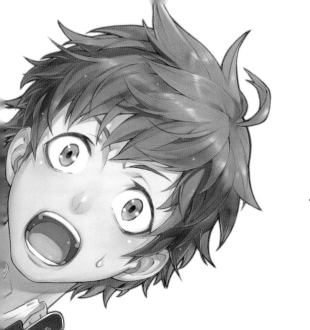

800 facial expressions from joy to terror, anger, surprise, sadness and more

Drawing Anime Faces and Feelings

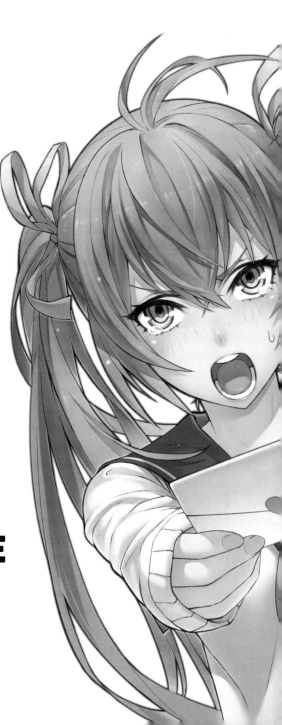

STUDIO HARD DELUXE

CONTENTS

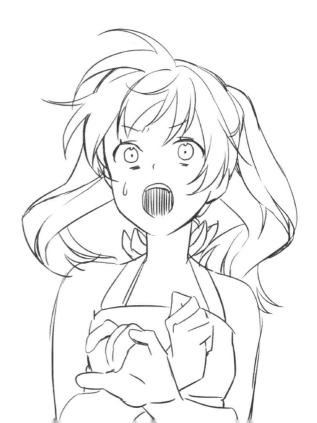

INTRODUCTION

Reading people's facial expressions is part of everyday life—it's how we assess the emotions of our friends, family, co-workers, and even complete strangers. And when drawing, it's important to capture accurate facial expressions to convey a character's feelings without the need for words.

This book includes over 800 examples illustrating how to draw facial expressions. Chapter 1 introduces the basic mechanisms of facial expressions and methods for drawing the face. In Chapter 2, you'll learn how to draw facial expressions for six universal emotions: joy, anger, sadness, surprise, fear, and disgust, as well as the varying intensities at which these emotions can be experienced. Chapter 3 showcases specific facial expressions for scenes and storylines that commonly appear in manga, such as romantic encounters, important conversations, and daily life. Finally, Chapter 4 focuses on drawing methods for hair, which is essential when drawing faces and developing characters.

Use this book as a reference whenever you have a question about drawing faces for your characters. Our goal is to help you develop as an artist and make your characters and their stories stronger than ever before.

—Studio Hard Deluxe

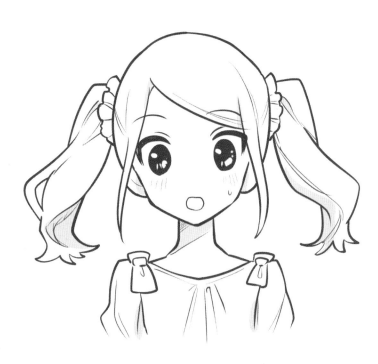

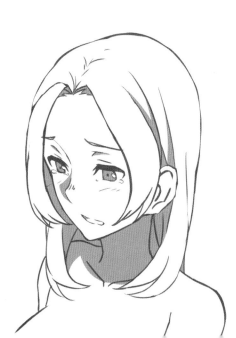

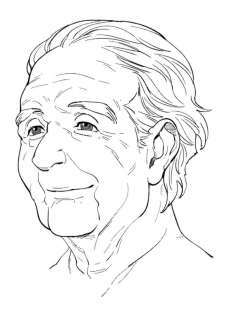

CHAPTER 1

BASIC TECHNIQUES FOR DRAWING FACIAL EXPRESSIONS

CAPTURING EXPRESSIONS IN THE MOMENT

We make various facial expressions in daily life. They are often unconscious responses, a reaction to something we see or hear—we rarely consciously change our expressions. When creating manga illustrations, it's important to capture expressions in the moment in order to show your readers exactly what a character is feeling. Before starting to draw them, let's think about when those expressions are created.

▶ Emotional Expressions

Humans experience feelings such as joy, sadness, or anger through what they see, hear, or communicate. The emotional response then moves the muscles of the face to create expressions that we can recognize.

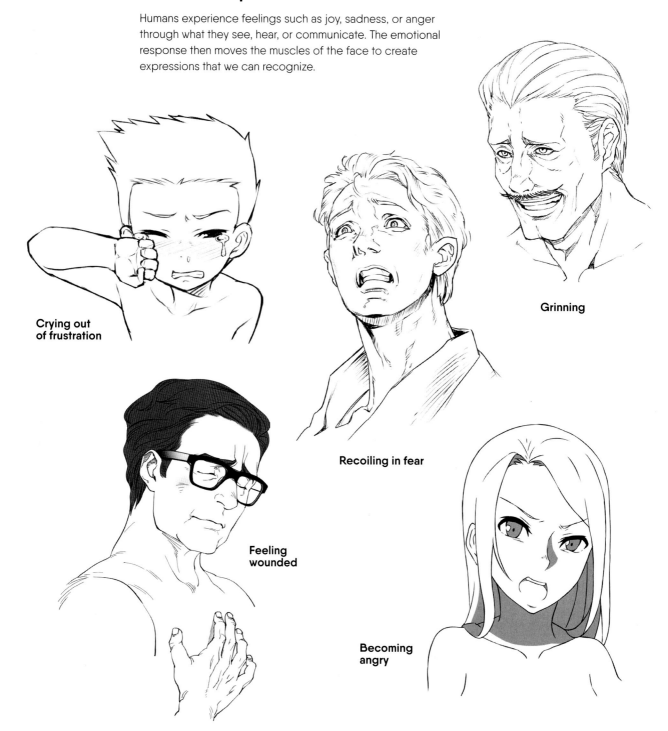

Grinning

Crying out
of frustration

Recoiling in fear

Feeling
wounded

Becoming
angry

▷ Physiological Expressions

When the body is presented with certain stimuli, such as heat, cold, sickness, or exhaustion, facial expressions are automatic, involuntary reactions that we cannot control.

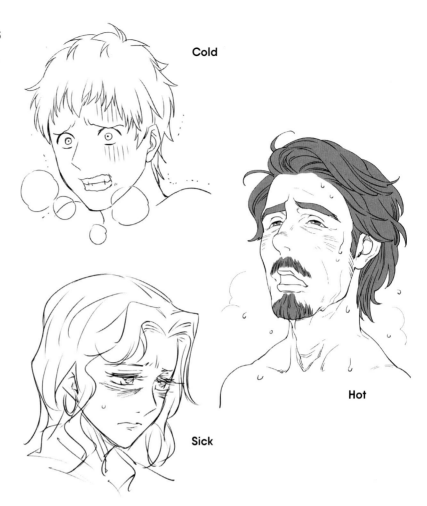

Cold

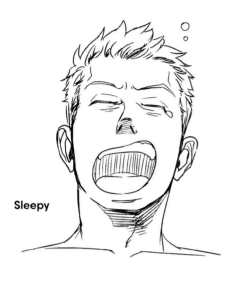

Sleepy

Sick

Hot

▷ Expressions While Eating

Putting food in the mouth, chewing, and drinking can change the shape of the face. A yummy taste leads to happiness, while a disgusting taste leads to dislike, each of which creates natural facial expressions while eating.

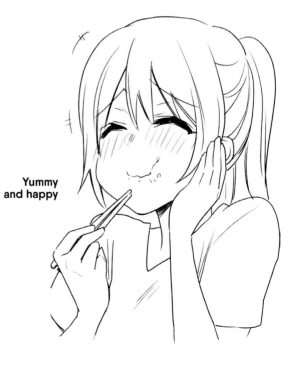

Yummy and happy

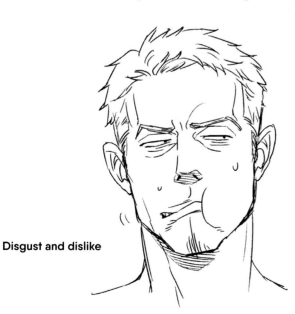

Disgust and dislike

TYPES OF EMOTIONS

Before we get started learning how to draw facial expressions, it's important to understand the different emotions that are responsible for creating these expressions. It may seem like we humans experience hundreds of different emotions, but scientists have discovered that there are really just a handful of basic emotions.

▷ Universal Emotions

According to the results of several studies, humans around the globe exhibit the same facial expressions regardless of race, religion, or culture when experiencing the following six emotions: joy, anger, sadness, surprise, fear, and disgust.

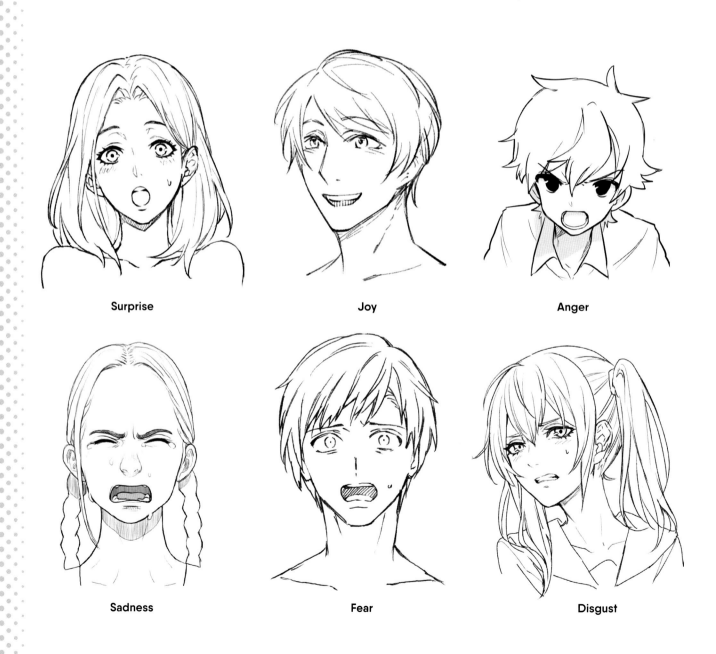

| Surprise | Joy | Anger |

| Sadness | Fear | Disgust |

Wheel of Emotions

Psychologist Robert Plutchik developed the "Wheel of Emotions," a model that identifies eight primary emotions (the six universal emotions from page 10 plus trust and anticipation). Based on the color wheel, his model proposes that these primary emotions can be expressed at different intensities and can mix with one another to form different emotions. This book will use the emotions featured in this model as a guide for learning how to draw facial expressions.

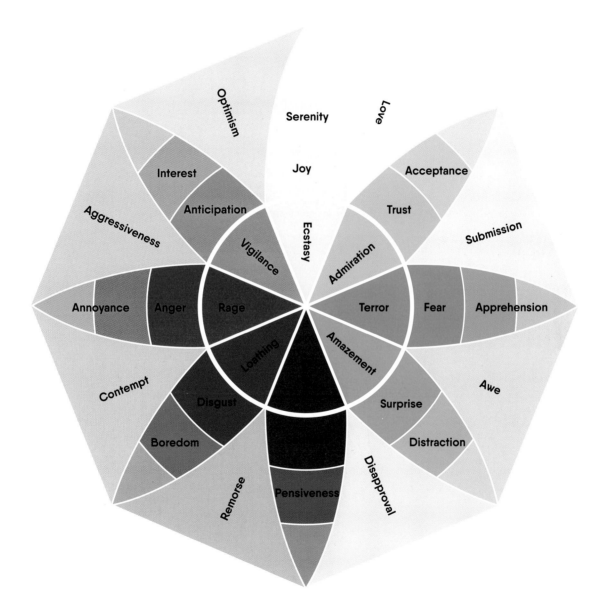

KEY FACIAL FEATURES FOR EXPRESSIONS

We naturally read people's feelings just by looking at their faces. Which part of the face should you look at to read those expressions? In this lesson, let's talk about the key facial features that you should focus on to display expressive feelings for your characters.

The most important part of the facial expression is the movement of eyes, eyebrows, and mouth. Focusing on these three features will help you draw many different types of expressions.

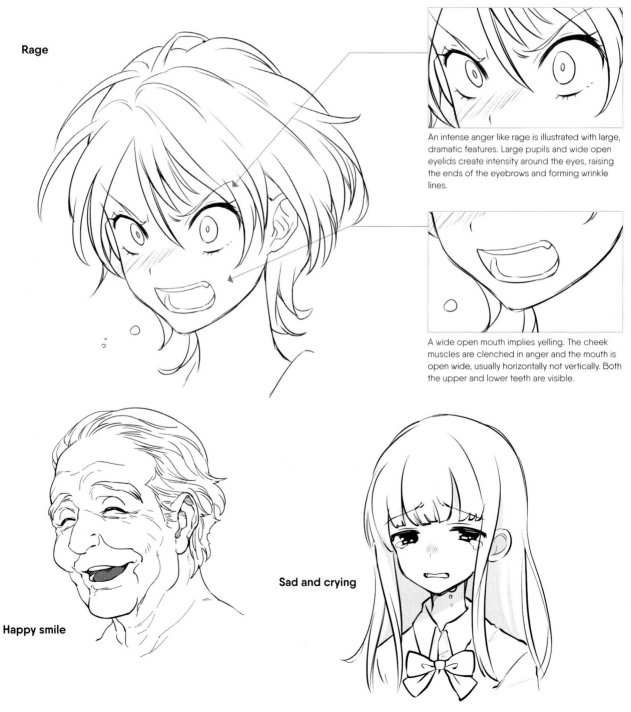

Rage

An intense anger like rage is illustrated with large, dramatic features. Large pupils and wide open eyelids create intensity around the eyes, raising the ends of the eyebrows and forming wrinkle lines.

A wide open mouth implies yelling. The cheek muscles are clenched in anger and the mouth is open wide, usually horizontally not vertically. Both the upper and lower teeth are visible.

Happy smile

Sad and crying

▶ Eyes and Eyebrows

Expression in the eyes is a combination of two important features: the eyelids and the pupils. Open your character's eyelids wide or have them squint shut, then draw small or large pupils to create different expressions. The eyebrows can be raised or furrowed. Don't forget to add wrinkles for more detail.

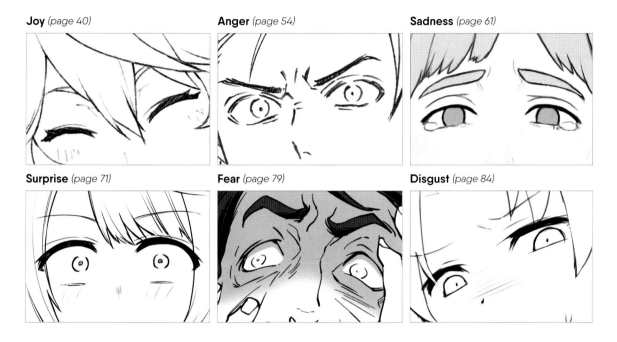

Joy *(page 40)*

Anger *(page 54)*

Sadness *(page 61)*

Surprise *(page 71)*

Fear *(page 79)*

Disgust *(page 84)*

▶ Mouth

To show expression with the mouth, you'll want to indicate movement, such as raising the ends of the lips, clenching the teeth, or closing the lips tightly. The important points are the shape of the lips and how you show the teeth. Intensify the shape of the lower lip with extra lines to make it more three-dimensional.

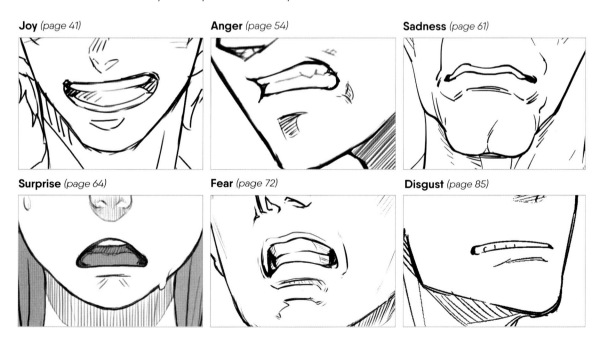

Joy *(page 41)*

Anger *(page 54)*

Sadness *(page 61)*

Surprise *(page 64)*

Fear *(page 72)*

Disgust *(page 85)*

THE FOUNDATION OF EXPRESSIONS: BONES & MUSCLES

Facial lines, such as wrinkles on the cheek from smiling or angry furrows between the eyebrows, are created by the bones and muscles under the skin. To draw believable expressions, you need to understand the foundation. Here, we explain the bones and muscles related to facial expressions.

▷ The Bones & Muscles of the Face

The bones and muscles that make up the human face may seem complicated, but don't worry—you don't need to memorize all the scientific terms! It is most useful to remember the cheekbones, lower jawbone, and the muscles around the eyes, eyebrows, and mouth. The following guide will help you understand the basic anatomical structure and how it changes with different facial expressions.

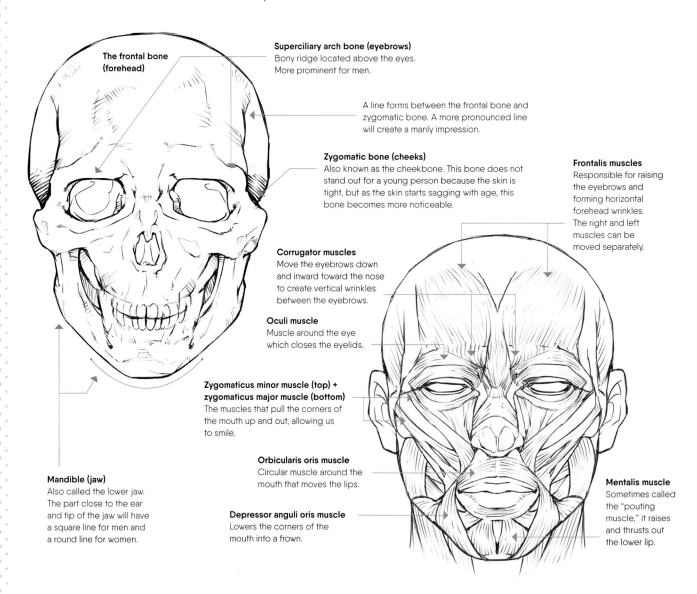

The frontal bone (forehead)

Superciliary arch bone (eyebrows)
Bony ridge located above the eyes. More prominent for men.

A line forms between the frontal bone and zygomatic bone. A more pronounced line will create a manly impression.

Zygomatic bone (cheeks)
Also known as the cheekbone. This bone does not stand out for a young person because the skin is tight, but as the skin starts sagging with age, this bone becomes more noticeable.

Frontalis muscles
Responsible for raising the eyebrows and forming horizontal forehead wrinkles. The right and left muscles can be moved separately.

Corrugator muscles
Move the eyebrows down and inward toward the nose to create vertical wrinkles between the eyebrows.

Oculi muscle
Muscle around the eye which closes the eyelids.

Zygomaticus minor muscle (top) + zygomaticus major muscle (bottom)
The muscles that pull the corners of the mouth up and out, allowing us to smile.

Orbicularis oris muscle
Circular muscle around the mouth that moves the lips.

Mandible (jaw)
Also called the lower jaw. The part close to the ear and tip of the jaw will have a square line for men and a round line for women.

Depressor anguli oris muscle
Lowers the corners of the mouth into a frown.

Mentalis muscle
Sometimes called the "pouting muscle," it raises and thrusts out the lower lip.

Facial Expressions & Muscle Movements

The following examples illustrate how the muscles move with different facial expressions. Pay particular attention to the areas around the eyes and mouth and observe the differences between emotions.

Try dividing the upper eyelid and eyebrow into six blocks to capture the shape.

Joy

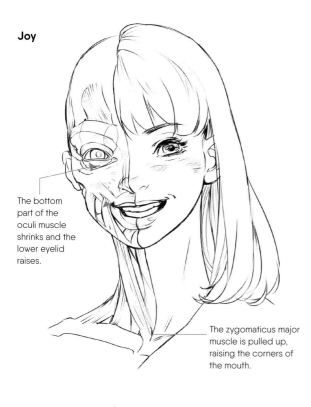

The bottom part of the oculi muscle shrinks and the lower eyelid raises.

The zygomaticus major muscle is pulled up, raising the corners of the mouth.

Sadness

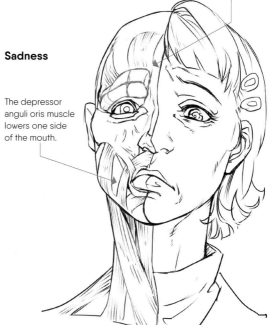

The depressor anguli oris muscle lowers one side of the mouth.

Anger

The corrugator muscle shrinks to make vertical wrinkles between the eyebrows.

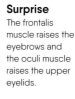

The orbicularis oris muscle opens the lips wide.

Surprise

The frontalis muscle raises the eyebrows and the oculi muscle raises the upper eyelids.

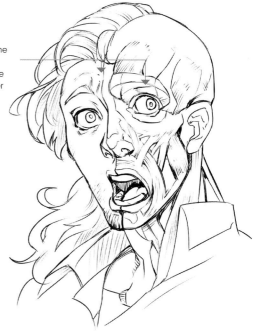

TIP: *Remember, facial expressions involving wide open eyes and mouths do not change the position of the hairline, eyes, nose, or ears.*

AGING FACES

The human face loses skin tightness with age; wrinkles increase and the skin sags with the decline of muscle tone. Let's understand how wrinkles appear in order to draw the facial expressions that illustrate long and full lives.

The areas of the face that are prone to developing wrinkles and sagging are the forehead, temples, eyes, cheeks, nasolabial folds, around the mouth, jaw, and neck.

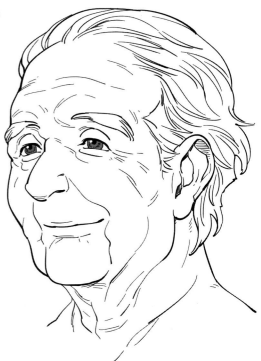

▶ Draw wrinkles on the forehead, between the eyebrows, at the corners of eyes, along the nasolabial folds, and the loose skin on the throat to create the face of a grandpa.

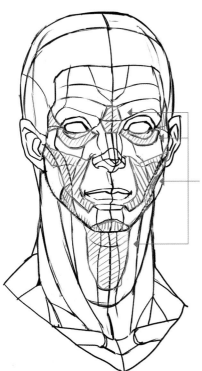

The parts shown in red will become loose and wrinkle with age. These include: between the eyebrows, underneath the eyes, at the temples, cheeks, nasolabial folds (laugh lines from the nose to the corners of the mouth), lower jawline, and the Adam's apple.

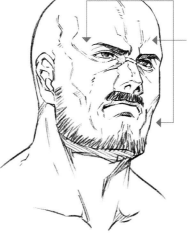

Wrinkles are created from the end of the eyes toward the temples and between the eyebrows toward the forehead. Because the cheek is thin here, the line appears next to the corner of the mouth and looks like it's floating.

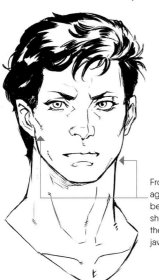

From around middle age, the cheeks become thinner and show the lines of the cheekbone and jawbone.

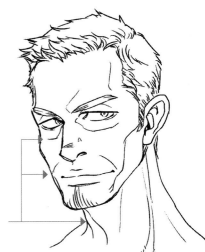

Draw lines underneath the eyes, along the nasolabial folds, and Adam's apple to create a more mature looking character.

Aging Timeline

Skin and muscle aging usually starts in the 30s. Depending on the individual, the eyes and cheeks start showing signs of aging from the late 30s to 40s, become more obvious in the 50s, and then facial skin sags greatly in the 60s.

Late 30s to 40s

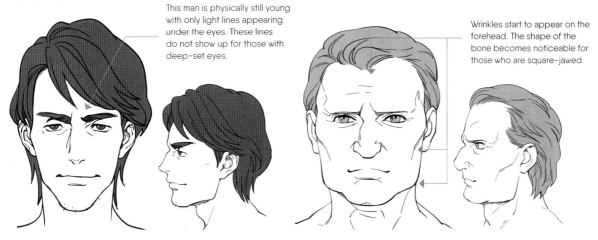

This man is physically still young with only light lines appearing under the eyes. These lines do not show up for those with deep-set eyes.

Wrinkles start to appear on the forehead. The shape of the bone becomes noticeable for those who are square-jawed.

50s

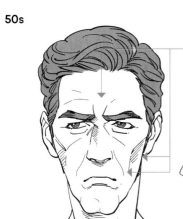

The cheeks become thin and darker shadows emphasize the cheekbones. Wrinkles appear between the eyebrows and end of the nose, and the nasolabial folds become more prominent.

The skin around the eyes becomes loose and wrinkles appear. Even with smaller jaws, the cheeks are thinner and the bones stand out.

After 60s

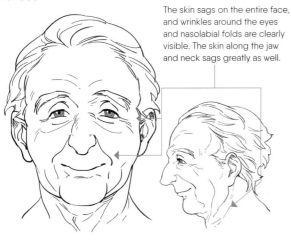

The skin sags on the entire face, and wrinkles around the eyes and nasolabial folds are clearly visible. The skin along the jaw and neck sags greatly as well.

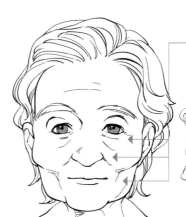

The lines are softer for women compared to men, but signs of aging, such as wrinkles at the corners of the eyes, along the nasolabial folds, and cheekbones still become obvious.

A VARIETY OF FACE SHAPES

You can draw a variety of characters of all ages by changing the basic shape of the face. Using this section as reference, let's think about the shape of the face line you want to draw.

▶ Oval

An oval face shape is a good base for drawing a standard character in many age ranges, from a youth to middle-aged men and women.

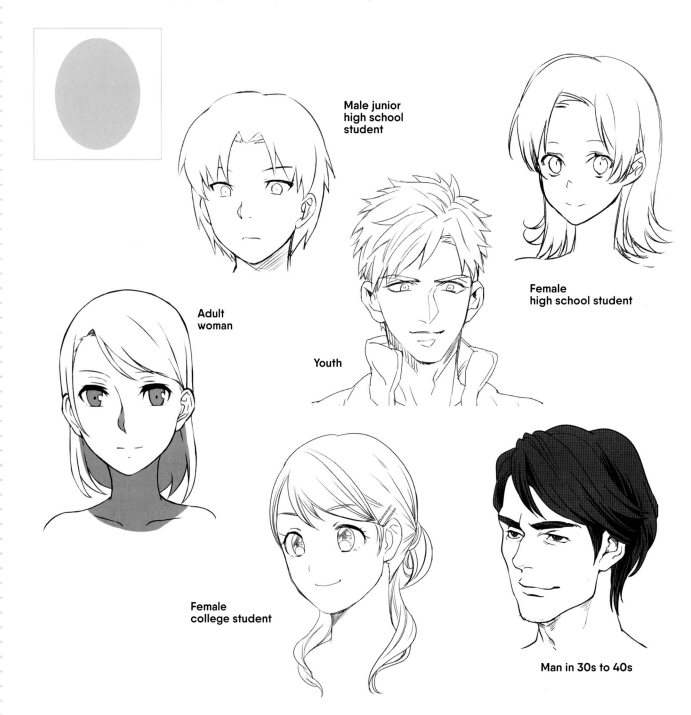

Male junior high school student

Female high school student

Adult woman

Youth

Female college student

Man in 30s to 40s

▷ Circle

A circle is a good base for drawing a round faced character, such as a baby, toddler, heavyset person, or a grandpa.

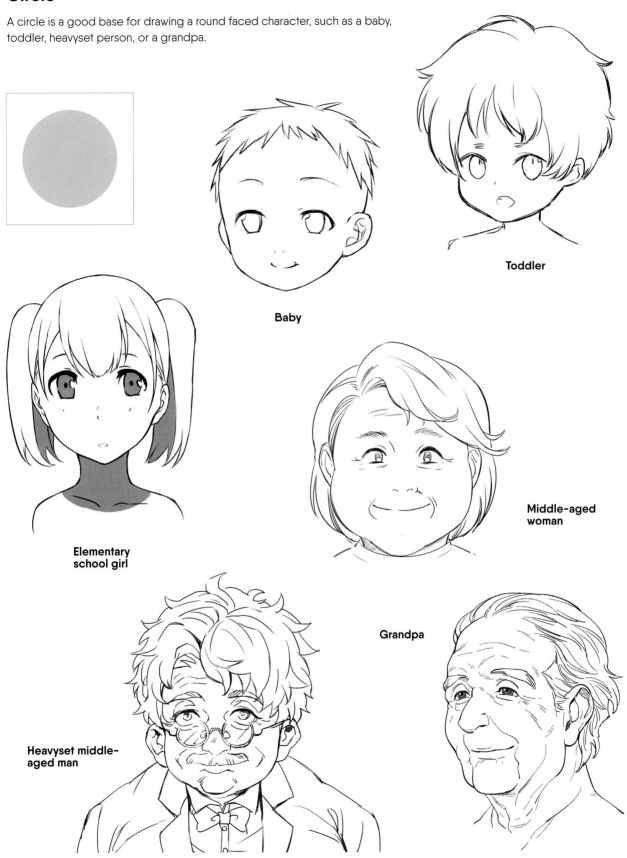

Toddler

Baby

Elementary school girl

Middle-aged woman

Grandpa

Heavyset middle-aged man

▶ Rectangle

A rectangular-shaped face is suitable for drawing bony, square, rough-figured characters. Adult males often fall into this category.

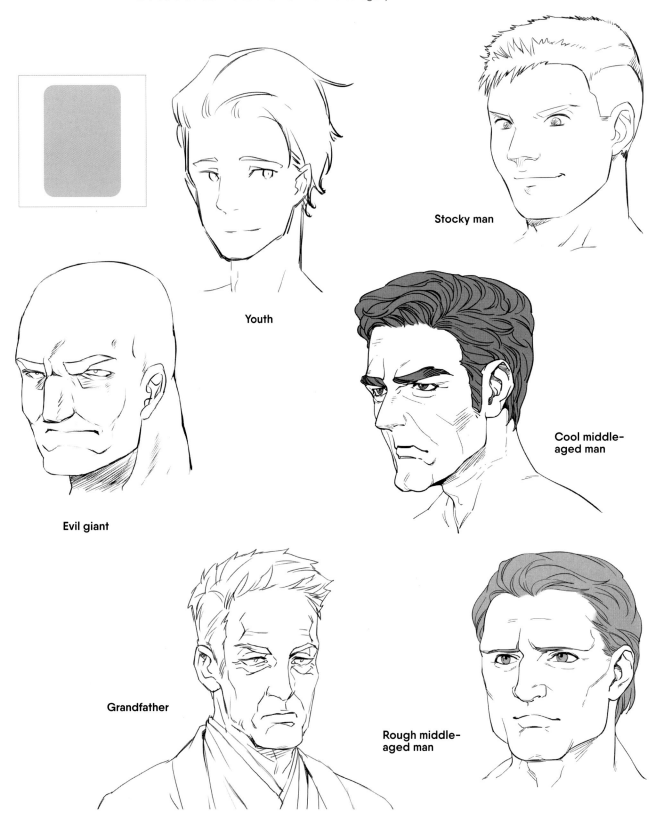

Youth

Stocky man

Evil giant

Cool middle-aged man

Grandfather

Rough middle-aged man

▷ Uncommon Shapes

To draw a distinctive character, use an uncommon face shape such as an inverted triangle or trapezoid.

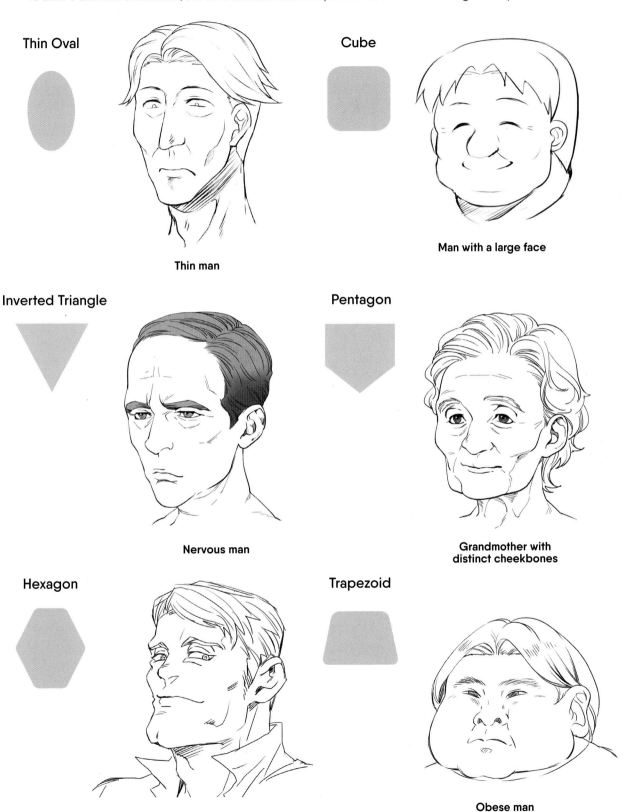

Thin Oval

Thin man

Cube

Man with a large face

Inverted Triangle

Nervous man

Pentagon

Grandmother with
distinct cheekbones

Hexagon

Square-jawed man

Trapezoid

Obese man

CARTOON DEFORMATION

In manga, artists often use deformation techniques to simplify or exaggerate certain characteristics, for stylistic purposes, as well as to convey emotion and action. Before starting to draw, let's discuss the basics of this technique.

It is a challenge to draw using reduced lines while still expressing the character's unique features. First, practice drawing realistic faces using photos as reference, then reduce the main lines to simplify.

Man

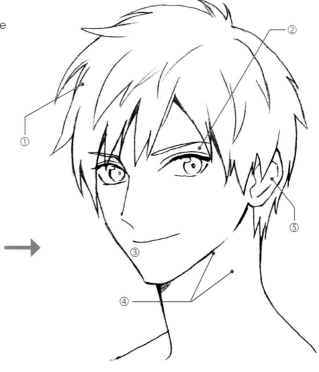

① Bundle thin hair into one thick line

② Draw double eyelids with one line and darken the outside of the eyelashes

③ Remove the nostrils and the lines under the bottom lip, drawing the mouth with one line

④ Soften the jawline and remove lines on neck

⑤ Reduce ear lines, drawing only the outline

Woman

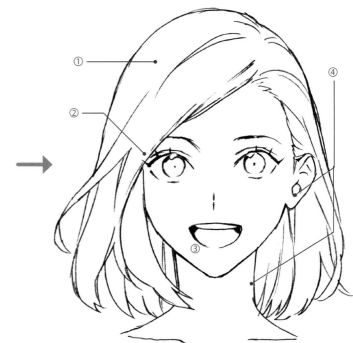

① Reduce lines of hair and emphasize the outline of the hair

② Widen the eyes and draw the bottom eyelashes with one line

③ Round the corners of the mouth and draw the upper lip using a simple curved line

④ Connect the ear and cheek line, as well as the neck and shoulder cross-section

Exaggerate Proportions for Small Characters

To draw facial expressions of small characters, enlarge the head to be 2 to 4 heads tall, and exaggerate facial features, such as the eyes and mouth.

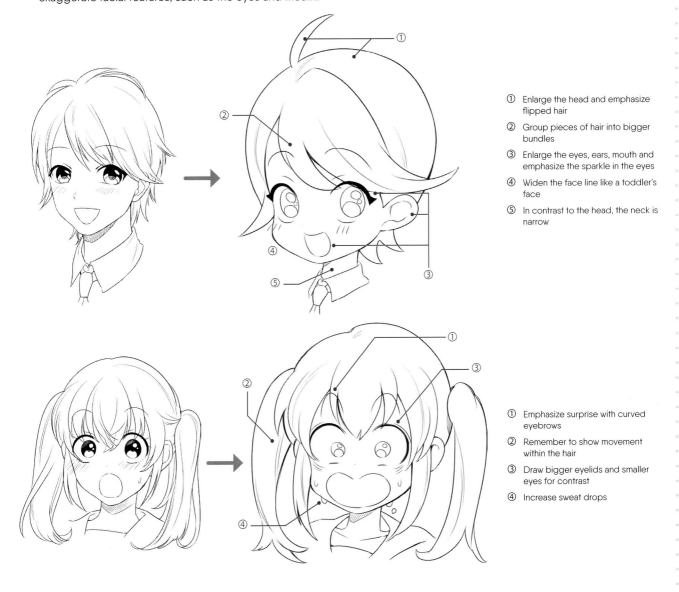

① Enlarge the head and emphasize flipped hair

② Group pieces of hair into bigger bundles

③ Enlarge the eyes, ears, mouth and emphasize the sparkle in the eyes

④ Widen the face line like a toddler's face

⑤ In contrast to the head, the neck is narrow

① Emphasize surprise with curved eyebrows

② Remember to show movement within the hair

③ Draw bigger eyelids and smaller eyes for contrast

④ Increase sweat drops

Other Deformation Examples

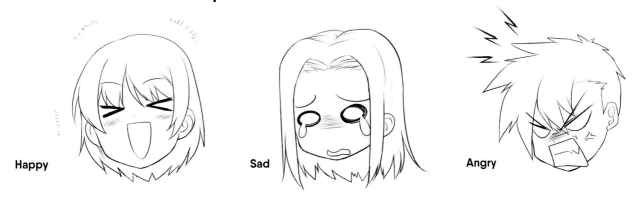

Happy

Sad

Angry

HOW TO DRAW FACIAL GUIDELINES

To draw a face with complicated parts, you'll need to start with guidelines. Let's learn how to draw the face from a variety of different angles. Whichever angle you choose, the same basic principles will apply.

Front

When you follow these basic guidelines, positioning the eyes, nose, and mouth for the frontal view of a face is easy. Out of place features will be obvious and can be corrected in the early stages of your sketch.

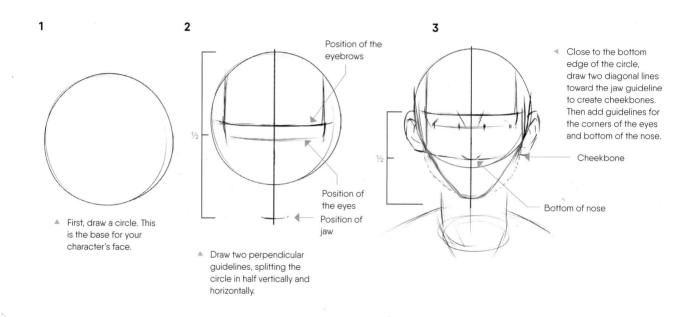

1

△ First, draw a circle. This is the base for your character's face.

2

Position of the eyebrows

Position of the eyes

Position of jaw

△ Draw two perpendicular guidelines, splitting the circle in half vertically and horizontally.

3

◁ Close to the bottom edge of the circle, draw two diagonal lines toward the jaw guideline to create cheekbones. Then add guidelines for the corners of the eyes and bottom of the nose.

Cheekbone

Bottom of nose

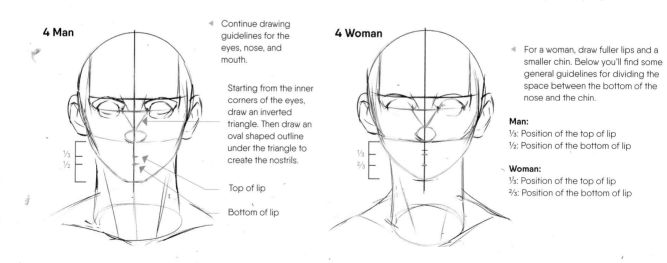

4 Man

◁ Continue drawing guidelines for the eyes, nose, and mouth.

Starting from the inner corners of the eyes, draw an inverted triangle. Then draw an oval shaped outline under the triangle to create the nostrils.

Top of lip

Bottom of lip

4 Woman

◁ For a woman, draw fuller lips and a smaller chin. Below you'll find some general guidelines for dividing the space between the bottom of the nose and the chin.

Man:
⅓: Position of the top of lip
½: Position of the bottom of lip

Woman:
⅓: Position of the top of lip
⅔: Position of the bottom of lip

Complete

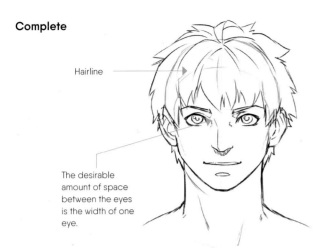

Hairline

The desirable amount of space between the eyes is the width of one eye.

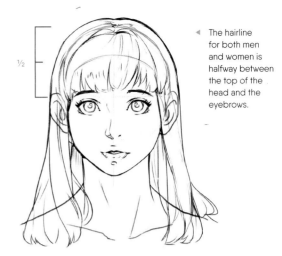

◄ The hairline for both men and women is halfway between the top of the head and the eyebrows.

½

Three-Quarter

The three-quarter view is a great way to show dimension in the face. However, the shape of each part of the face changes when turned, so be mindful of the position of the center line of the face to keep it balanced.

1

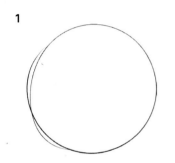

▲ Draw a circle, just like for the frontal view.

2

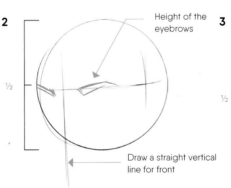

Height of the eyebrows

½

Draw a straight vertical line for front

▲ To decide the orientation of the face, draw guidelines for the front and side. Then, draw a horizontal guideline to divide the sphere into two. This line also marks the eyebrow placement.

3

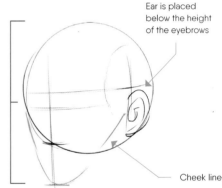

Ear is placed below the height of the eyebrows

½

Cheek line

▲ Draw a guideline for the position of the eyes a little below the eyebrow line. Using the position of the eyes as the center, measure the distance to the top of the head and use the same distance to mark the position of the bottom of the jaw.

4 Man

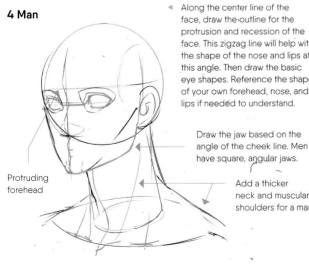

Protruding forehead

▲ Along the center line of the face, draw the outline for the protrusion and recession of the face. This zigzag line will help with the shape of the nose and lips at this angle. Then draw the basic eye shapes. Reference the shape of your own forehead, nose, and lips if needed to understand.

Draw the jaw based on the angle of the cheek line. Men have square, angular jaws.

Add a thicker neck and muscular shoulders for a man.

4 Woman

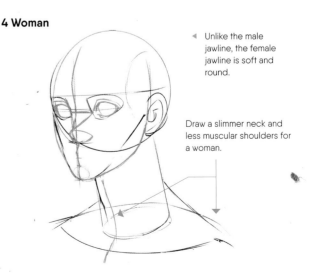

◄ Unlike the male jawline, the female jawline is soft and round.

Draw a slimmer neck and less muscular shoulders for a woman.

Complete

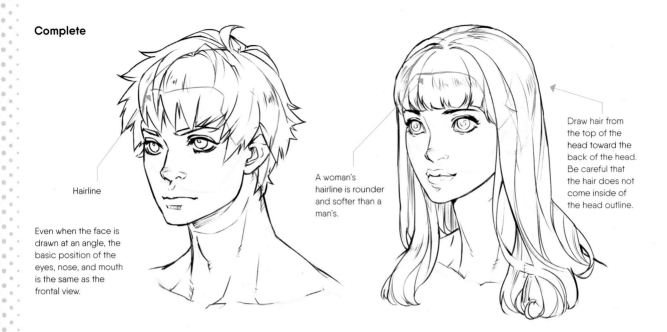

Hairline

Even when the face is drawn at an angle, the basic position of the eyes, nose, and mouth is the same as the frontal view.

A woman's hairline is rounder and softer than a man's.

Draw hair from the top of the head toward the back of the head. Be careful that the hair does not come inside of the head outline.

▶ High Angle/Bird's Eye View

With this view, you're looking down on the subject from above. Compared to the level position of the face, the mouth and nose are pointed downward, the eyes are looking down, and the top of the head is visible.

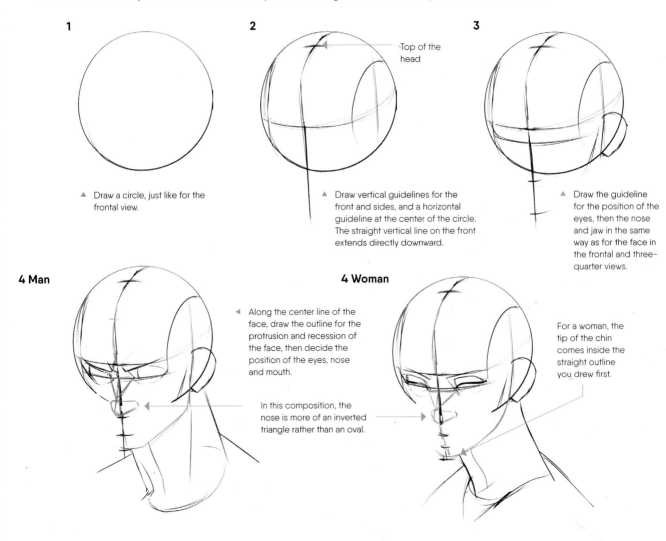

1

▲ Draw a circle, just like for the frontal view.

2

Top of the head

▲ Draw vertical guidelines for the front and sides, and a horizontal guideline at the center of the circle. The straight vertical line on the front extends directly downward.

3

▲ Draw the guideline for the position of the eyes, then the nose and jaw in the same way as for the face in the frontal and three-quarter views.

4 Man

4 Woman

◄ Along the center line of the face, draw the outline for the protrusion and recession of the face, then decide the position of the eyes, nose and mouth.

In this composition, the nose is more of an inverted triangle rather than an oval.

For a woman, the tip of the chin comes inside the straight outline you drew first.

Complete

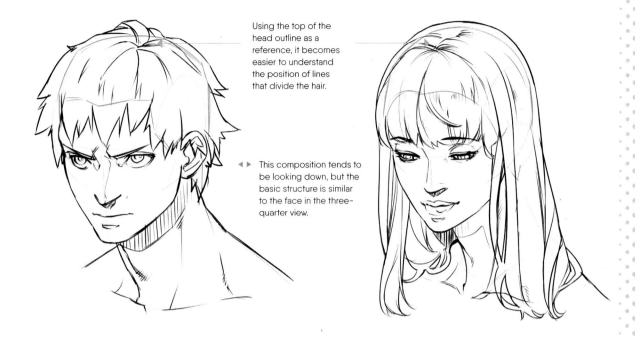

Using the top of the head outline as a reference, it becomes easier to understand the position of lines that divide the hair.

◄► This composition tends to be looking down, but the basic structure is similar to the face in the three-quarter view.

► Low Angle/Worm's Eye View

Drawing the face from this angle can be a bit challenging because you need to draw unfamiliar areas such as the underside of the jaw and nose. Using the center line of the face as a guideline, draw the parts of the face parallel to each other.

1　　　　　　　　**2**　　　　　　　　**3**

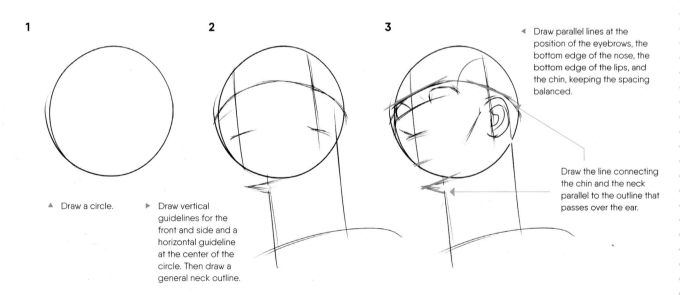

◄ Draw parallel lines at the position of the eyebrows, the bottom edge of the nose, the bottom edge of the lips, and the chin, keeping the spacing balanced.

▲ Draw a circle.

► Draw vertical guidelines for the front and side and a horizontal guideline at the center of the circle. Then draw a general neck outline.

Draw the line connecting the chin and the neck parallel to the outline that passes over the ear.

4 Man

4 Woman

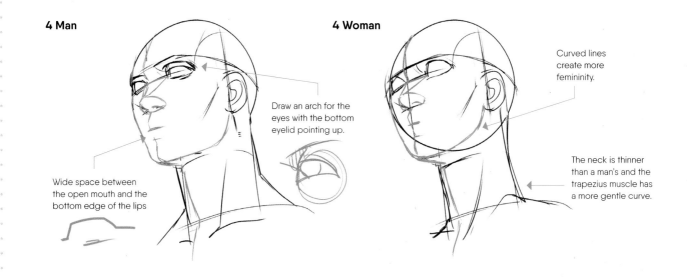

Draw an arch for the eyes with the bottom eyelid pointing up.

Wide space between the open mouth and the bottom edge of the lips

Curved lines create more femininity.

The neck is thinner than a man's and the trapezius muscle has a more gentle curve.

Complete

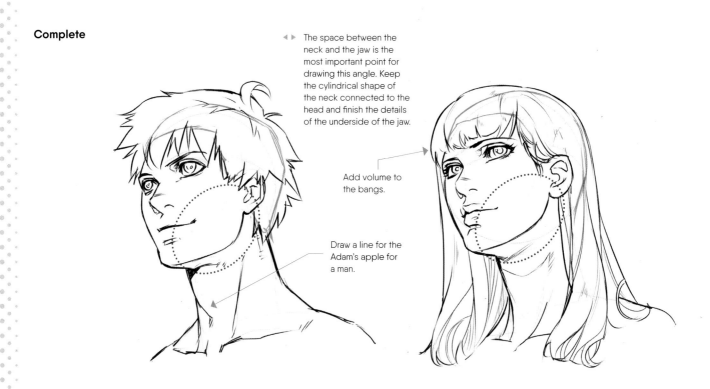

◄ ► The space between the neck and the jaw is the most important point for drawing this angle. Keep the cylindrical shape of the neck connected to the head and finish the details of the underside of the jaw.

Add volume to the bangs.

Draw a line for the Adam's apple for a man.

▶ Side

The important points for a side profile composition are the position of the nose and the mouth and the shape of the eyes. You may find it intimidating at first, but there are fewer parts to draw, and they're easy to grasp, so side profiles are suitable for beginners.

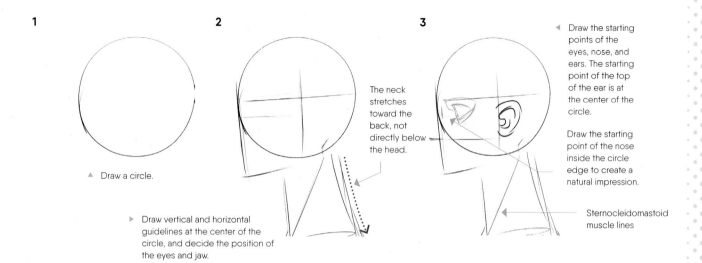

1

▲ Draw a circle.

2

▶ Draw vertical and horizontal guidelines at the center of the circle, and decide the position of the eyes and jaw.

The neck stretches toward the back, not directly below the head.

3

◀ Draw the starting points of the eyes, nose, and ears. The starting point of the top of the ear is at the center of the circle.

Draw the starting point of the nose inside the circle edge to create a natural impression.

Sternocleidomastoid muscle lines

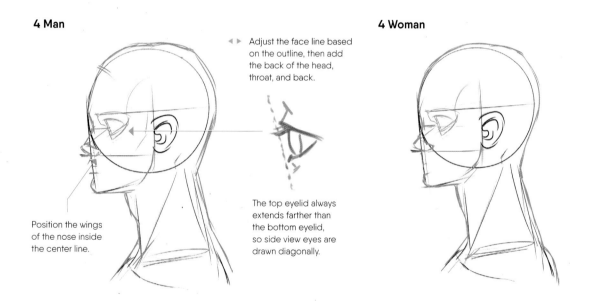

4 Man

Position the wings of the nose inside the center line.

◀ ▶ Adjust the face line based on the outline, then add the back of the head, throat, and back.

The top eyelid always extends farther than the bottom eyelid, so side view eyes are drawn diagonally.

4 Woman

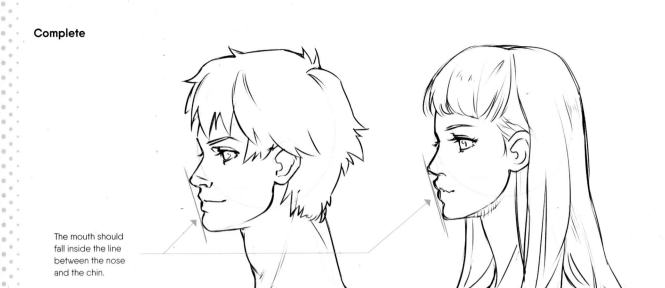

The mouth should fall inside the line between the nose and the chin.

▷ Back

A back view can be very difficult to capture because most of the face cannot be seen from this angle. To make it realistic, it is important to draw the shape of the neck, shoulder, and ear aligned with the center line.

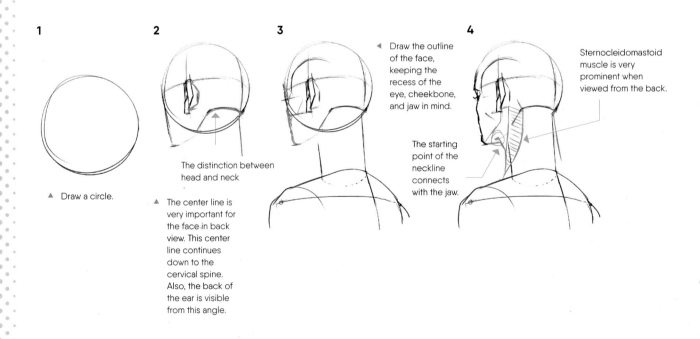

1

▲ Draw a circle.

2

The distinction between head and neck

▲ The center line is very important for the face in back view. This center line continues down to the cervical spine. Also, the back of the ear is visible from this angle.

3

◁ Draw the outline of the face, keeping the recess of the eye, cheekbone, and jaw in mind.

4

Sternocleidomastoid muscle is very prominent when viewed from the back.

The starting point of the neckline connects with the jaw.

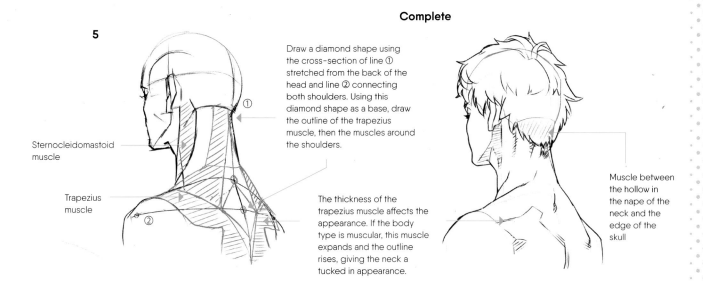

Complete

5

Draw a diamond shape using the cross-section of line ① stretched from the back of the head and line ② connecting both shoulders. Using this diamond shape as a base, draw the outline of the trapezius muscle, then the muscles around the shoulders.

Sternocleidomastoid muscle

Trapezius muscle

The thickness of the trapezius muscle affects the appearance. If the body type is muscular, this muscle expands and the outline rises, giving the neck a tucked in appearance.

Muscle between the hollow in the nape of the neck and the edge of the skull

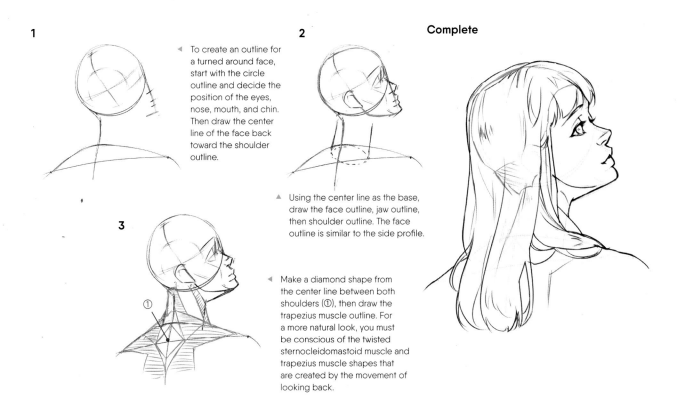

1

◄ To create an outline for a turned around face, start with the circle outline and decide the position of the eyes, nose, mouth, and chin. Then draw the center line of the face back toward the shoulder outline.

2

Complete

▲ Using the center line as the base, draw the face outline, jaw outline, then shoulder outline. The face outline is similar to the side profile.

3

◄ Make a diamond shape from the center line between both shoulders (①), then draw the trapezius muscle outline. For a more natural look, you must be conscious of the twisted sternocleidomastoid muscle and trapezius muscle shapes that are created by the movement of looking back.

Lesson 09

HOW TO DRAW VARIOUS FACES

Creating guidelines is an important tool for drawing faces, but the position of the lines can differ for each individual character. Here we introduce various examples that differ in age, gender, and drawing method.

▶ **Man: Around 20**

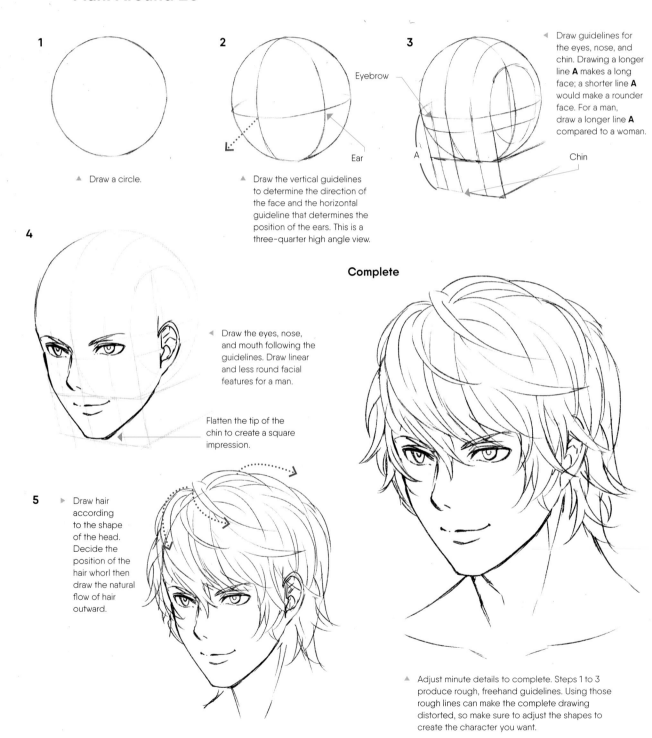

1

▲ Draw a circle.

2

Eyebrow

Ear

▲ Draw the vertical guidelines to determine the direction of the face and the horizontal guideline that determines the position of the ears. This is a three-quarter high angle view.

3

A

Chin

◄ Draw guidelines for the eyes, nose, and chin. Drawing a longer line **A** makes a long face; a shorter line **A** would make a rounder face. For a man, draw a longer line **A** compared to a woman.

4

◄ Draw the eyes, nose, and mouth following the guidelines. Draw linear and less round facial features for a man.

Flatten the tip of the chin to create a square impression.

Complete

5

▶ Draw hair according to the shape of the head. Decide the position of the hair whorl then draw the natural flow of hair outward.

▲ Adjust minute details to complete. Steps 1 to 3 produce rough, freehand guidelines. Using those rough lines can make the complete drawing distorted, so make sure to adjust the shapes to create the character you want.

Woman: Late Teens

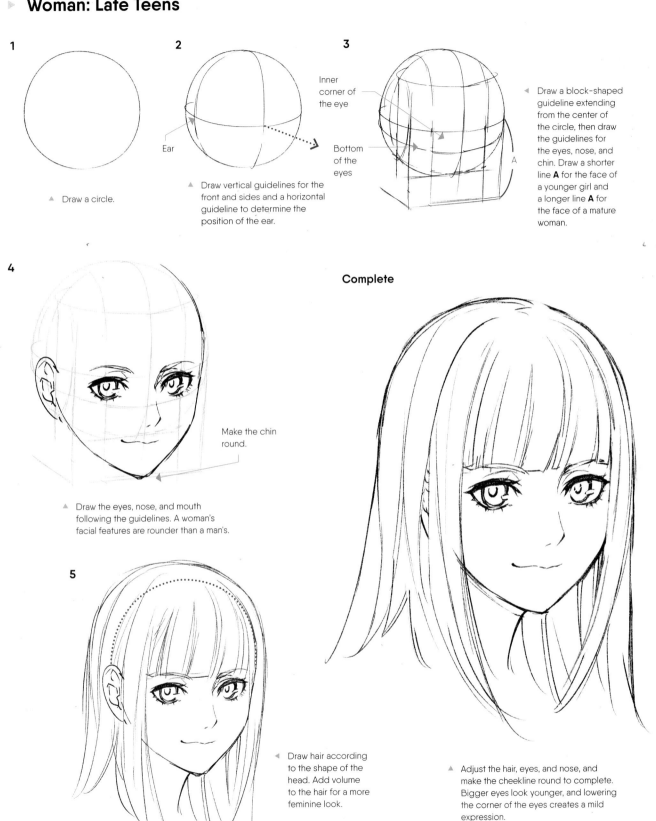

1

▲ Draw a circle.

2

Ear

▲ Draw vertical guidelines for the front and sides and a horizontal guideline to determine the position of the ear.

3

Inner corner of the eye

Bottom of the eyes

A

◄ Draw a block-shaped guideline extending from the center of the circle, then draw the guidelines for the eyes, nose, and chin. Draw a shorter line **A** for the face of a younger girl and a longer line **A** for the face of a mature woman.

4

Make the chin round.

▲ Draw the eyes, nose, and mouth following the guidelines. A woman's facial features are rounder than a man's.

5

◄ Draw hair according to the shape of the head. Add volume to the hair for a more feminine look.

Complete

▲ Adjust the hair, eyes, and nose, and make the cheekline round to complete. Bigger eyes look younger, and lowering the corner of the eyes creates a mild expression.

▶ Girl: Fantasy

1

① Draw a circle for the head.
② Draw a vertical guideline that determines the center of the face.
③ Draw a horizontal guideline that determines the position of the eyes.

2

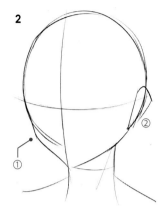

① Draw the jawline based on the vertical guideline.
② The ear is placed on the side of the eyeline.

3

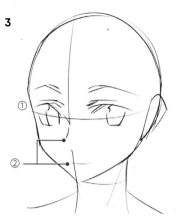

① Draw the eyes using the horizontal guideline as the center point.
② Determine the position of the nose and mouth using the vertical guideline as a reference.

4

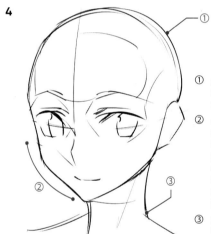

Complete

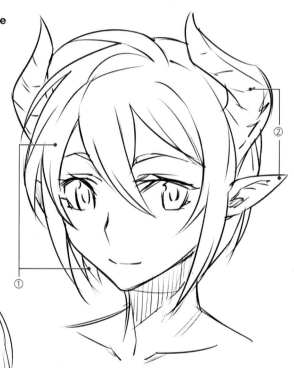

① Add fullness to the back of the head for a more natural look.
② Adjust the position and shape of the eyes, nose, and the mouth with the projection and recession of an actual face in mind, such as where the eyes sink in and the side of the face slopes.
③ Lean the neck slightly forward.

5

Draw hair with volume extending out from the faceline.

▶ Draw the hair using the head shape as a guideline, then add details, such as the pupils.

① Add details to the bangs and back of the hair.
② Add fantasy parts on the side of the head, such as horns and pointed ears. These were added last in this drawing, but you can add accessories and other elements whenever it's easy to draw.

TIP: *As you become more comfortable drawing faces, you can easily rearrange elements with different angles and patterns for various characters.*

▶ Girl: Crying

1

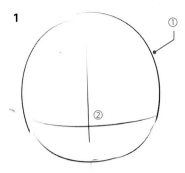

① Draw a circle for the head.

② Draw vertical and horizontal guidelines to determine the direction of the face. This is a frontal high angle view.

2

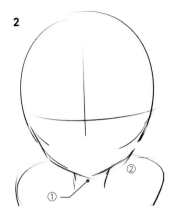

① Determine the position of the chin and draw the guideline.

② Determine the general position of the neck and shoulders at this stage.

3

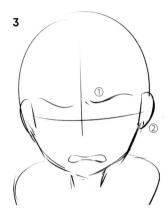

① Draw the eyebrows and ears based on the horizontal guideline, and the mouth based on the vertical guideline.

② The ears are the same height as the eyes.

4

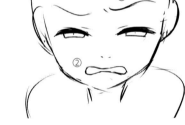

① Draw the eyes above the horizontal guideline. The eyes are closed tightly, so the upper eyelids are down, and bottom eyelids form an upward arc.

② Because she is crying, draw the nose with nostrils opened.

5

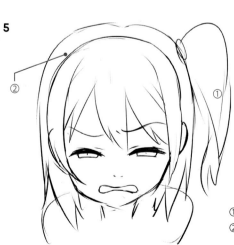

Complete

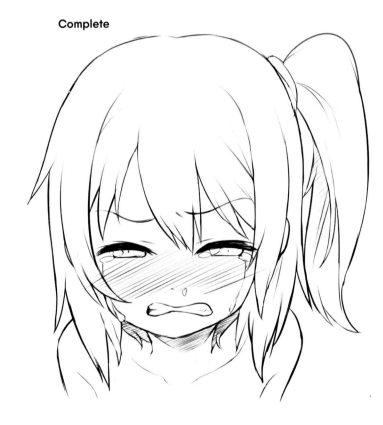

▲ As you erase the guidelines from the head, hair, and shoulders, draw the final position of each part. Add diagonal lines under the eyes to express redness and tears, and complete the crying expression.

① Draw the general silhouette of hair.

② Determine the shape of the hair apart from the head to add volume.

▶ Middle-Aged Man

1

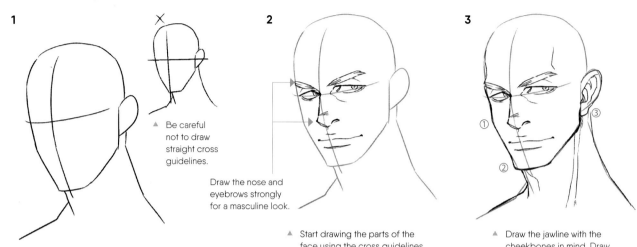

▲ Be careful not to draw straight cross guidelines.

▲ Draw the outline of the face, and add vertical and horizontal cross guidelines curving at the center according to the direction of the face.

2

Draw the nose and eyebrows strongly for a masculine look.

▲ Start drawing the parts of the face using the cross guidelines as a reference. Many people start drawing from the edge and work toward the center. The order does not matter—choose the method that works best for you.

3

▲ Draw the jawline with the cheekbones in mind. Draw prominent cheekbones (①), chin (②), and jaw (③) to emphasize manliness. Draw the neck thicker also.

Complete

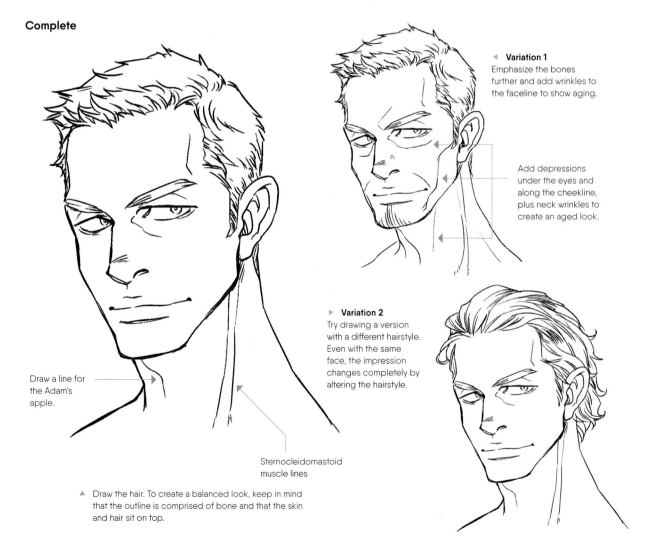

Draw a line for the Adam's apple.

Sternocleidomastoid muscle lines

▲ Draw the hair. To create a balanced look, keep in mind that the outline is comprised of bone and that the skin and hair sit on top.

◀ **Variation 1**
Emphasize the bones further and add wrinkles to the faceline to show aging.

Add depressions under the eyes and along the cheekline, plus neck wrinkles to create an aged look.

▶ **Variation 2**
Try drawing a version with a different hairstyle. Even with the same face, the impression changes completely by altering the hairstyle.

1

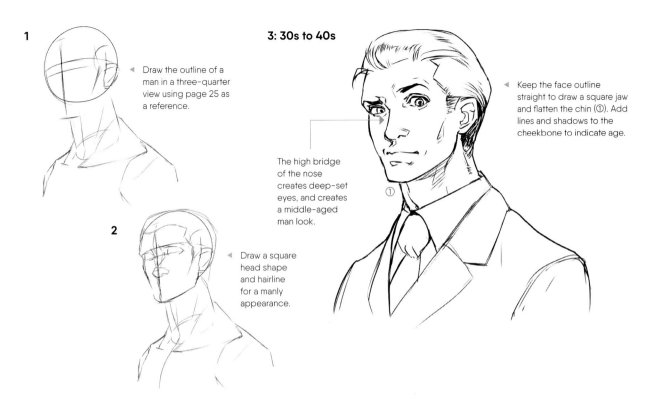

◄ Draw the outline of a man in a three-quarter view using page 25 as a reference.

2

◄ Draw a square head shape and hairline for a manly appearance.

3: 30s to 40s

The high bridge of the nose creates deep-set eyes, and creates a middle-aged man look.

► Keep the face outline straight to draw a square jaw and flatten the chin (①). Add lines and shadows to the cheekbone to indicate age.

①

3: 50s to 60s

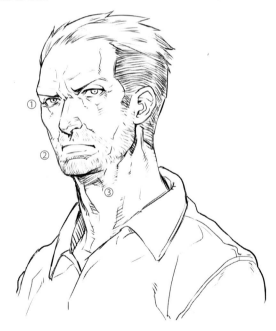

①
②
③

3: 60s and Older

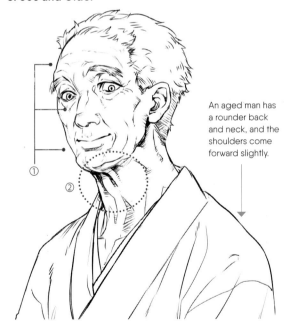

①
②

An aged man has a rounder back and neck, and the shoulders come forward slightly.

① A person in their 50s will have eyes that lower at the corners because skin loosens with age.

② For a realistic effect, draw the beard around the mouth following the three-dimensional shape of the square jaw.

③ Jaw shape changes with age—capture the looseness between the jaw and the neck.

① The tightness of the skin is lost as aging progresses. Wrinkles are prominent at the eyes, mouth, and forehead.

② Around the throat area, two bumps become obvious for the Adam's apple. To illustrate the maturity of age, the neck will have extra wrinkles and shadows along the jaw and around the bumps of the Adam's apple.

Developing a Character's Personality Through Facial Expressions

When we look at people's faces, we unconsciously imagine their personality or what emotions they're feeling. For example, we consider the person with narrowed eyes and no expression as cool and detached, while the person with soft eyes and a smile is considered warm and approachable. Sometimes emotions are that simple, but in a creative world, combining common expressive elements can better illustrate the personality or emotion of characters.

By combining the six universal emotions with other emotional elements we encounter daily, you can draw a variety of complex characters.

Bright girl

A person with naturally lifted corners of the mouth and wide open eyes always looks like they're smiling and gives a positive impression. On the other hand, if she feels down, not many people notice.

Cool woman

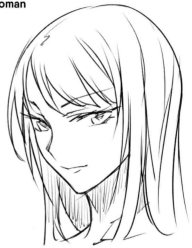

She has stylish features, such as almond eyes and a confident mouth. But her countenance is harsh and it often looks like she is angry.

Sad girl

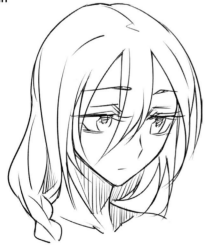

Downcast eyes and lowered corners of the mouth indicate that she is feeling blue and gives a dark impression. This type of character shows less emotion and even their smiles can look sad.

Lying middle-aged man

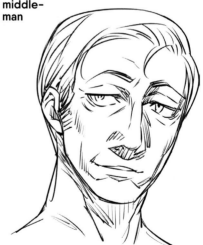

He looks like he is lying because his eyes are not smiling. He gives the impression that he cheats others.

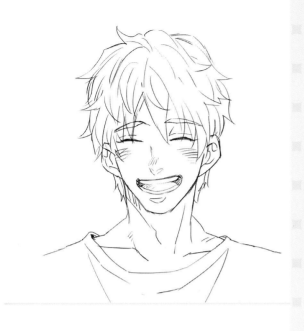

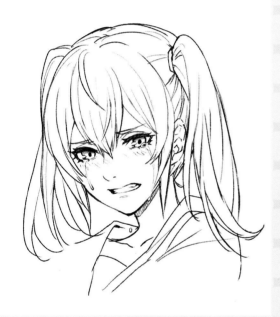

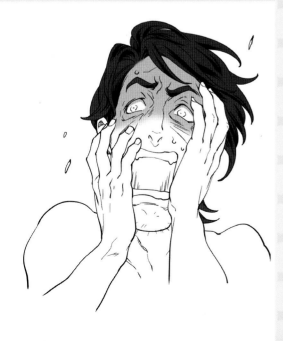

CHAPTER 2

HOW TO DRAW THE SIX UNIVERSAL EMOTIONS

EXPRESSING JOY

The expressions generated from a joyful emotion are bright and positive, shown with happy, fun, smiling faces. This is the most basic and common expression drawn in manga illustrations.

Joy

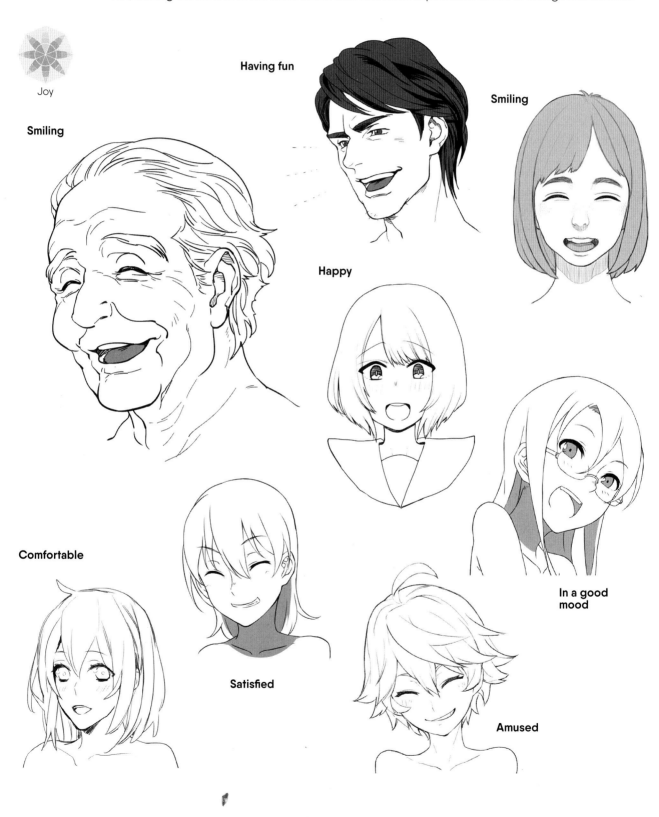

Having fun

Smiling

Smiling

Happy

Comfortable

Satisfied

In a good mood

Amused

Facial Features for Joy

Eyes & Eyebrows

When expressing joy, the muscle around the eye contracts to raise the bottom eyelid, making the eye become thinner (①). On the other hand, the upper eyelid does not move (②), but the end of the eyebrow lowers (③).

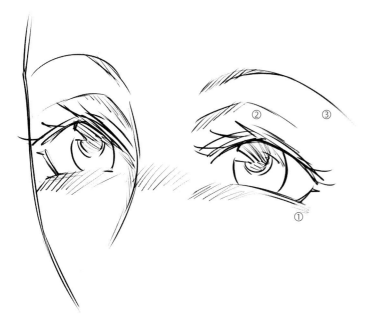

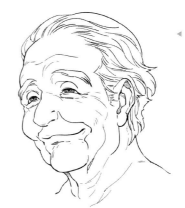

◁ All the wrinkles on an elderly face have sagged, so the laugh lines at the corners of the eyes stand out more.

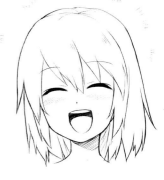

▷ Drawing the eyebrows away from the eyes creates a calm and cheerful expression.

Mouth

The cheekbone muscle that is connected to the jaw muscle shrinks, pulling the lips toward the ears and raising the corners of the mouth (①). Cheeks are raised (②) and a dimple appears close to the mouth (③).

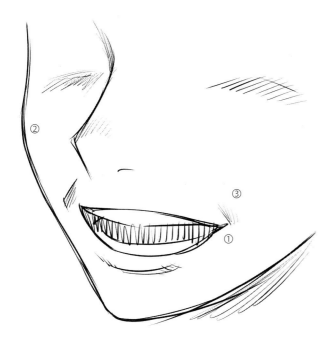

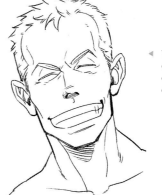

◁ To depict a carefree smile, draw the mouth open wide.

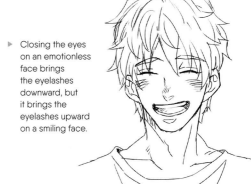

▷ Closing the eyes on an emotionless face brings the eyelashes downward, but it brings the eyelashes upward on a smiling face.

INTENSITY LEVELS OF JOY

Emotions can have various levels of strength. This is especially true with joy where the intensity is clearly recognizable. For that reason, it is a good emotion to practice drawing at a variety of different strengths.

Low Intensity

Less intense joy can be described by words such as peaceful, calm, and at ease. This expression features a natural smile.

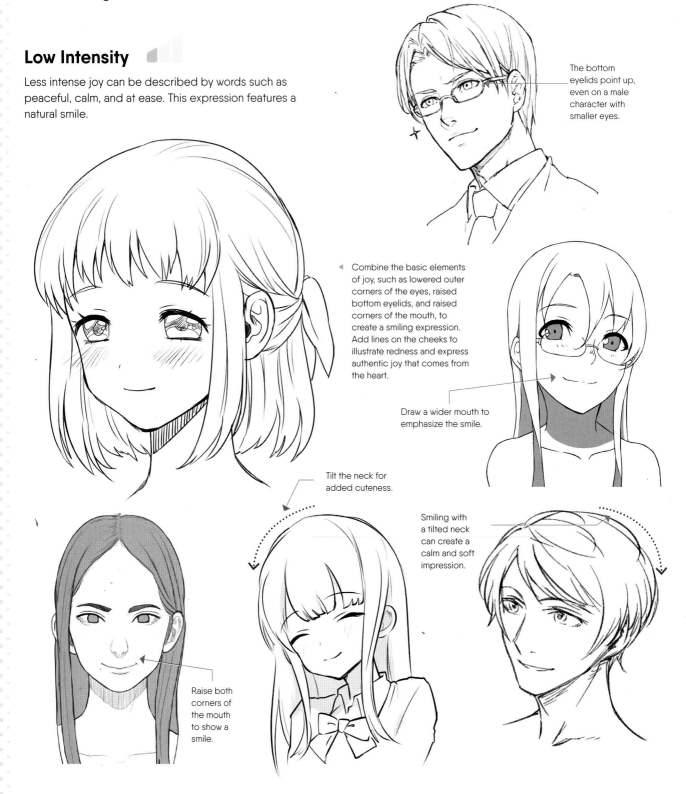

The bottom eyelids point up, even on a male character with smaller eyes.

◀ Combine the basic elements of joy, such as lowered outer corners of the eyes, raised bottom eyelids, and raised corners of the mouth, to create a smiling expression. Add lines on the cheeks to illustrate redness and express authentic joy that comes from the heart.

Draw a wider mouth to emphasize the smile.

Tilt the neck for added cuteness.

Smiling with a tilted neck can create a calm and soft impression.

Raise both corners of the mouth to show a smile.

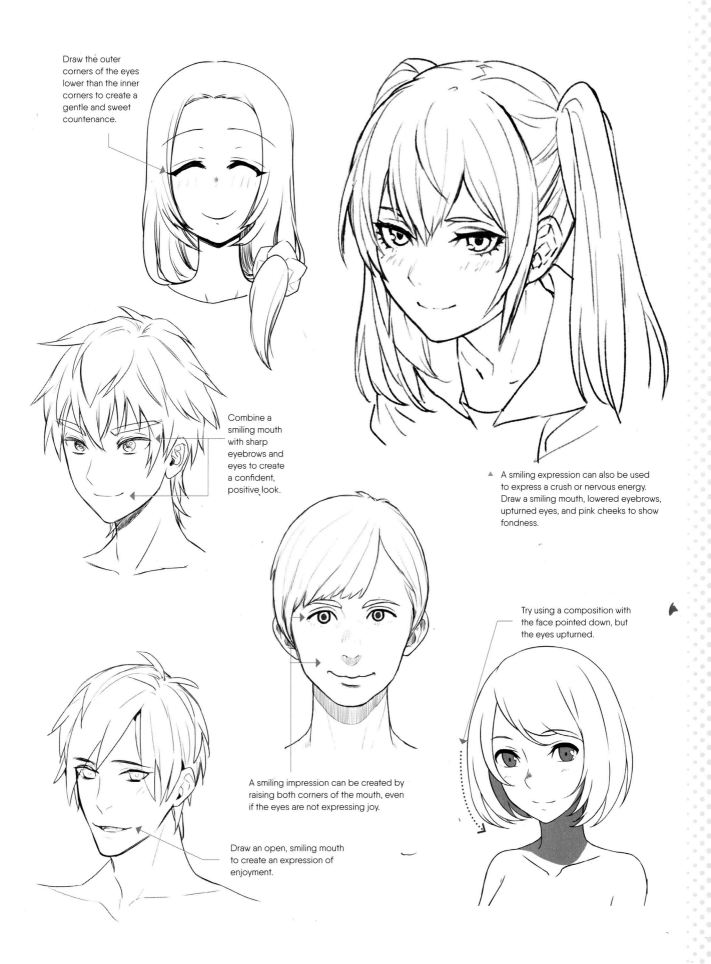

Draw the outer corners of the eyes lower than the inner corners to create a gentle and sweet countenance.

Combine a smiling mouth with sharp eyebrows and eyes to create a confident, positive look.

A smiling expression can also be used to express a crush or nervous energy. Draw a smiling mouth, lowered eyebrows, upturned eyes, and pink cheeks to show fondness.

Try using a composition with the face pointed down, but the eyes upturned.

A smiling impression can be created by raising both corners of the mouth, even if the eyes are not expressing joy.

Draw an open, smiling mouth to create an expression of enjoyment.

Medium Intensity

A medium intensity joy will feature clear smiling expressions, showing feelings of happiness, fun, and satisfaction.

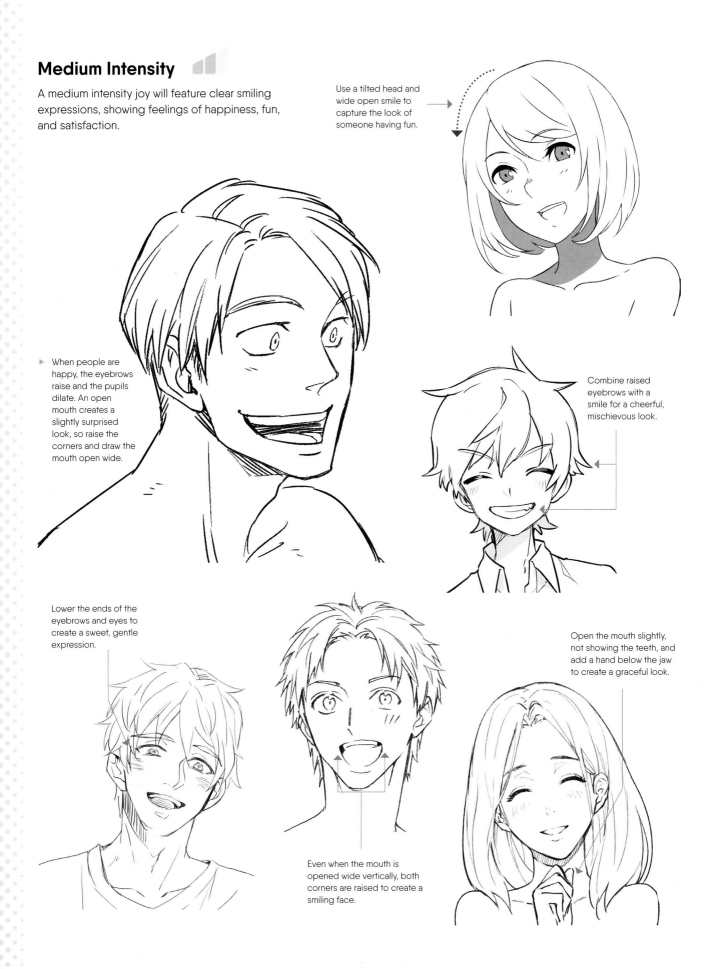

Use a tilted head and wide open smile to capture the look of someone having fun.

► When people are happy, the eyebrows raise and the pupils dilate. An open mouth creates a slightly surprised look, so raise the corners and draw the mouth open wide.

Combine raised eyebrows with a smile for a cheerful, mischievous look.

Lower the ends of the eyebrows and eyes to create a sweet, gentle expression.

Open the mouth slightly, not showing the teeth, and add a hand below the jaw to create a graceful look.

Even when the mouth is opened wide vertically, both corners are raised to create a smiling face.

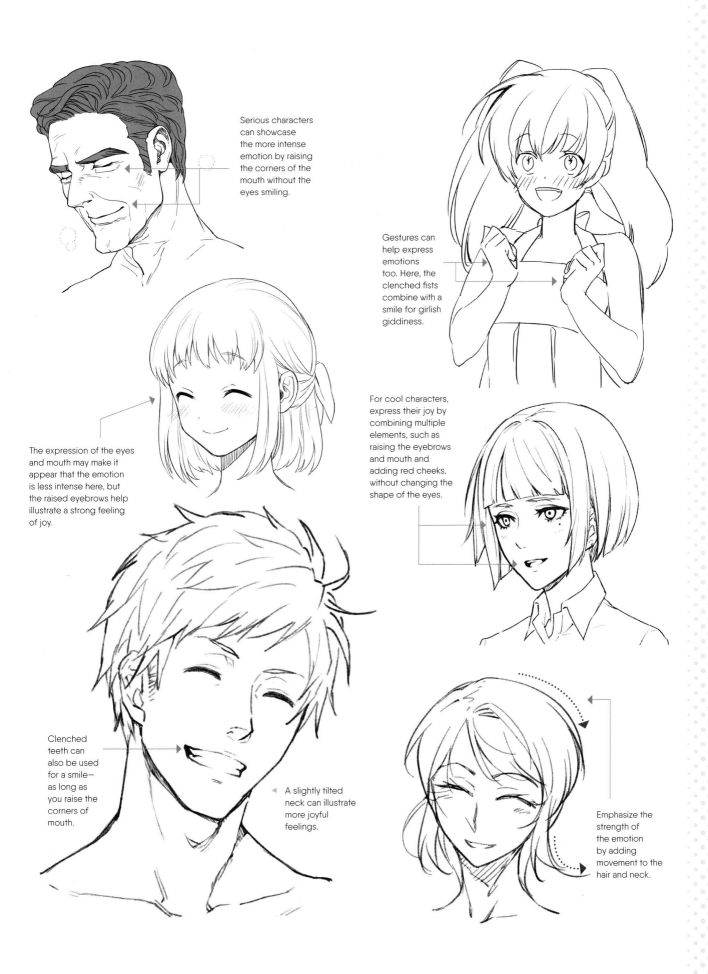

Serious characters can showcase the more intense emotion by raising the corners of the mouth without the eyes smiling.

Gestures can help express emotions too. Here, the clenched fists combine with a smile for girlish giddiness.

The expression of the eyes and mouth may make it appear that the emotion is less intense here, but the raised eyebrows help illustrate a strong feeling of joy.

For cool characters, express their joy by combining multiple elements, such as raising the eyebrows and mouth and adding red cheeks, without changing the shape of the eyes.

Clenched teeth can also be used for a smile— as long as you raise the corners of mouth.

A slightly tilted neck can illustrate more joyful feelings.

Emphasize the strength of the emotion by adding movement to the hair and neck.

High Intensity

Stronger feelings of joy can create intense emotions such as delight, ecstasy, and franticness. Imagine the face is breaking into a smile with these emotions.

To illustrate an expression of delight, raise the bottom eyelids to indicate eyes squeezed shut in laughter and open the mouth wide vertically.

The neck leans back in reaction to the face breaking into a smile.

A deformed smile can be used to illustrate an intense feeling. Here, the upper lip imitates a cat rather than a human, but both corners of the mouth are raised to create a smiling face. The eyebrows curve downward, but the mouth is smiling, which creates a happy impression overall.

▼ To capture the expression of joy mixed with the feeling of being deeply moved, add highlights to the widely opened eyes to make them twinkle. Then draw the mouth open vertically.

▼ When drawing a bright smile, add recessed lines around the eyes for realistic dimension. Add or omit certain details, such as wrinkles on the nose or missing teeth, depending on the individual.

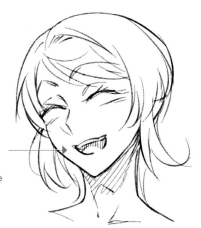
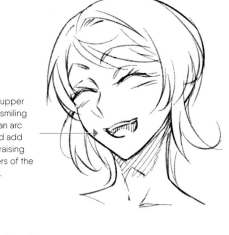

Draw the upper lip of the smiling mouth in an arc shape and add detail by raising the corners of the mouth up.

To create a frantic expression, draw small pupils against big, open eyes. Use wavy lines for the eyebrows and upper lip to depict the abnormality of laughing with excitement.

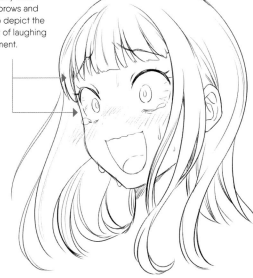

A deformed smile is often used in manga scenes for comedic effect. To create this exaggerated expression, draw eyes shaped like half of an X, and draw a wide open mouth. When drawing the mouth, focus on the size instead of worrying about the structure.

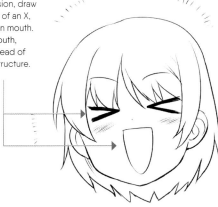

◄ Dramatically raising both corners of the mouth up to the height of the nose creates a comical, playful expression. Including a youthful gesture, such as clasping both hands together, creates interesting contrast and emphasizes the charm of this middle-aged man.

Diagonal lines on the cheeks capture the redness of a shy face when blushing, while also accenting the smile.

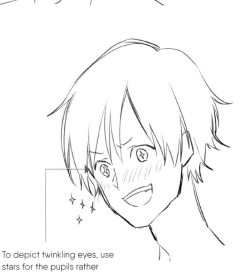

To depict twinkling eyes, use stars for the pupils rather than circles.

EXPRESSING ANGER

Anger is the emotion that occurs when tangible things, such as the body, or intangible things, such as honor, are threatened. Anger is a powerful emotion, so it's important to capture the intensity of the feeling to have an impact on your readers.

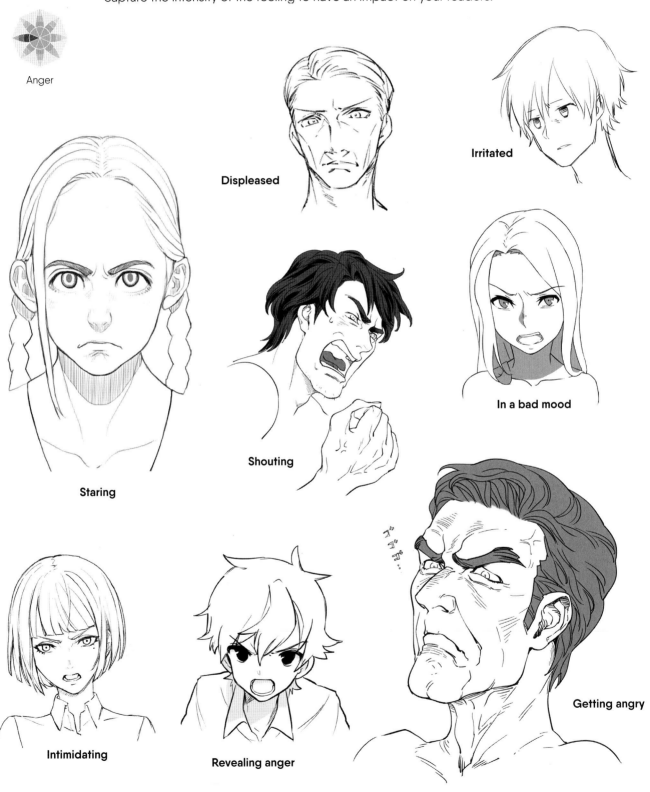

Anger

Displeased

Irritated

In a bad mood

Shouting

Staring

Intimidating

Revealing anger

Getting angry

▶ Facial Features for Anger

Eyes & Eyebrows

The corrugator muscles move the eyebrows down and inward, decreasing the distance between the eyes (①). At the same time, the eyes open widely and the pupils are positioned directly under the upper eyelids (②), while the lower eyelids grow taut and straight (③).

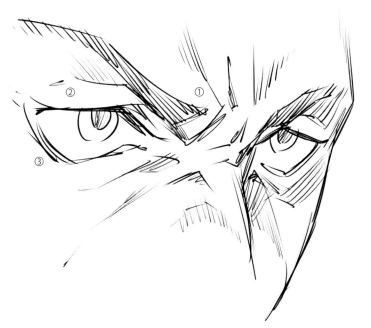

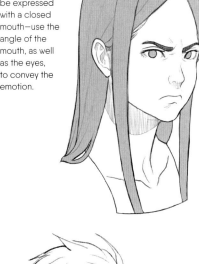

▶ Anger can even be expressed with a closed mouth—use the angle of the mouth, as well as the eyes, to convey the emotion.

Mouth

The levator labii superioris shrinks and raises the upper lip (①). The bottom lip is pulled horizontally by the risorius muscle (②) and lowered by the depressor labii inferioris muscle (③).

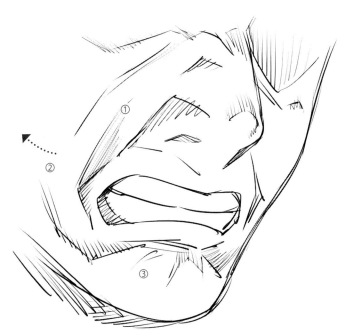

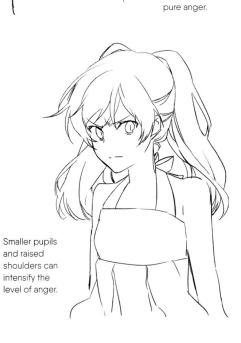

◀ Staring down at opponents from an angle can create an expression of pure anger.

▶ Smaller pupils and raised shoulders can intensify the level of anger.

INTENSITY LEVELS OF ANGER

Anger is an emotion that some people suppress in daily life. It's important to capture the magnitude of a character's anger in order for readers to understand the intensity of the situation. Let's draw various expressions of anger, ranging from minor annoyance to moments of intense explosion.

Low Intensity

Less intense anger may involve a character being in a bad mood, irritated, or silent. It is still a rational state, and shows that the character is able to control themselves.

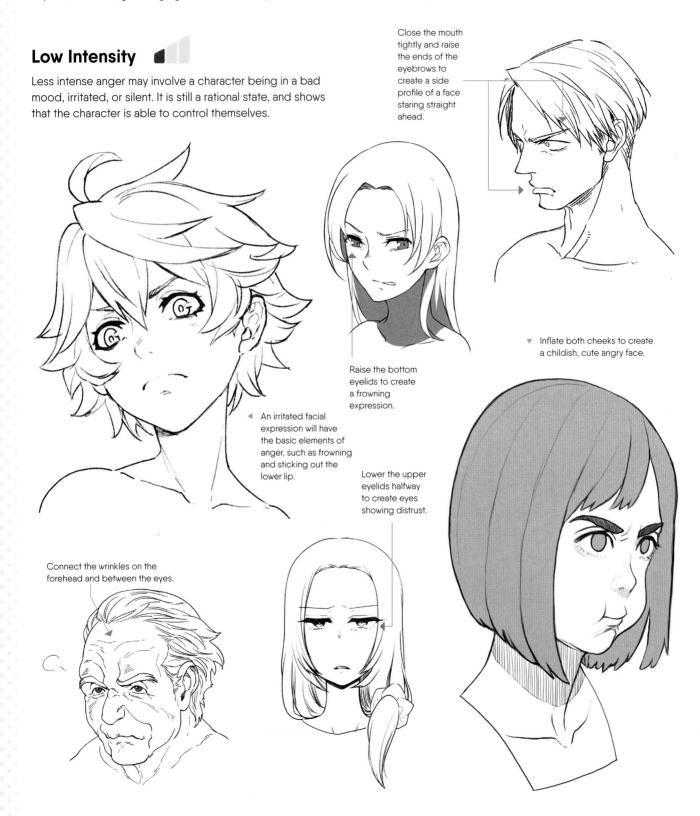

Close the mouth tightly and raise the ends of the eyebrows to create a side profile of a face staring straight ahead.

Inflate both cheeks to create a childish, cute angry face.

Raise the bottom eyelids to create a frowning expression.

An irritated facial expression will have the basic elements of anger, such as frowning and sticking out the lower lip.

Lower the upper eyelids halfway to create eyes showing distrust.

Connect the wrinkles on the forehead and between the eyes.

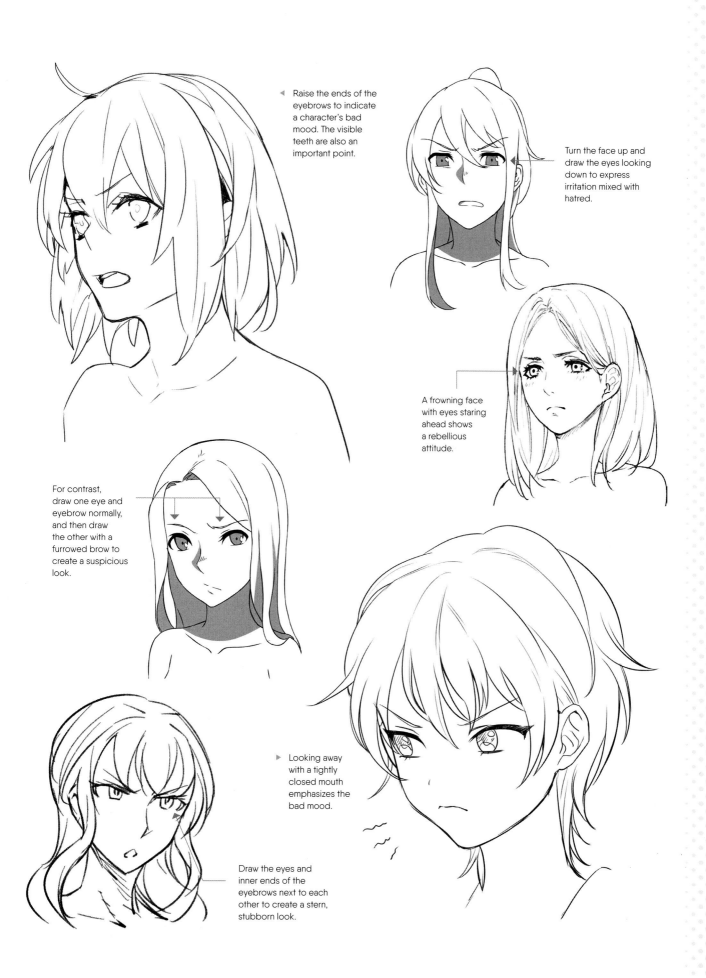

◄ Raise the ends of the eyebrows to indicate a character's bad mood. The visible teeth are also an important point.

Turn the face up and draw the eyes looking down to express irritation mixed with hatred.

A frowning face with eyes staring ahead shows a rebellious attitude.

For contrast, draw one eye and eyebrow normally, and then draw the other with a furrowed brow to create a suspicious look.

► Looking away with a tightly closed mouth emphasizes the bad mood.

Draw the eyes and inner ends of the eyebrows next to each other to create a stern, stubborn look.

Medium Intensity

This anger is more obvious on the face and is illustrated through staring eyes or bulging veins. This is one step before the explosion of anger, but it can still be suppressed.

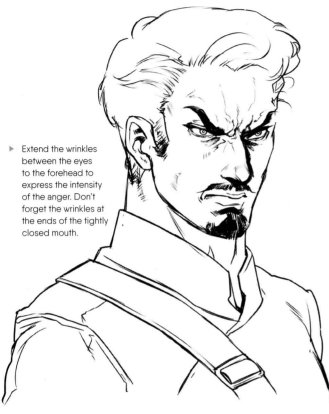

▶ Extend the wrinkles between the eyes to the forehead to express the intensity of the anger. Don't forget the wrinkles at the ends of the tightly closed mouth.

It is important to draw the side profile with the end of the eyebrow raised. Draw pointed, fang-like teeth for an aggressive expression.

A stronger expression in the eyes combined with a more subtle shaping of the mouth can create a cool but angry look.

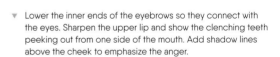

▽ Lower the inner ends of the eyebrows so they connect with the eyes. Sharpen the upper lip and show the clenching teeth peeking out from one side of the mouth. Add shadow lines above the cheek to emphasize the anger.

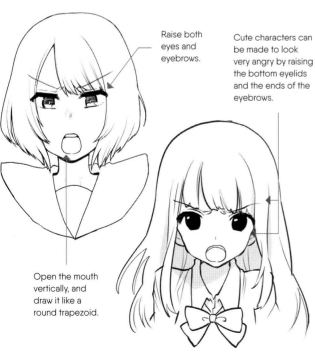

Raise both eyes and eyebrows.

Cute characters can be made to look very angry by raising the bottom eyelids and the ends of the eyebrows.

Open the mouth vertically, and draw it like a round trapezoid.

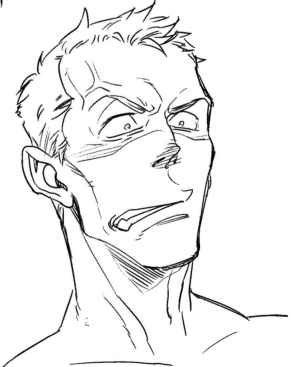

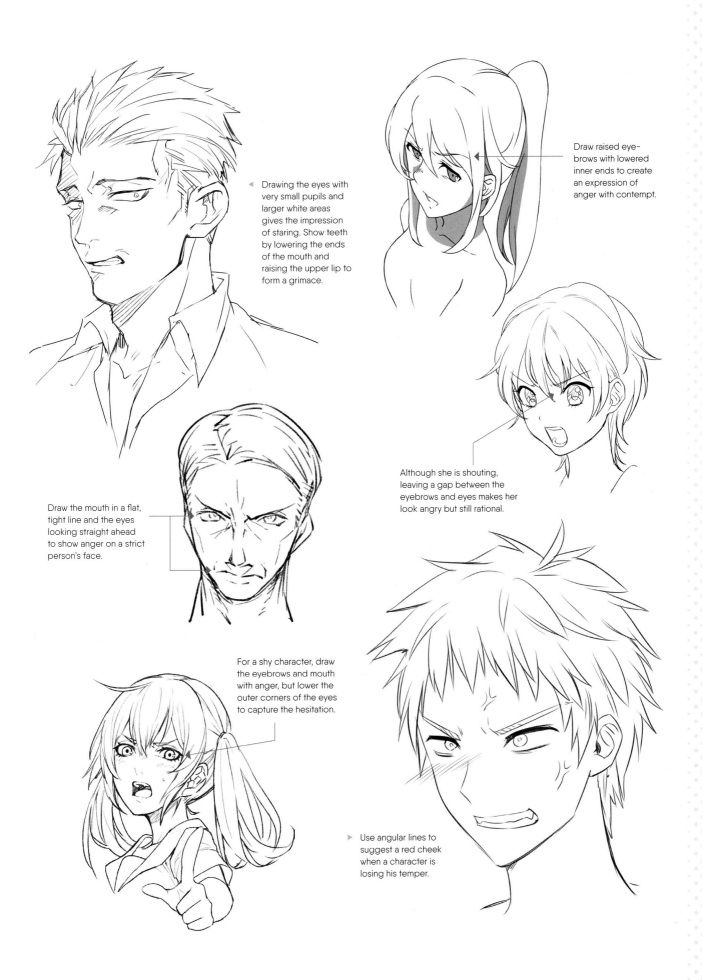

Drawing the eyes with very small pupils and larger white areas gives the impression of staring. Show teeth by lowering the ends of the mouth and raising the upper lip to form a grimace.

Draw raised eyebrows with lowered inner ends to create an expression of anger with contempt.

Draw the mouth in a flat, tight line and the eyes looking straight ahead to show anger on a strict person's face.

Although she is shouting, leaving a gap between the eyebrows and eyes makes her look angry but still rational.

For a shy character, draw the eyebrows and mouth with anger, but lower the outer corners of the eyes to capture the hesitation.

Use angular lines to suggest a red cheek when a character is losing his temper.

High Intensity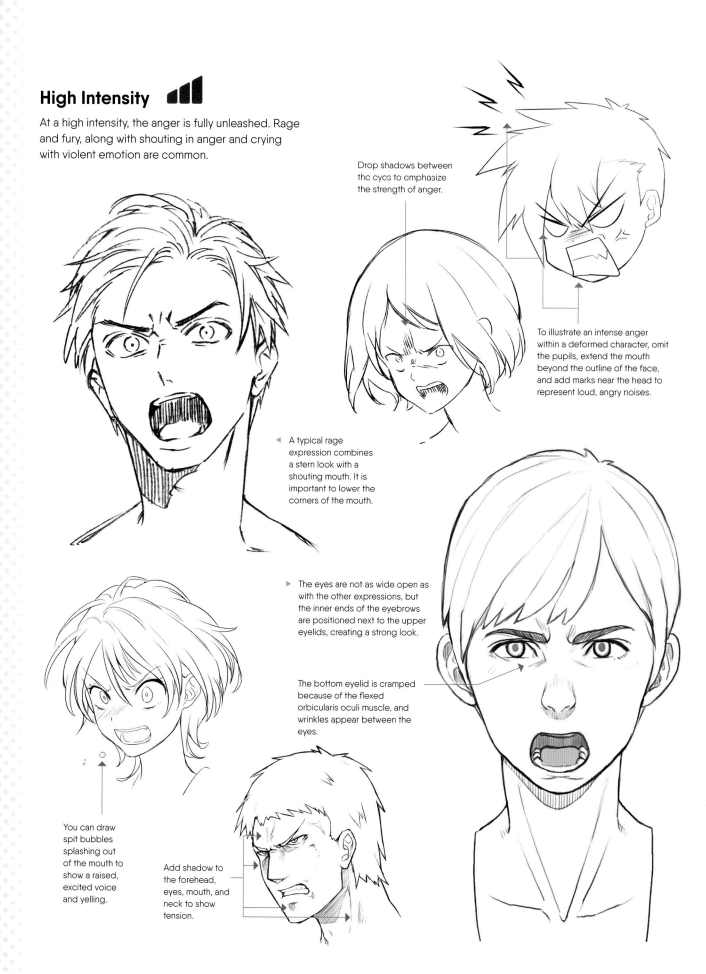

At a high intensity, the anger is fully unleashed. Rage and fury, along with shouting in anger and crying with violent emotion are common.

Drop shadows between the eyes to emphasize the strength of anger.

To illustrate an intense anger within a deformed character, omit the pupils, extend the mouth beyond the outline of the face, and add marks near the head to represent loud, angry noises.

◄ A typical rage expression combines a stern look with a shouting mouth. It is important to lower the corners of the mouth.

► The eyes are not as wide open as with the other expressions, but the inner ends of the eyebrows are positioned next to the upper eyelids, creating a strong look.

The bottom eyelid is cramped because of the flexed orbicularis oculi muscle, and wrinkles appear between the eyes.

You can draw spit bubbles splashing out of the mouth to show a raised, excited voice and yelling.

Add shadow to the forehead, eyes, mouth, and neck to show tension.

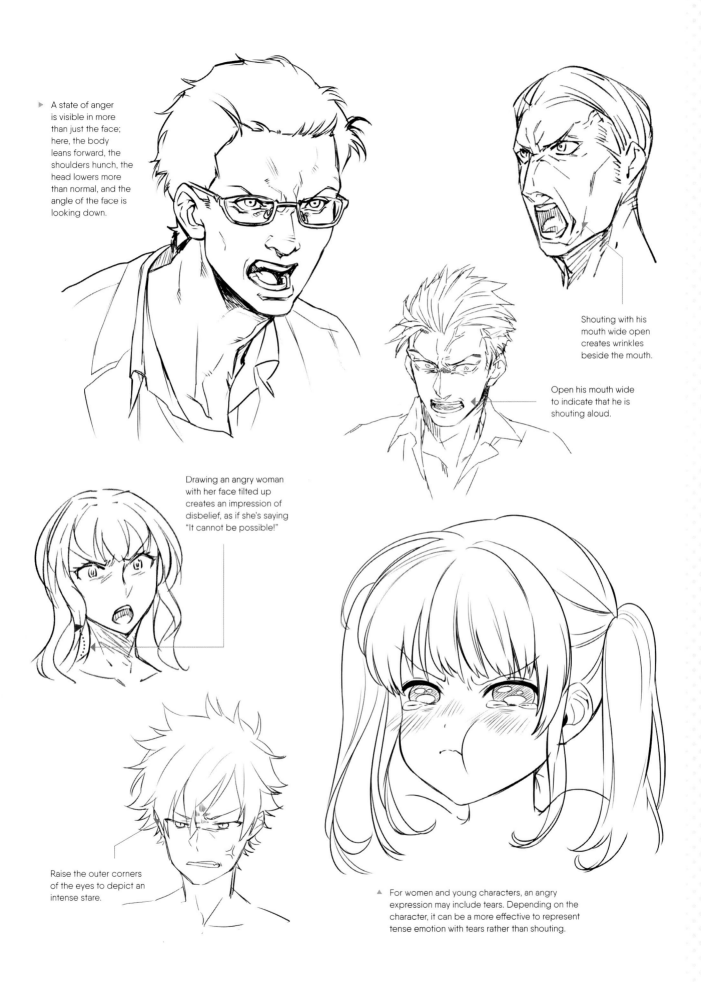

A state of anger is visible in more than just the face; here, the body leans forward, the shoulders hunch, the head lowers more than normal, and the angle of the face is looking down.

Shouting with his mouth wide open creates wrinkles beside the mouth.

Open his mouth wide to indicate that he is shouting aloud.

Drawing an angry woman with her face tilted up creates an impression of disbelief, as if she's saying "It cannot be possible!"

Raise the outer corners of the eyes to depict an intense stare.

For women and young characters, an angry expression may include tears. Depending on the character, it can be a more effective to represent tense emotion with tears rather than shouting.

EXPRESSING SADNESS

The emotions expressing sadness include being sad, lonely, and depressed. The point is to draw your characters with expressions so painful, they make your readers feel sorrow in their hearts. In particular, tears are an important element to express sorrow.

Sadness

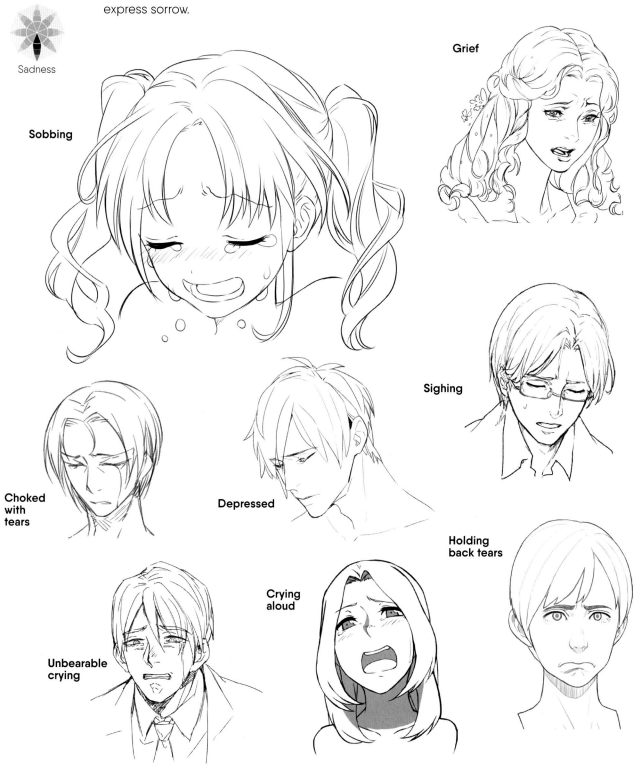

Grief

Sobbing

Sighing

Choked with tears

Depressed

Holding back tears

Unbearable crying

Crying aloud

▷ Facial Features for Sadness

Eyes & Eyebrows
The center of the frontalis muscle pulls the eyebrows, raising the inner ends (①) and creating wrinkles between the eyebrows (②). The oculi muscle shrinks, closing the eyes slightly (③).

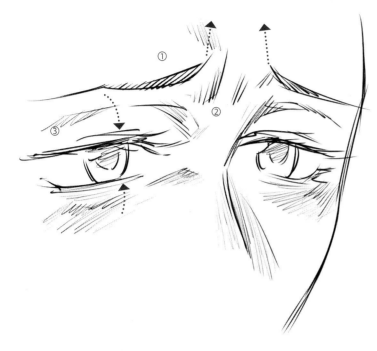

▷ Sometimes when crying, the eyebrows form an inverted V shape. The inner ends of the eyebrows rise to create this shape, while the outer ends stay positioned in their normal place.

Mouth
The mouth is pulled sideways, creating wrinkles beside the mouth. At the same time, the nostrils widen (①). The corners of the mouth lower (②) and wrinkles form beneath the lower lip (③).

◁ Closing the mouth is another way to create a sad expression. Both ends of the mouth point down. It is also effective to squint the eyes.

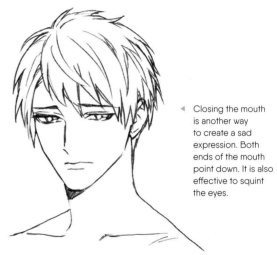

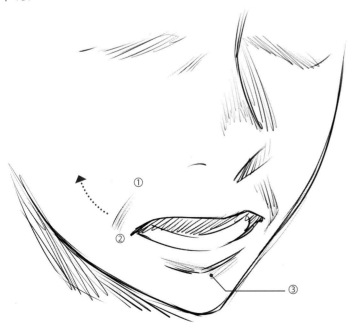

▷ A crying face with an opened mouth and closed eyes can create a strong sad expression. Add tears to emphasize the feeling.

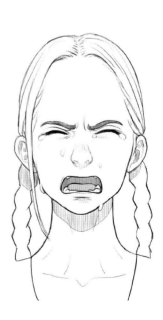

INTENSITY LEVELS OF SADNESS

People naturally look down when they feel sadness, so when illustrating sad faces, high angle or bird's eye view perspectives are commonly used. Also, note that tears do not necessarily connect to the intensity of the emotion.

Low Intensity

A less intense expression of sadness may include disappointment, unhappiness, or depression.

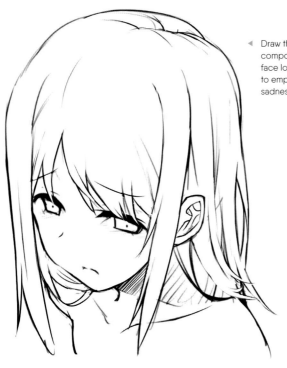

◄ Draw the composition with the face looking down to emphasize the sadness.

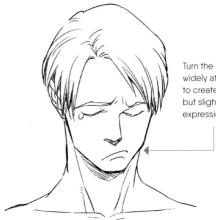

Turn the mouth down widely at the corners to create a sad, but slightly comical expression.

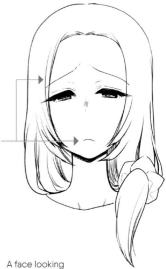

The inverted V-shaped eyebrows and the mouth turned down at the corners are two main characteristics for showing sadness.

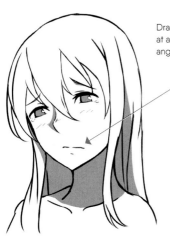

Draw the mouth at a diagonal angle.

A face looking down can illustrate a depressed feeling.

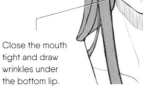

Close the mouth tight and draw wrinkles under the bottom lip.

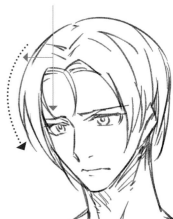

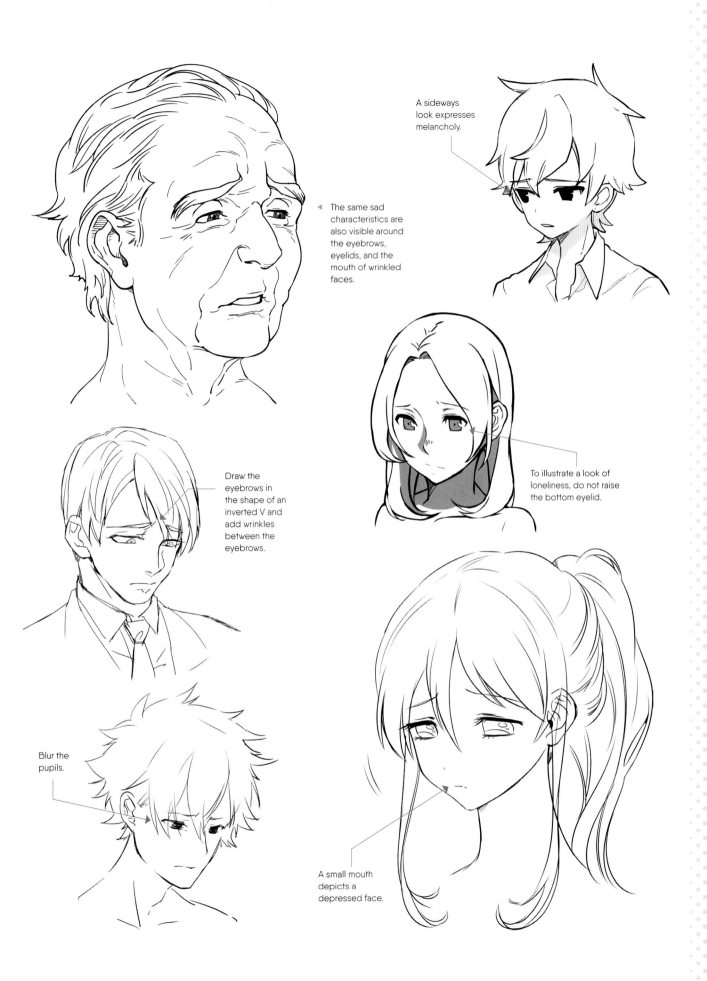

A sideways look expresses melancholy.

The same sad characteristics are also visible around the eyebrows, eyelids, and the mouth of wrinkled faces.

Draw the eyebrows in the shape of an inverted V and add wrinkles between the eyebrows.

To illustrate a look of loneliness, do not raise the bottom eyelid.

Blur the pupils.

A small mouth depicts a depressed face.

Medium Intensity

A medium level of sadness is painful and unbearable. Depending on the nature of the characters, you can increase the expression by depicting the face with tears and tightly closed eyes.

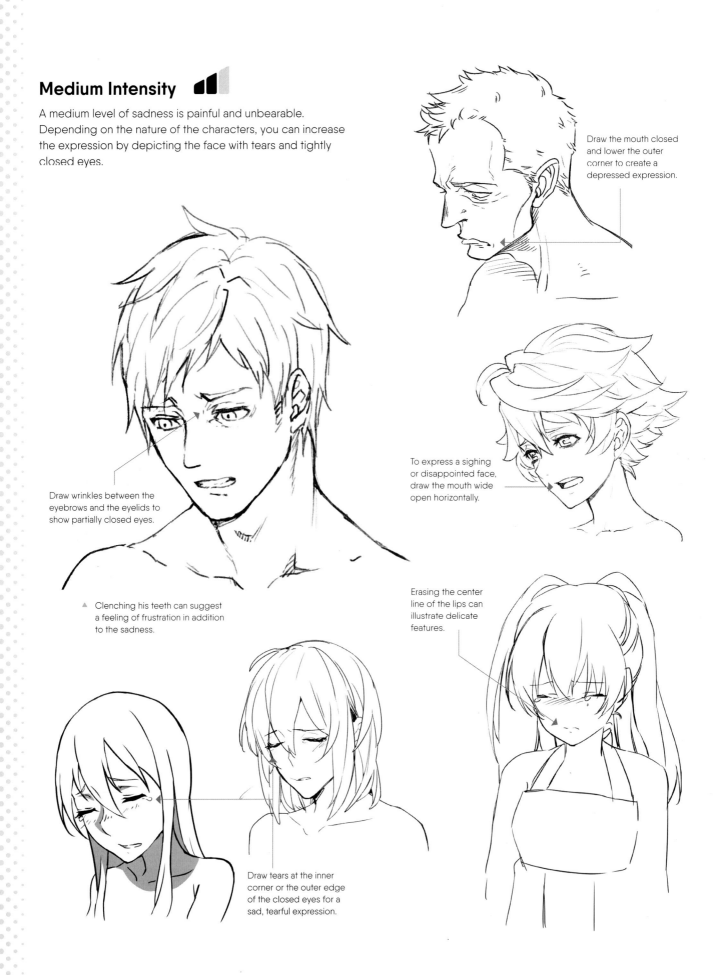

Draw the mouth closed and lower the outer corner to create a depressed expression.

Draw wrinkles between the eyebrows and the eyelids to show partially closed eyes.

To express a sighing or disappointed face, draw the mouth wide open horizontally.

▲ Clenching his teeth can suggest a feeling of frustration in addition to the sadness.

Erasing the center line of the lips can illustrate delicate features.

Draw tears at the inner corner or the outer edge of the closed eyes for a sad, tearful expression.

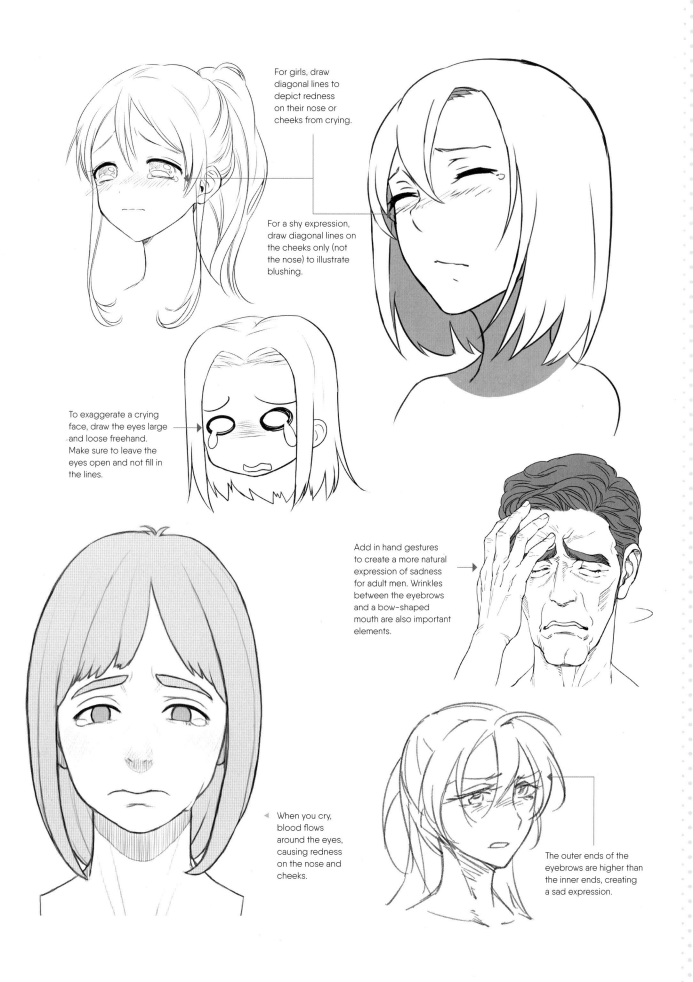

For girls, draw diagonal lines to depict redness on their nose or cheeks from crying.

For a shy expression, draw diagonal lines on the cheeks only (not the nose) to illustrate blushing.

To exaggerate a crying face, draw the eyes large and loose freehand. Make sure to leave the eyes open and not fill in the lines.

Add in hand gestures to create a more natural expression of sadness for adult men. Wrinkles between the eyebrows and a bow-shaped mouth are also important elements.

When you cry, blood flows around the eyes, causing redness on the nose and cheeks.

The outer ends of the eyebrows are higher than the inner ends, creating a sad expression.

High Intensity

Intense sadness causes unstoppable tears to flow or loud crying. Expressions such as wailing, weeping, and grieving are in this category.

Use two lines to draw three-dimensional tears that appear as if they're rolling down the cheek.

Overflowing tears and a deformed mouth create this exaggerated facial expression. You can distort the features while keeping realistic proportions, as long as the position of the eyes, the nose, and the mouth are accurate.

▼ Draw a frustrated mouth with teeth clenched to depict a strong-minded girl.

Here, the mouth is closed tightly with tearful eyes.

The intensity of the sadness raises her shoulders, causing the shrugged posture.

For a cool character, simple tears can express strong inner feelings.

Draw big deformed eyes without worrying about the frame.

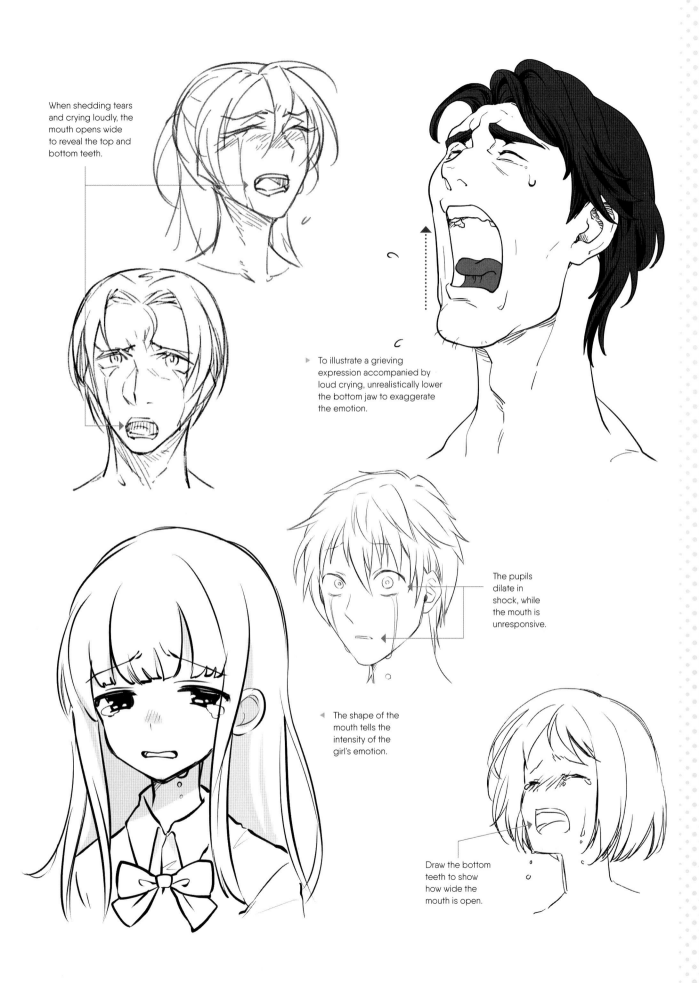

When shedding tears and crying loudly, the mouth opens wide to reveal the top and bottom teeth.

▶ To illustrate a grieving expression accompanied by loud crying, unrealistically lower the bottom jaw to exaggerate the emotion.

The pupils dilate in shock, while the mouth is unresponsive.

◀ The shape of the mouth tells the intensity of the girl's emotion.

Draw the bottom teeth to show how wide the mouth is open.

EXPRESSING SURPRISE

The expressions of surprise are created in response to seeing or hearing unexpected things. The main features to express surprise are wide open eyes and mouths, and raised lips.

Surprise

Vacant look

Amazed

Astonished

Marvel

Startled

Stunned

Panicked

Shocked
and
frozen

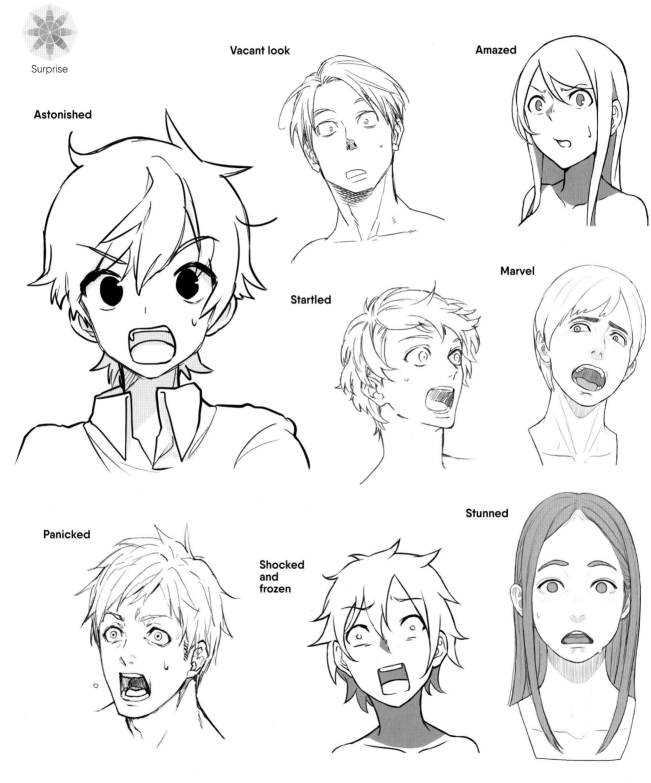

▶ Facial Features for Surprise

Eyes & Eyebrows

The frontalis muscle shrinks to raise the eyebrows (①). The upper eyelids are lifted (②) and the pupils are centered in the whites of the eyes (③). Surprise often widens the pupils. However, smaller pupils look more surprised in manga drawing.

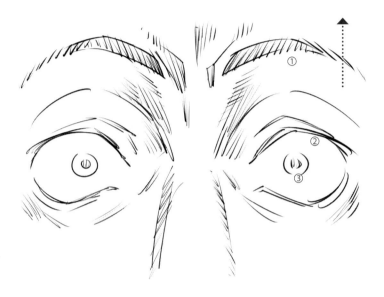

Mouth

The mouth becomes weak with surprise. With no power to support the lower jaw, the mouth falls open (①). Another possible reaction is that the lips move forward and form the shape of a small O.

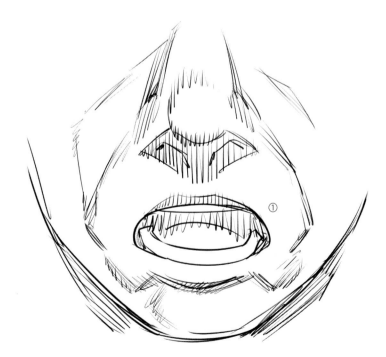

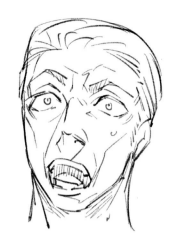

▲ To illustrate big surprise, the features of the eyes and eyebrows do not change much, but the mouth opens wide.

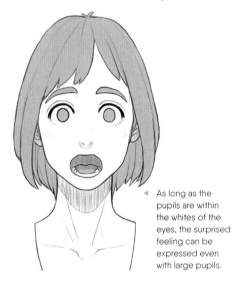

◀ As long as the pupils are within the whites of the eyes, the surprised feeling can be expressed even with large pupils.

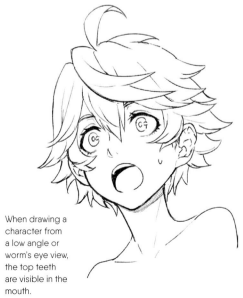

▶ When drawing a character from a low angle or worm's eye view, the top teeth are visible in the mouth.

INTENSITY LEVELS OF SURPRISE

The main characteristic of the surprised expression is wide open eyes. This is common in all levels of intensity for the expression. As the feeling of surprise gets more intense, the body leans forward or backward.

Low Intensity

When slightly surprised, the character might jump or look blank. Sometimes with a surprised expression, a character might sweat.

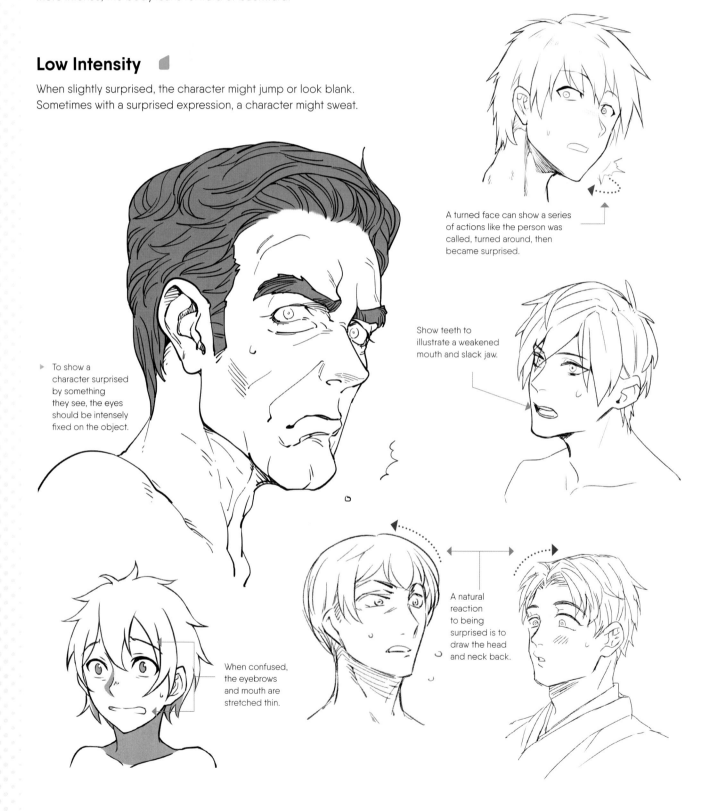

A turned face can show a series of actions like the person was called, turned around, then became surprised.

Show teeth to illustrate a weakened mouth and slack jaw.

▶ To show a character surprised by something they see, the eyes should be intensely fixed on the object.

When confused, the eyebrows and mouth are stretched thin.

A natural reaction to being surprised is to draw the head and neck back.

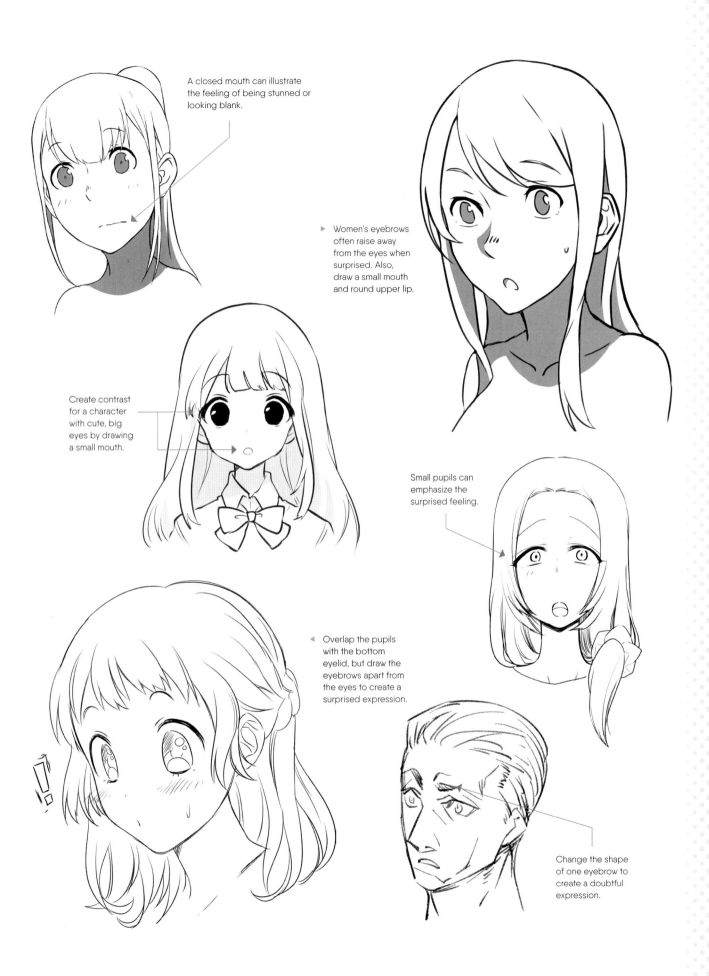

A closed mouth can illustrate the feeling of being stunned or looking blank.

▶ Women's eyebrows often raise away from the eyes when surprised. Also, draw a small mouth and round upper lip.

Create contrast for a character with cute, big eyes by drawing a small mouth.

Small pupils can emphasize the surprised feeling.

◀ Overlap the pupils with the bottom eyelid, but draw the eyebrows apart from the eyes to create a surprised expression.

Change the shape of one eyebrow to create a doubtful expression.

Medium Intensity

A medium intensity of this expression shows characters as surprised and stunned. Many are passive expressions such as being overwhelmed and frozen.

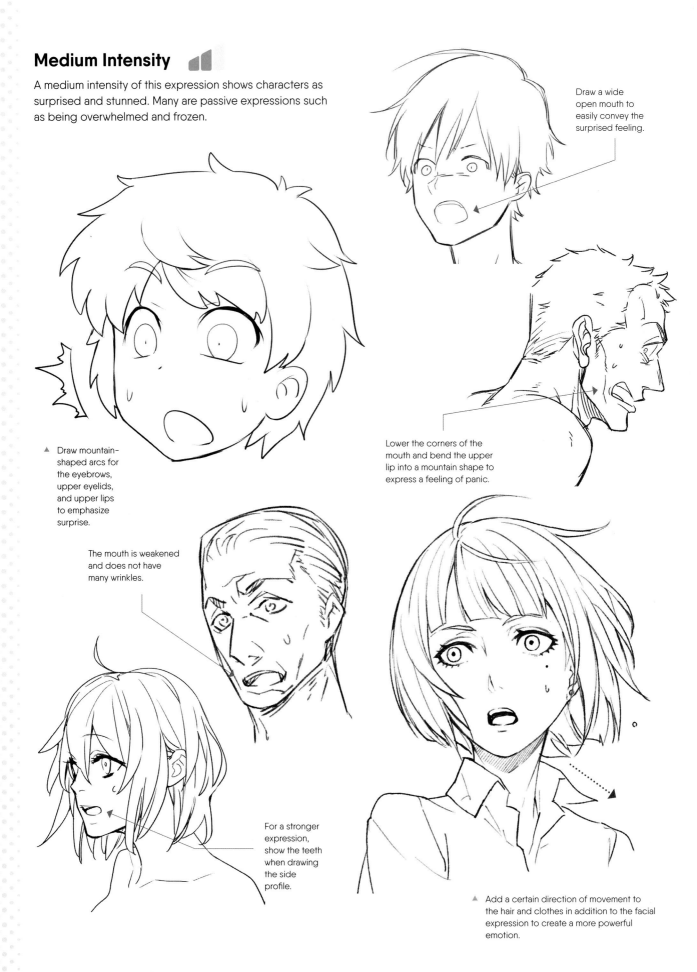

Draw a wide open mouth to easily convey the surprised feeling.

Lower the corners of the mouth and bend the upper lip into a mountain shape to express a feeling of panic.

▲ Draw mountain-shaped arcs for the eyebrows, upper eyelids, and upper lips to emphasize surprise.

The mouth is weakened and does not have many wrinkles.

For a stronger expression, show the teeth when drawing the side profile.

▲ Add a certain direction of movement to the hair and clothes in addition to the facial expression to create a more powerful emotion.

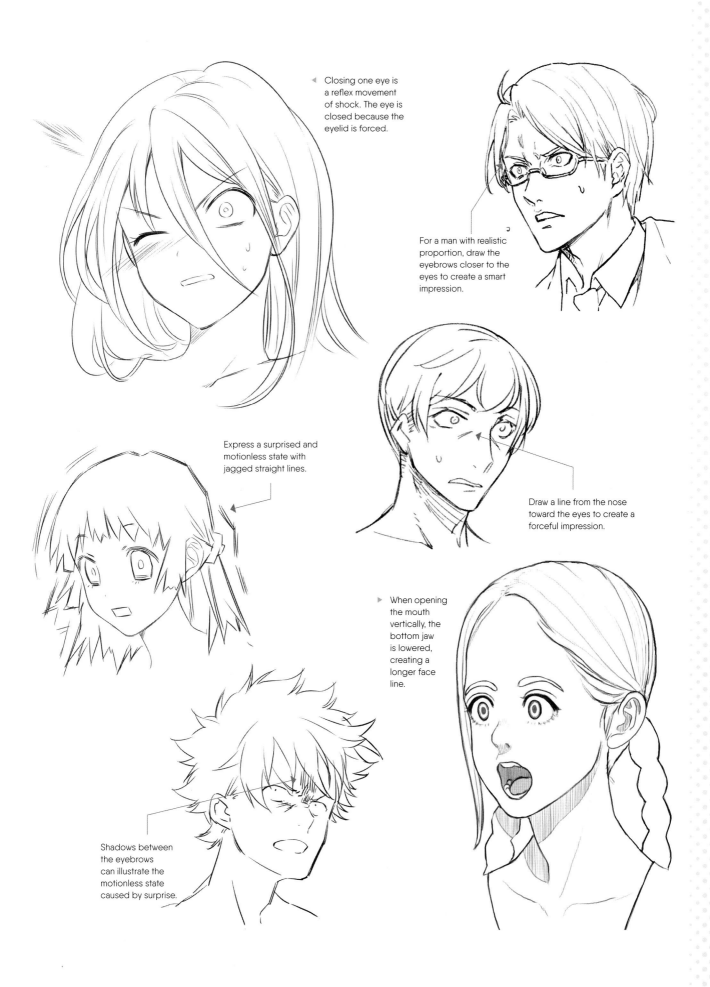

◁ Closing one eye is a reflex movement of shock. The eye is closed because the eyelid is forced.

For a man with realistic proportion, draw the eyebrows closer to the eyes to create a smart impression.

Express a surprised and motionless state with jagged straight lines.

Draw a line from the nose toward the eyes to create a forceful impression.

▶ When opening the mouth vertically, the bottom jaw is lowered, creating a longer face line.

Shadows between the eyebrows can illustrate the motionless state caused by surprise.

High Intensity

Stronger emotions of surprise can produce reactions such as panic and being startled, often with the body leaning forward. The mouth is open in the shape used to pronounce "E" or "A".

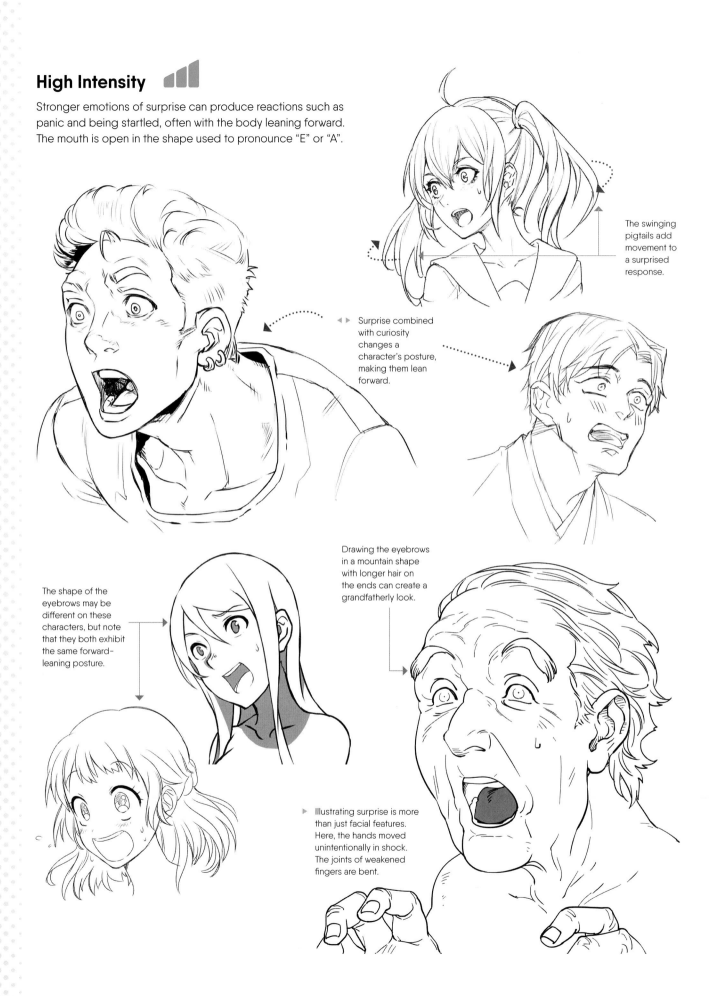

The swinging pigtails add movement to a surprised response.

Surprise combined with curiosity changes a character's posture, making them lean forward.

The shape of the eyebrows may be different on these characters, but note that they both exhibit the same forward-leaning posture.

Drawing the eyebrows in a mountain shape with longer hair on the ends can create a grandfatherly look.

Illustrating surprise is more than just facial features. Here, the hands moved unintentionally in shock. The joints of weakened fingers are bent.

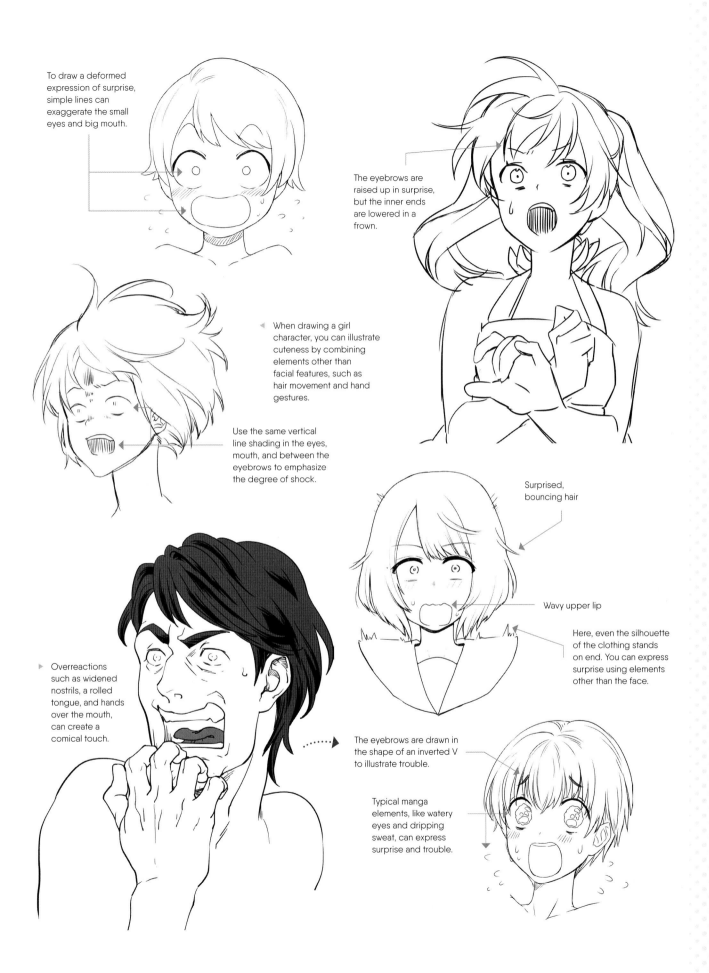

To draw a deformed expression of surprise, simple lines can exaggerate the small eyes and big mouth.

The eyebrows are raised up in surprise, but the inner ends are lowered in a frown.

◁ When drawing a girl character, you can illustrate cuteness by combining elements other than facial features, such as hair movement and hand gestures.

Use the same vertical line shading in the eyes, mouth, and between the eyebrows to emphasize the degree of shock.

Surprised, bouncing hair

Wavy upper lip

Here, even the silhouette of the clothing stands on end. You can express surprise using elements other than the face.

▶ Overreactions such as widened nostrils, a rolled tongue, and hands over the mouth, can create a comical touch.

The eyebrows are drawn in the shape of an inverted V to illustrate trouble.

Typical manga elements, like watery eyes and dripping sweat, can express surprise and trouble.

EXPRESSING FEAR

Lesson 05

Fear is the feeling expressed when a character is horrified or facing a desperate life or death situation. In order to illustrate a realistic fearful situation, you have to understand the key characteristics of this emotion.

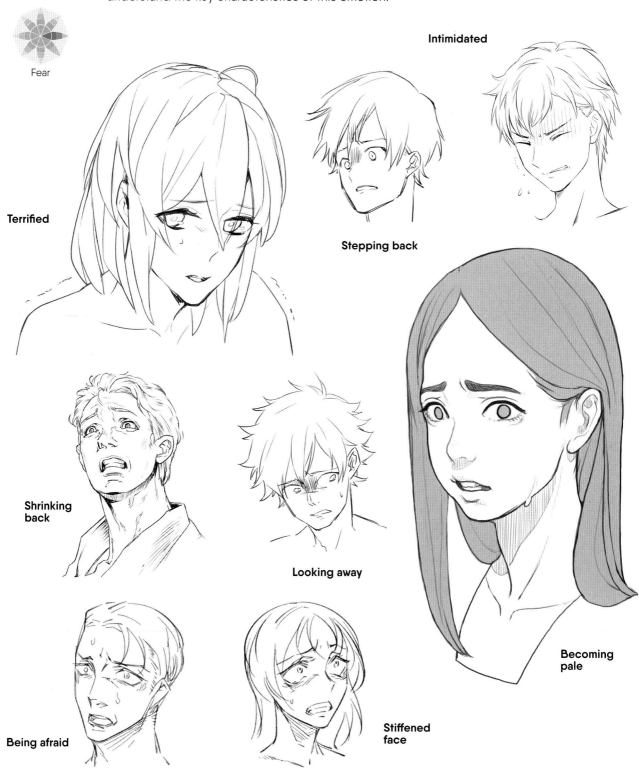

Fear

Intimidated

Terrified

Stepping back

Shrinking back

Looking away

Being afraid

Stiffened face

Becoming pale

▷ Facial Features for Fear

Eyes & Eyebrows

The key feature for capturing fear is wide open eyes (①). The eyebrows are raised by the frontalis muscle (②), and the contraction of the eye muscles causes wrinkles to appear between the eyebrows (③).

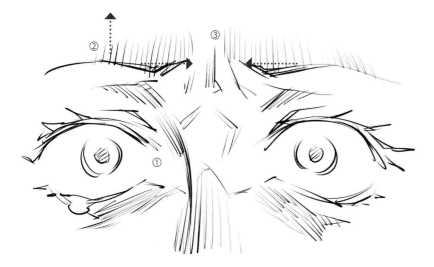

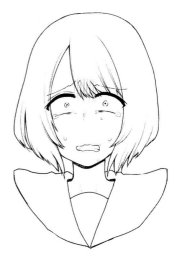

▲ The pupils are very small, emphasizing the size of the opened eyes. For extra effect, add tears at the outer corners of the eyes.

Mouth

The risorious muscle shrinks and the corners of the mouth widen outward horizontally (①). The upper lip loosens (②). The mouth is wide open, causing wrinkles to form from the nose to the mouth (③).

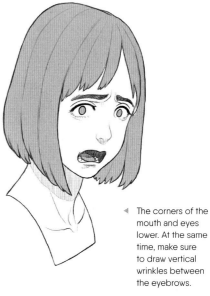

◀ The corners of the mouth and eyes lower. At the same time, make sure to draw vertical wrinkles between the eyebrows.

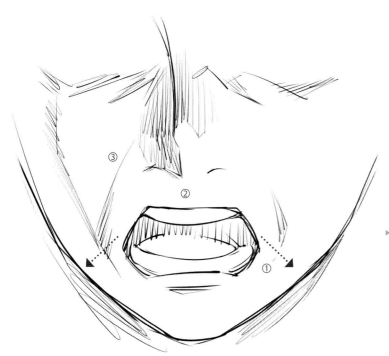

▷ The eyes open so wide that whites are visible above and below the pupils. The eyebrows are shaped like an inverted V. These are the basic elements of a fearful expression.

INTENSITY LEVELS OF FEAR

In reality, it is rare to face a life or death situation, but fear itself is a common emotion. Many people feel fear as part of everyday life, such as uncertainty about the future. Let's look at various levels of fear, from a worried look to a screaming face.

Low Intensity

When the feeling of fear is small, the expression is uneasy, impatient, or worried. Let's look at how to create a realistic scary atmosphere.

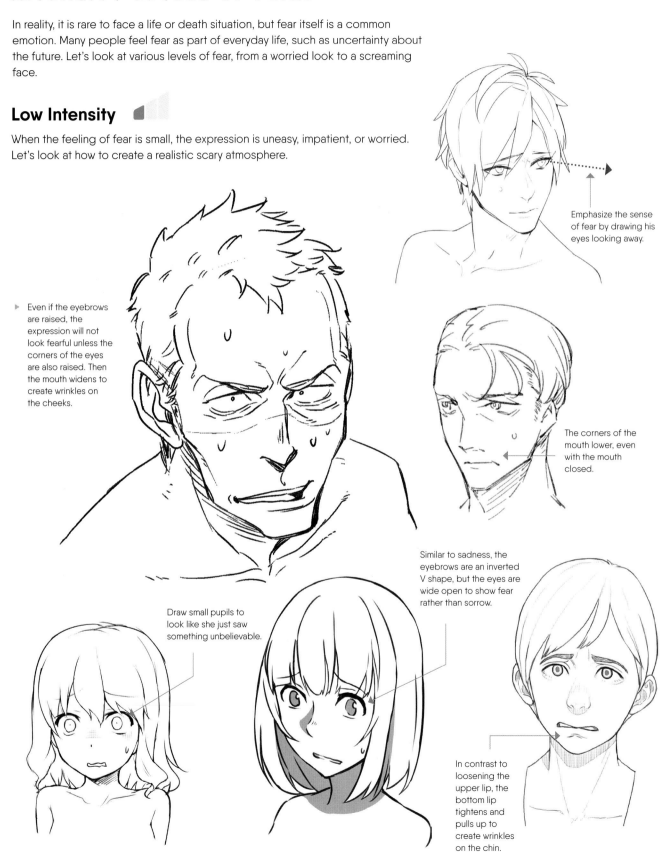

▶ Even if the eyebrows are raised, the expression will not look fearful unless the corners of the eyes are also raised. Then the mouth widens to create wrinkles on the cheeks.

Emphasize the sense of fear by drawing his eyes looking away.

The corners of the mouth lower, even with the mouth closed.

Draw small pupils to look like she just saw something unbelievable.

Similar to sadness, the eyebrows are an inverted V shape, but the eyes are wide open to show fear rather than sorrow.

In contrast to loosening the upper lip, the bottom lip tightens and pulls up to create wrinkles on the chin.

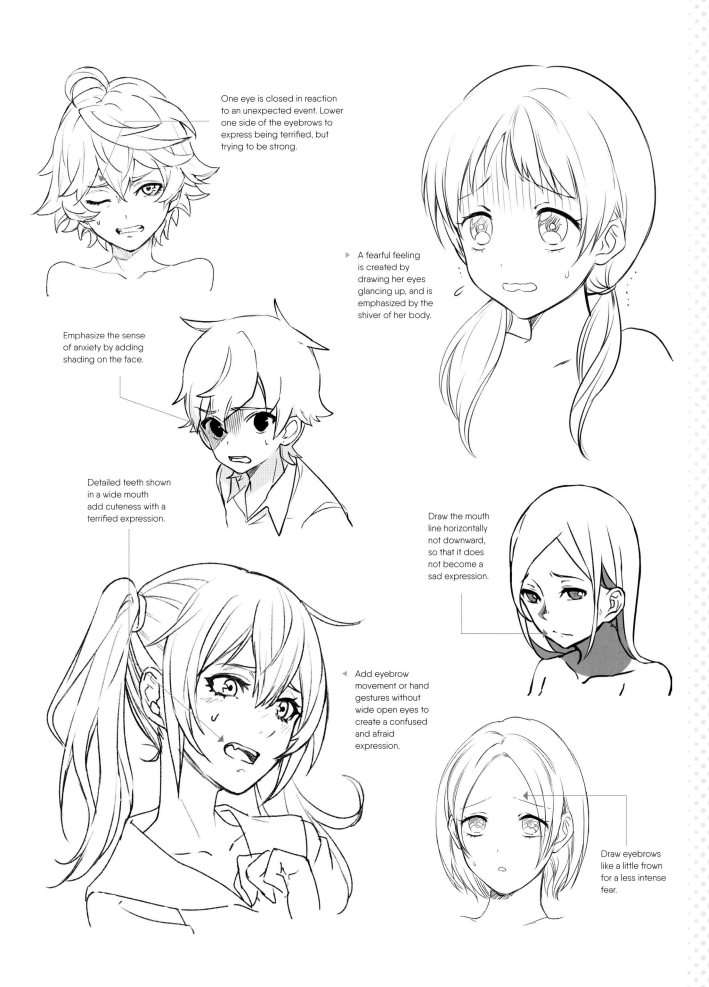

One eye is closed in reaction to an unexpected event. Lower one side of the eyebrows to express being terrified, but trying to be strong.

A fearful feeling is created by drawing her eyes glancing up, and is emphasized by the shiver of her body.

Emphasize the sense of anxiety by adding shading on the face.

Detailed teeth shown in a wide mouth add cuteness with a terrified expression.

Draw the mouth line horizontally not downward, so that it does not become a sad expression.

Add eyebrow movement or hand gestures without wide open eyes to create a confused and afraid expression.

Draw eyebrows like a little frown for a less intense fear.

Medium Intensity

A medium intensity of fear will show characters frowning, holding their breath, and shrieking small screams.

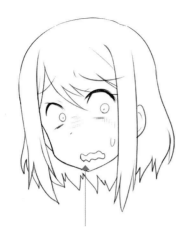

The line of the mouth is wavy, exaggerating the fearful expression.

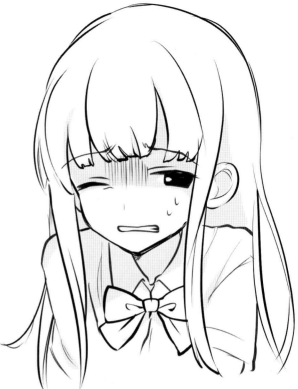

▲ When the eyes are closed tightly, lines appear underneath. The sense of fear is emphasized by drawing vertical lines between the eyebrows.

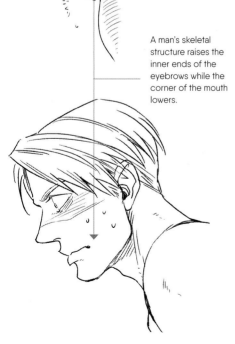

A man's skeletal structure raises the inner ends of the eyebrows while the corner of the mouth lowers.

For a troubled expression, draw wrinkles on the ends of the eyebrows.

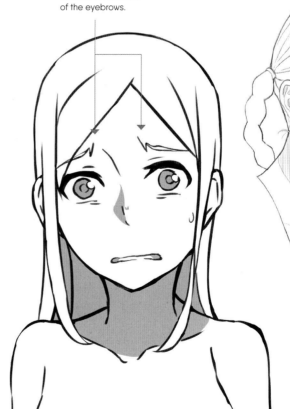

The bottom lip lowers, revealing the bottom teeth.

◄ The eyes are wide open but are about to squeeze shut in fear, creating wrinkles under the eyes.

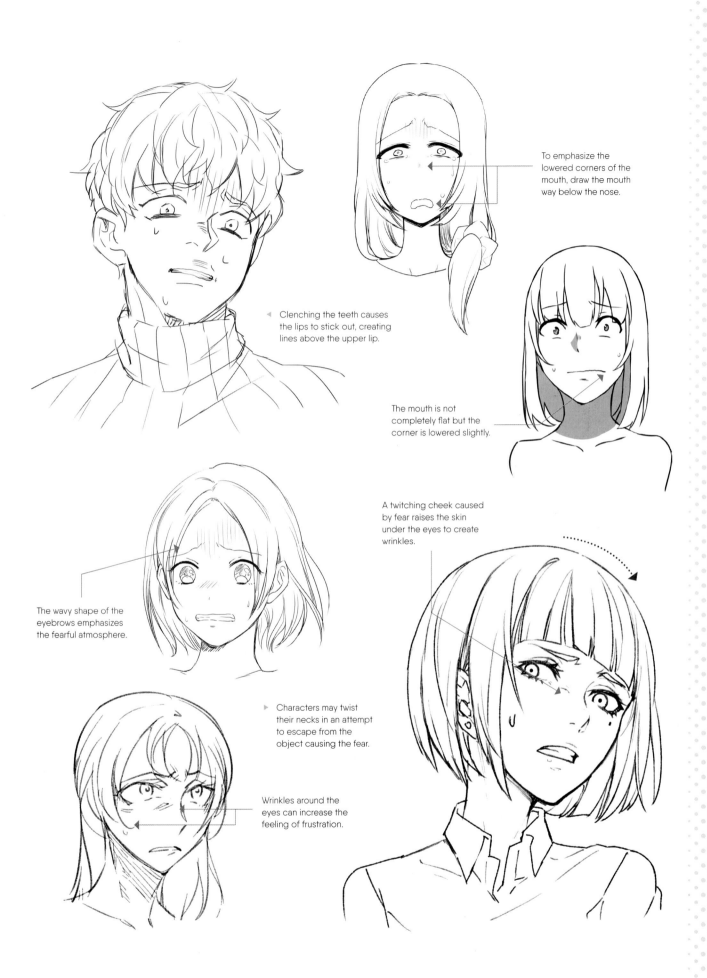

To emphasize the lowered corners of the mouth, draw the mouth way below the nose.

Clenching the teeth causes the lips to stick out, creating lines above the upper lip.

The mouth is not completely flat but the corner is lowered slightly.

A twitching cheek caused by fear raises the skin under the eyes to create wrinkles.

The wavy shape of the eyebrows emphasizes the fearful atmosphere.

Characters may twist their necks in an attempt to escape from the object causing the fear.

Wrinkles around the eyes can increase the feeling of frustration.

High Intensity

Facing a situation that might result in loss of life or something important causes desperate feelings or intense fear, which creates extreme expressions.

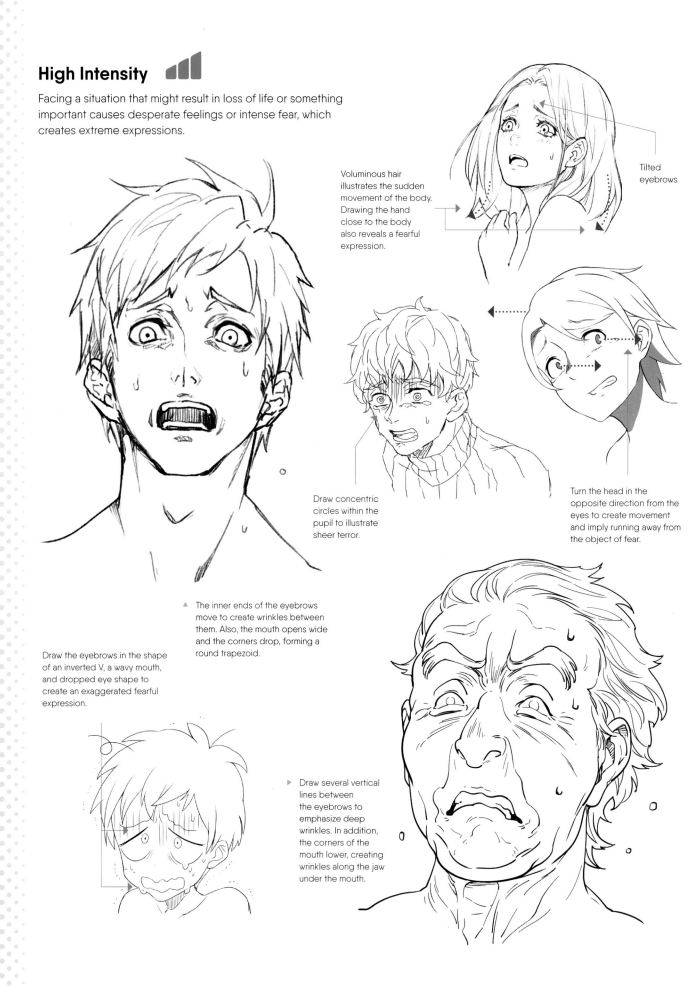

Voluminous hair illustrates the sudden movement of the body. Drawing the hand close to the body also reveals a fearful expression.

Tilted eyebrows

Draw concentric circles within the pupil to illustrate sheer terror.

Turn the head in the opposite direction from the eyes to create movement and imply running away from the object of fear.

▲ The inner ends of the eyebrows move to create wrinkles between them. Also, the mouth opens wide and the corners drop, forming a round trapezoid.

Draw the eyebrows in the shape of an inverted V, a wavy mouth, and dropped eye shape to create an exaggerated fearful expression.

▶ Draw several vertical lines between the eyebrows to emphasize deep wrinkles. In addition, the corners of the mouth lower, creating wrinkles along the jaw under the mouth.

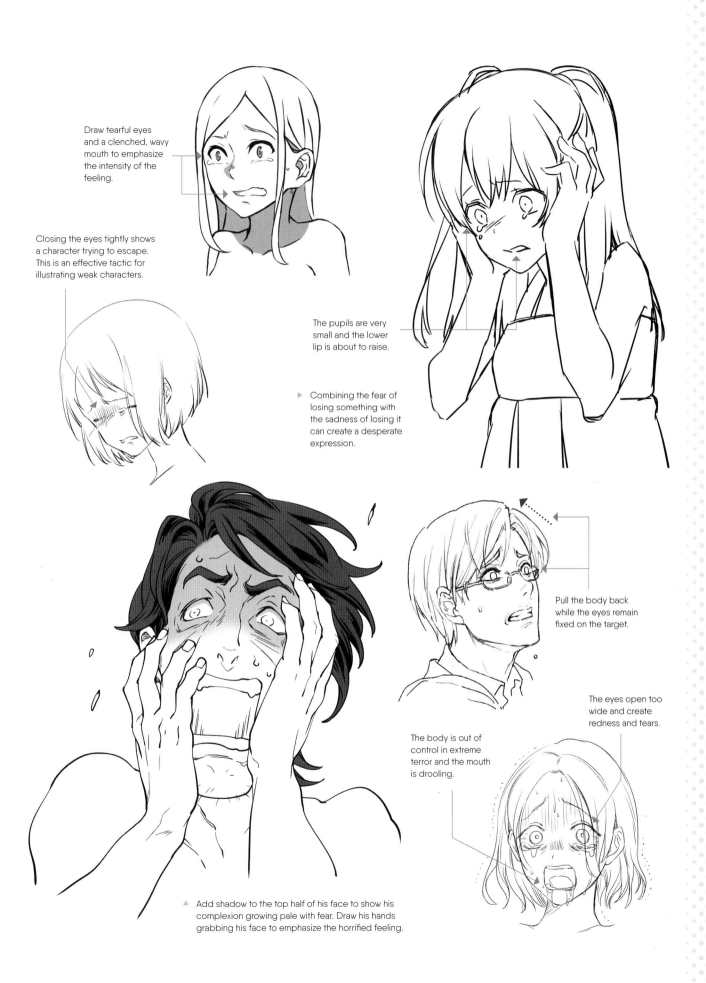

Draw tearful eyes and a clenched, wavy mouth to emphasize the intensity of the feeling.

Closing the eyes tightly shows a character trying to escape. This is an effective tactic for illustrating weak characters.

The pupils are very small and the lower lip is about to raise.

▶ Combining the fear of losing something with the sadness of losing it can create a desperate expression.

Pull the body back while the eyes remain fixed on the target.

The body is out of control in extreme terror and the mouth is drooling.

The eyes open too wide and create redness and tears.

▲ Add shadow to the top half of his face to show his complexion growing pale with fear. Draw his hands grabbing his face to emphasize the horrified feeling.

EXPRESSING DISGUST

Disgust is often expressed with feeling such as being bored or hateful. This emotion can easily lead to anger. The expressions are similar, but it is a different emotion in principle, so be careful not to confuse the two.

Lesson 06

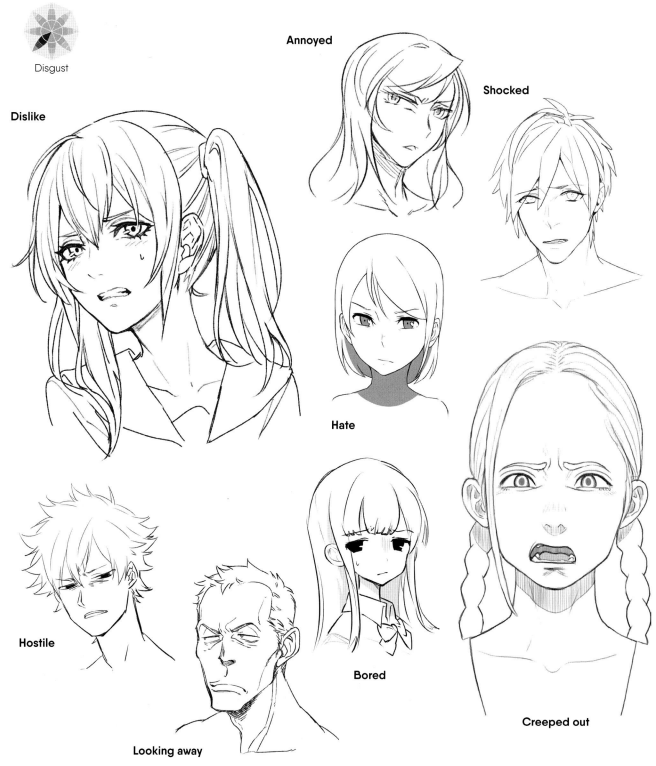

Disgust

Dislike

Annoyed

Shocked

Hate

Hostile

Looking away

Bored

Creeped out

▶ Facial Features for Disgust

Eyes & Eyebrows

A frowning face lowers the inner ends of the eyebrows to create vertical wrinkles between them (①). The oculi muscle shrinks to create thin eyes (②). Curved lines appear under the eyes (③).

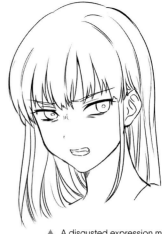

▲ A disgusted expression mixed with anger exposes clenched teeth.

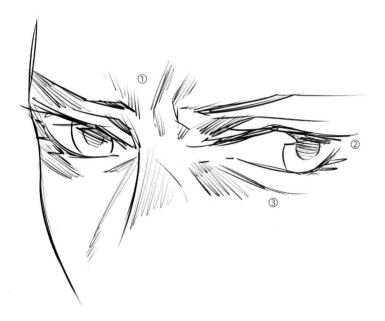

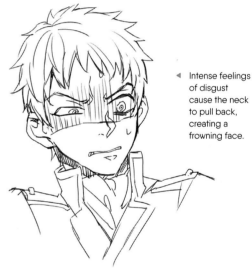

◀ Intense feelings of disgust cause the neck to pull back, creating a frowning face.

Mouth

The levator labii superioris muscle, which is located next to the nose, shrinks to raise the upper lip (①). At the same time, the cheek and wing of the nose are raised (②). The mentalis muscle shrinks to push the bottom lip up (③).

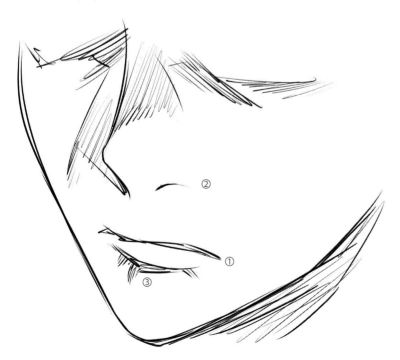

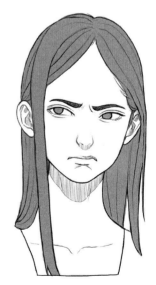

▶ Add wrinkles between the eyebrows, lines under eyes, and wrinkles under the bottom lip to create a disgusted feeling.

INTENSITY LEVELS OF DISGUST

The direction of the face and eyes is an important element to consider when drawing a disgusted expression. When experiencing strong feelings of disgust with anger, people tend to turn and look directly at the person or object. They may also look down on the person or object to express contempt.

Low Intensity

Less intense emotions show responses such as being bored, shocked, and showing contempt.

The top eyelids are flat, while the bottom eyelids are raised.

Draw the eye curving toward the bottom to represent a closed eyelid.

Draw a line under the closed eyes and form the mouth into a sighing "Ah" shape.

▶ Here, the sweat drop conveys a bored impression—omit it to transform the expression into one of anger.

Frowning eyes and eyebrows combined with raised corners of the mouth can create an expression of contempt.

The neck shrugs and pulls back.

Add wrinkles between the eyebrows as the character is looking away.

◀ ▶ Here, both characters are looking down, but different expressions are created by altering the angle of the neck, shape of the mouth, and adding sweat drops.

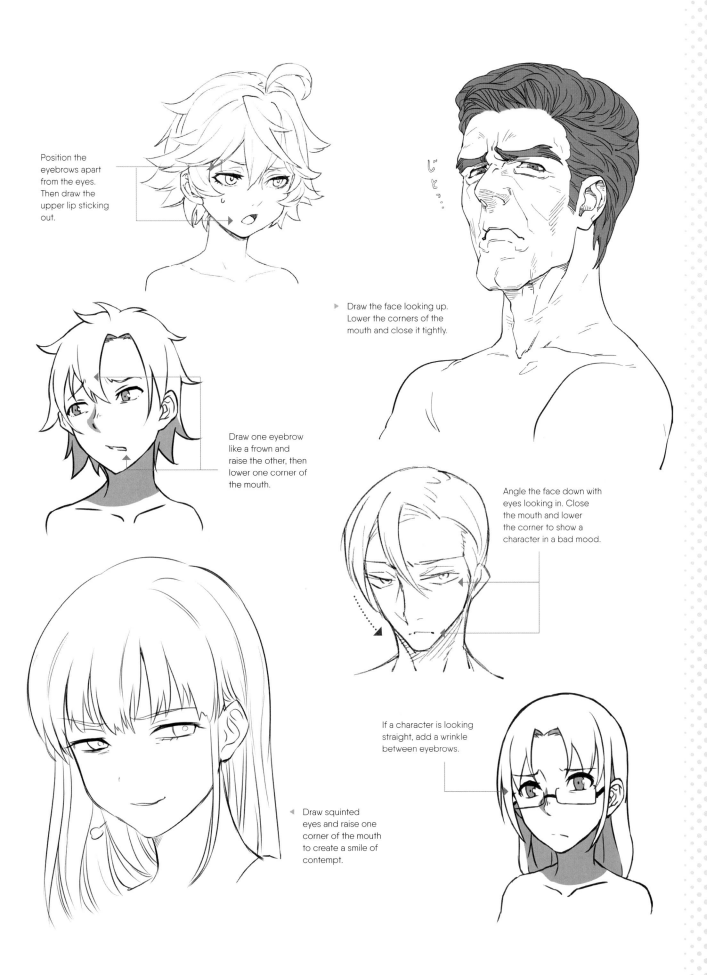

Position the eyebrows apart from the eyes. Then draw the upper lip sticking out.

▷ Draw the face looking up. Lower the corners of the mouth and close it tightly.

Draw one eyebrow like a frown and raise the other, then lower one corner of the mouth.

Angle the face down with eyes looking in. Close the mouth and lower the corner to show a character in a bad mood.

If a character is looking straight, add a wrinkle between eyebrows.

◁ Draw squinted eyes and raise one corner of the mouth to create a smile of contempt.

Medium Intensity

A medium intensity of disgust shows stronger feelings of dislike and wanting something to stop. It is often expressed by sighing aloud and eyes showing disgust or refusal.

An expression of contempt becomes a tired and shocked face when the eyes are closed. The smile disappears as the feeling of disgust intensifies.

Draw wavy eyebrows, lower the inner ends of the eyebrows, and lower the bottom jaw to open the mouth.

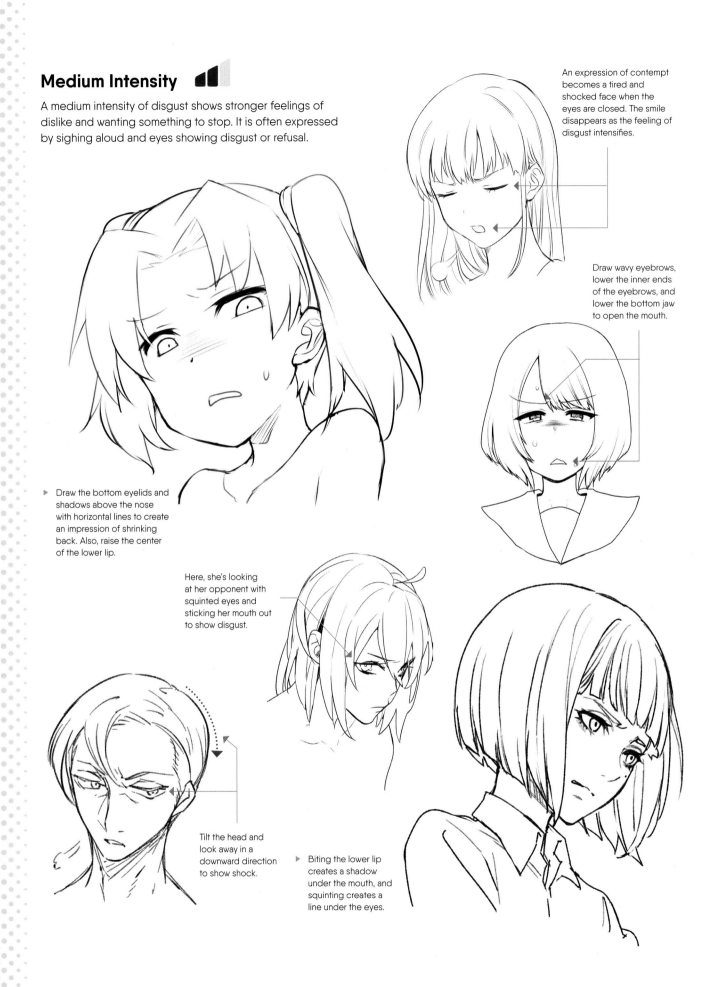

▶ Draw the bottom eyelids and shadows above the nose with horizontal lines to create an impression of shrinking back. Also, raise the center of the lower lip.

Here, she's looking at her opponent with squinted eyes and sticking her mouth out to show disgust.

Tilt the head and look away in a downward direction to show shock.

▶ Biting the lower lip creates a shadow under the mouth, and squinting creates a line under the eyes.

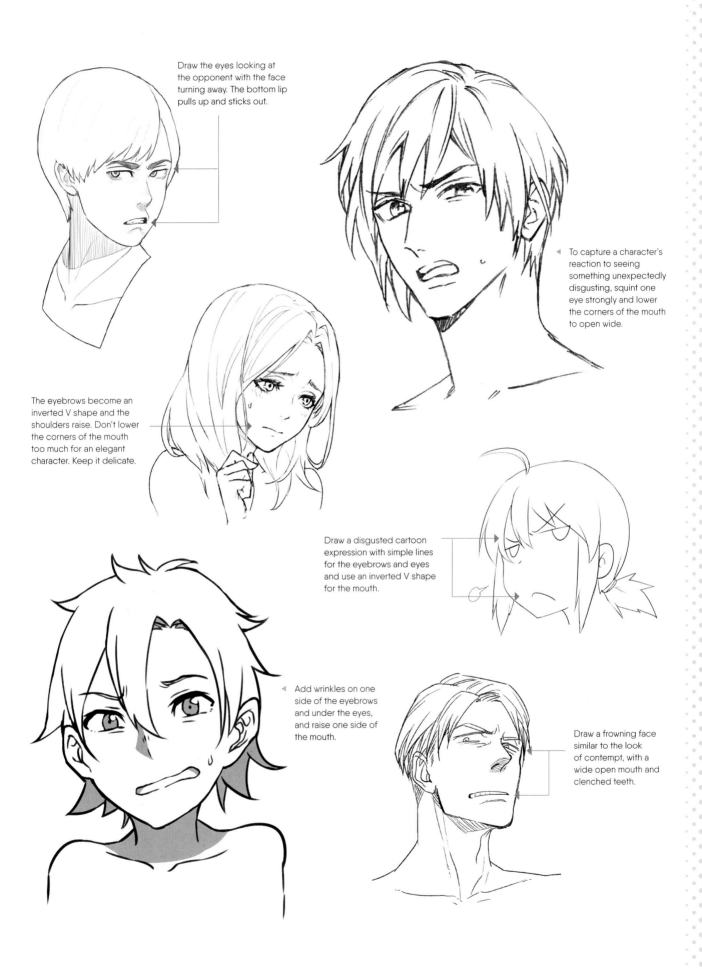

Draw the eyes looking at the opponent with the face turning away. The bottom lip pulls up and sticks out.

To capture a character's reaction to seeing something unexpectedly disgusting, squint one eye strongly and lower the corners of the mouth to open wide.

The eyebrows become an inverted V shape and the shoulders raise. Don't lower the corners of the mouth too much for an elegant character. Keep it delicate.

Draw a disgusted cartoon expression with simple lines for the eyebrows and eyes and use an inverted V shape for the mouth.

Add wrinkles on one side of the eyebrows and under the eyes, and raise one side of the mouth.

Draw a frowning face similar to the look of contempt, with a wide open mouth and clenched teeth.

High Intensity

Stronger feelings of disgust usually create aggressive looks when combined with anger. To draw a high intensity feeling of disgust, imagine the face a character would make when vomiting.

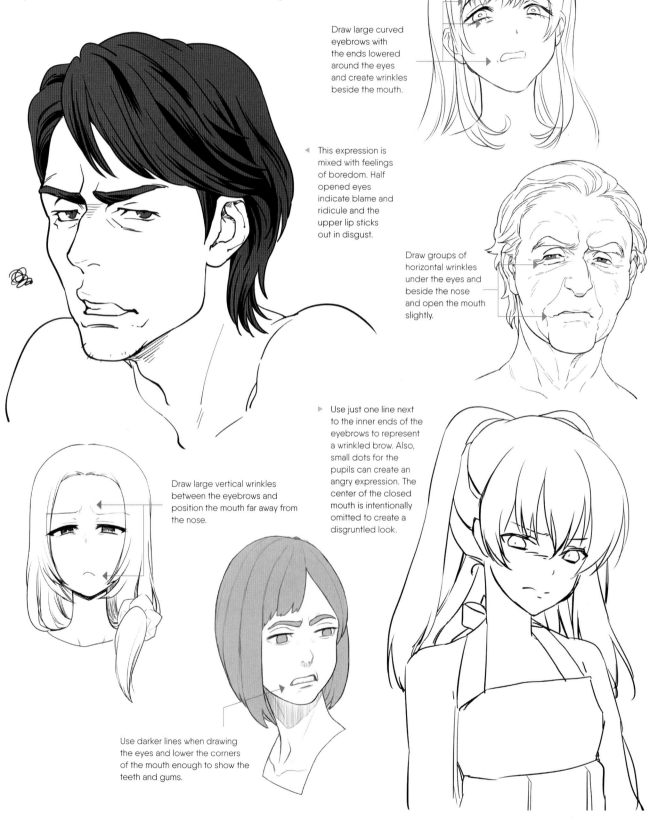

Draw large curved eyebrows with the ends lowered around the eyes and create wrinkles beside the mouth.

◁ This expression is mixed with feelings of boredom. Half opened eyes indicate blame and ridicule and the upper lip sticks out in disgust.

Draw groups of horizontal wrinkles under the eyes and beside the nose and open the mouth slightly.

Draw large vertical wrinkles between the eyebrows and position the mouth far away from the nose.

▷ Use just one line next to the inner ends of the eyebrows to represent a wrinkled brow. Also, small dots for the pupils can create an angry expression. The center of the closed mouth is intentionally omitted to create a disgruntled look.

Use darker lines when drawing the eyes and lower the corners of the mouth enough to show the teeth and gums.

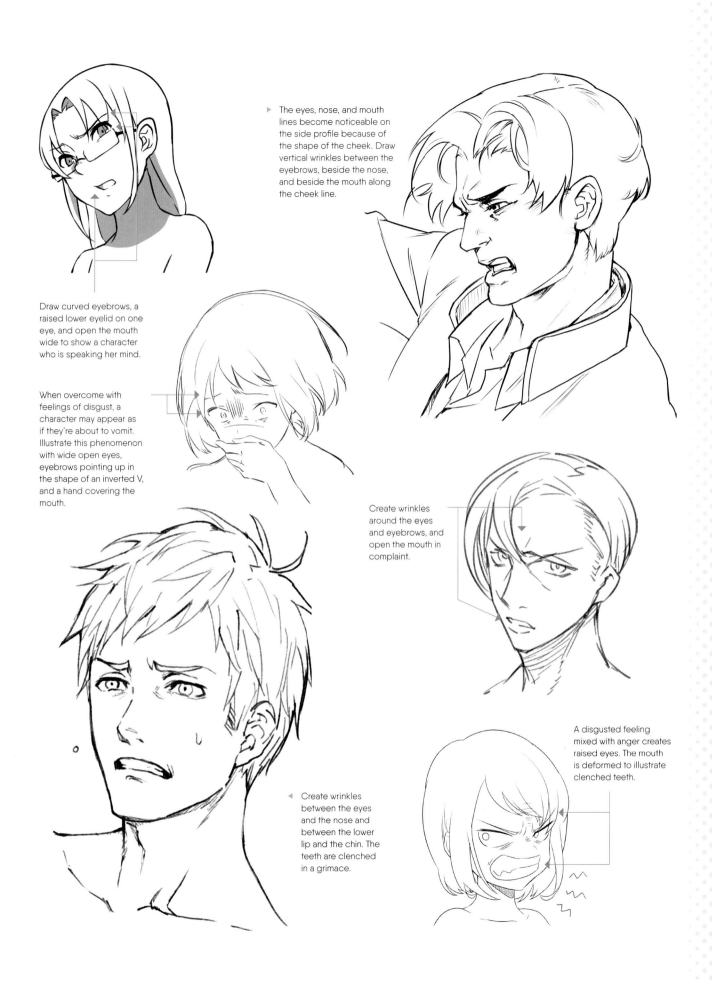

The eyes, nose, and mouth lines become noticeable on the side profile because of the shape of the cheek. Draw vertical wrinkles between the eyebrows, beside the nose, and beside the mouth along the cheek line.

Draw curved eyebrows, a raised lower eyelid on one eye, and open the mouth wide to show a character who is speaking her mind.

When overcome with feelings of disgust, a character may appear as if they're about to vomit. Illustrate this phenomenon with wide open eyes, eyebrows pointing up in the shape of an inverted V, and a hand covering the mouth.

Create wrinkles around the eyes and eyebrows, and open the mouth in complaint.

A disgusted feeling mixed with anger creates raised eyes. The mouth is deformed to illustrate clenched teeth.

Create wrinkles between the eyes and the nose and between the lower lip and the chin. The teeth are clenched in a grimace.

Using Shadow to Create Exaggerated Expressions

Shadow is an important element that can change the expression. Adding darker shadow with a depressed expression deepens the sorrow and adding shadow with an angry expression increases the rage. Shadow impacts emotions such as sadness, anger, fear, and surprise. Drawing shadows around the eyes, both sides of the nose, under the nose, and under the neck can emphasize these emotions. We are used to shadows that are created by light from above, but feelings of unease can be created when the shadow is formed by light from another direction. Using this knowledge, you can create a scary smile by adding shadow on the nose by lighting the smile from below.

Sadness

For a depressed emotion, draw the character looking down and create shadow on the face. Sorrow is emphasized by drawing darker shadows on half of the face.

Fear

Fear and anxiety can be expressed by adding shadows around the eyes, sinking them inward. Fear is expressed by adding strong shadows on the eyes, nose, temples, and neck.

Anger

Anger tenses the face and creates shadow. Light from behind emphasizes the anger by highlighting the shadow on the expression.

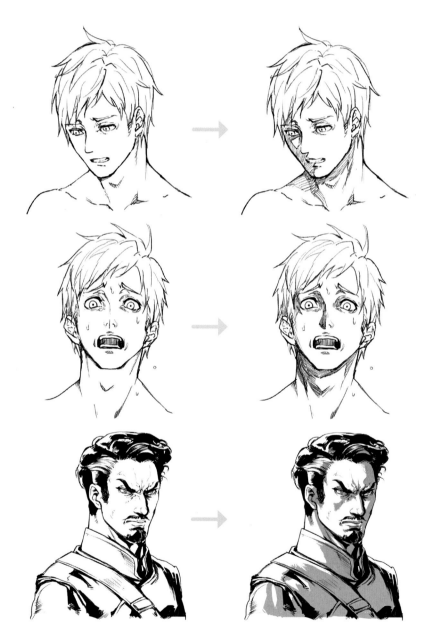

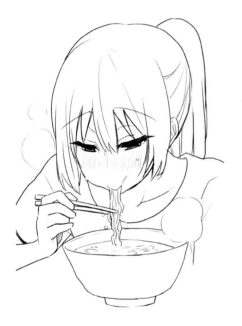

CHAPTER 3

FACIAL EXPRESSIONS FOR SCENES & STORYLINES

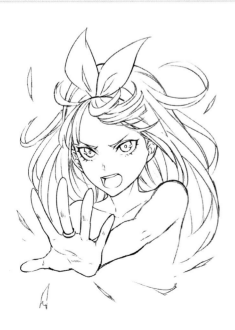

Lesson 01

ROMANCE & COMMUNICATION

People's hearts are very complicated and various expressions are made by combining multiple emotions other than the six basic emotions introduced in Chapter 2. In this section, we'll cover expressions related to romance and communication.

Love

▷ Blushing

The face reddens as a response to romantic stimulation, such as interaction with a crush. Other parts of the response differ depending on the individual; some make direct eye contact, while others look away.

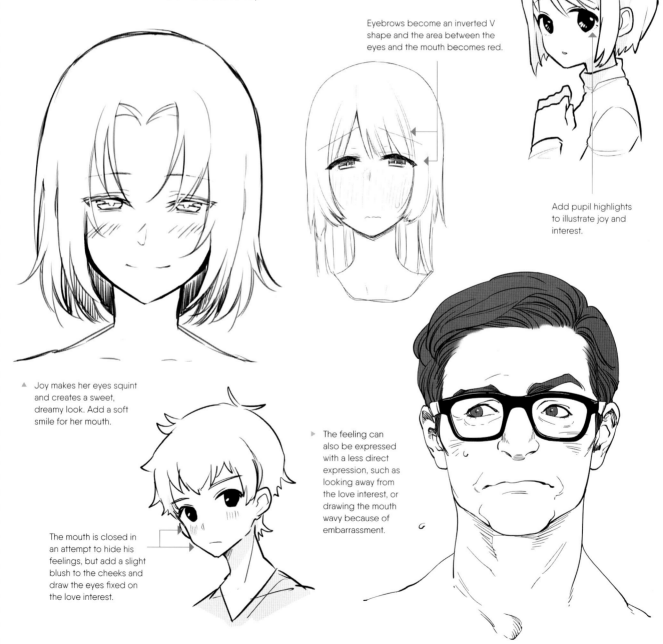

Eyebrows become an inverted V shape and the area between the eyes and the mouth becomes red.

Add pupil highlights to illustrate joy and interest.

▲ Joy makes her eyes squint and creates a sweet, dreamy look. Add a soft smile for her mouth.

The mouth is closed in an attempt to hide his feelings, but add a slight blush to the cheeks and draw the eyes fixed on the love interest.

▷ The feeling can also be expressed with a less direct expression, such as looking away from the love interest, or drawing the mouth wavy because of embarrassment.

Love

Startled

A started expression combines surprise and joy. The character is pleasantly surprised, with wide-open eyes, raised eyebrows, and flushed cheeks.

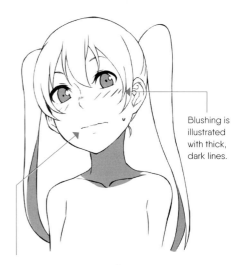

Blushing is illustrated with thick, dark lines.

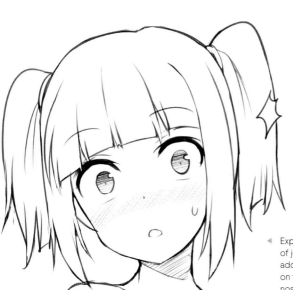

◁ Express the feelings of joy and favor by adding blush lines on the cheeks, nose, and neck of a surprised face.

Draw a wavy mouth to illustrate embarrassment.

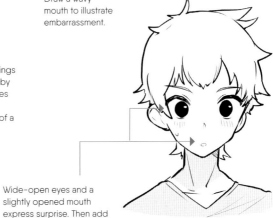

Wide-open eyes and a slightly opened mouth express surprise. Then add blush to the cheeks.

The mouth opens as a reflex when surprised. The shape of the mouth resembles the letter E.

Exaggerate the expression of surprise by adding highlights to the eyes and drawing the hair sticking out on end.

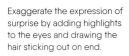

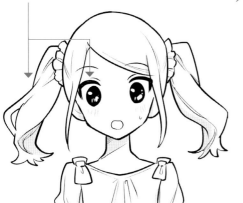

The lips stick out in surprise.

▷ The pursed bottom lip wrinkles in surprise, while the corners of the mouth are raised by joy.

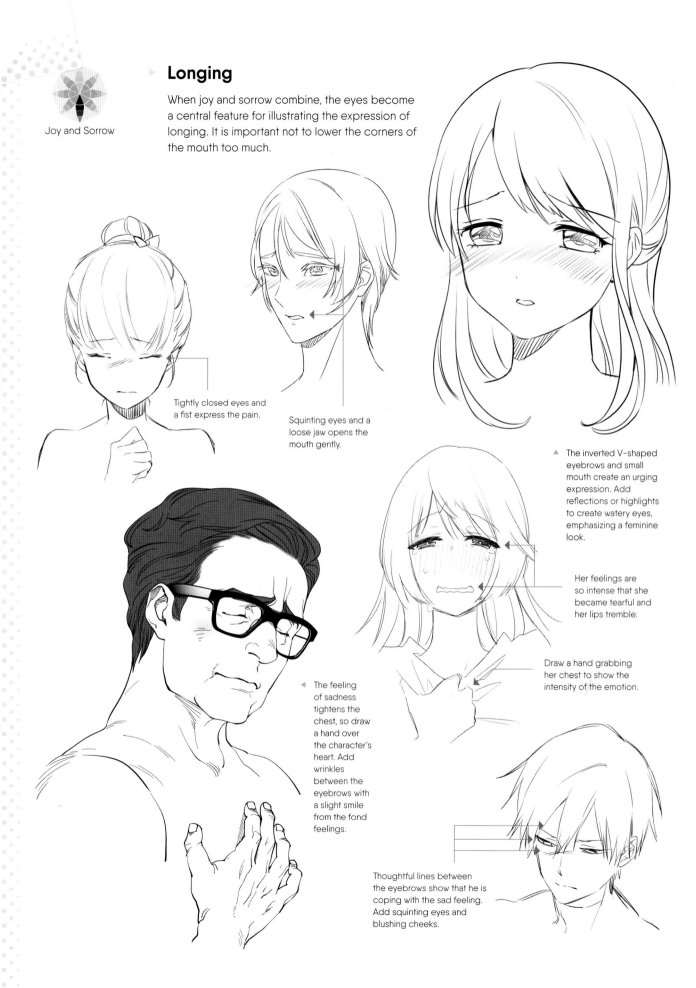

▶ Longing

When joy and sorrow combine, the eyes become a central feature for illustrating the expression of longing. It is important not to lower the corners of the mouth too much.

Joy and Sorrow

Tightly closed eyes and a fist express the pain.

Squinting eyes and a loose jaw opens the mouth gently.

▲ The inverted V-shaped eyebrows and small mouth create an urging expression. Add reflections or highlights to create watery eyes, emphasizing a feminine look.

Her feelings are so intense that she became tearful and her lips tremble.

Draw a hand grabbing her chest to show the intensity of the emotion.

◀ The feeling of sadness tightens the chest, so draw a hand over the character's heart. Add wrinkles between the eyebrows with a slight smile from the fond feelings.

Thoughtful lines between the eyebrows show that he is coping with the sad feeling. Add squinting eyes and blushing cheeks.

Smiling

Draw soft eyes to express the happy feeling of meeting a favorite person.

Love

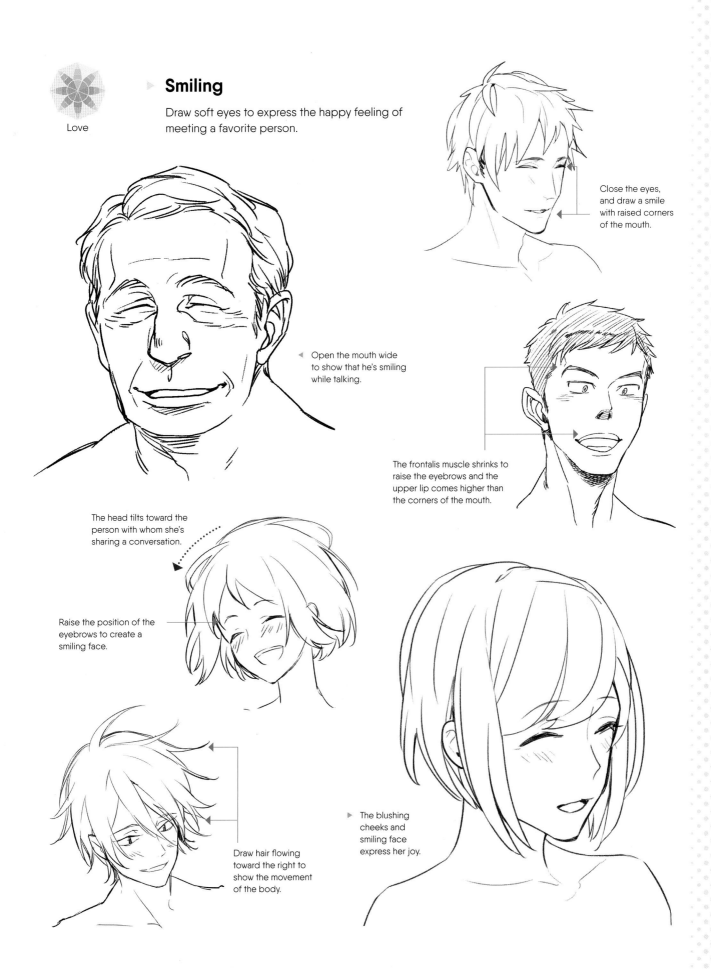

Close the eyes, and draw a smile with raised corners of the mouth.

Open the mouth wide to show that he's smiling while talking.

The frontalis muscle shrinks to raise the eyebrows and the upper lip comes higher than the corners of the mouth.

The head tilts toward the person with whom she's sharing a conversation.

Raise the position of the eyebrows to create a smiling face.

Draw hair flowing toward the right to show the movement of the body.

The blushing cheeks and smiling face express her joy.

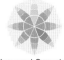

Joy and Surprise

Shy

When combining joy and surprise, a character can be shy. They may avert their eyes, become serious to hide the feeling, or look embarrassed.

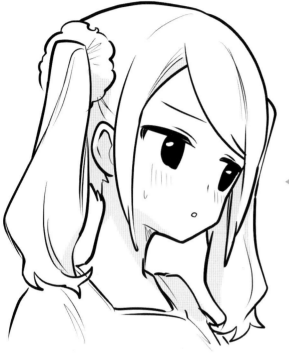

Squint the eyes to illustrate feeling embarrassed and place a hand on the neck.

◄ Draw her eyes looking away by lowering her upper eyelids, then shrink the mouth and tilt her head.

This character is feeling shy. He can't look straight ahead, and is scratching his cheek with his finger.

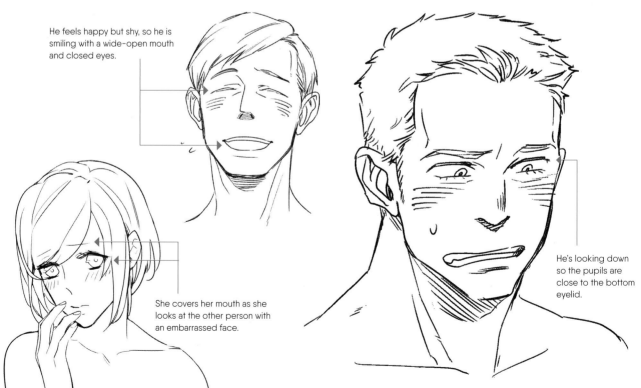

He feels happy but shy, so he is smiling with a wide-open mouth and closed eyes.

She covers her mouth as she looks at the other person with an embarrassed face.

He's looking down so the pupils are close to the bottom eyelid.

▲ For a male character's expression of shyness, draw a partially open mouth trying to say something.

Joy and Surprise

Shameful

Increase the blush more than with a shy expression. A shameful look shows an embarrassed smile as the character copes with the shame. Also, the eyebrows tend to raise.

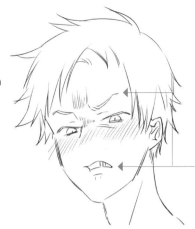

Wrinkles form between the eyebrows and under the clenched bottom lip as he endures the shame.

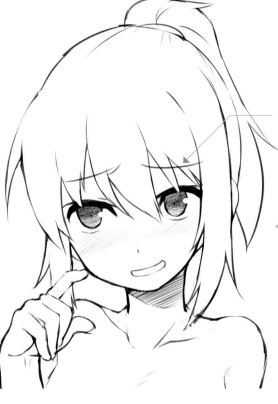

Draw the eyebrows curving toward the bottom of the face.

◄ Make the eyebrows and eyes look shy and embarrassed, but draw the eyes looking happy, to create a mixed expression of shame and joy.

The eyes are soft with joy and the lips are tight, but the corners are raised.

▶ For a man, inverted V-shaped eyebrows can express shame, while upward gazing eyes can express joy.

Draw the eyes looking away, and lower one end of the mouth.

The entire face blushes with shame and the character can't look up.

Happy Tears

Ecstasy

This expression occurs when a character is so happy or excited, they cry. Despite the tears, their eyes and mouths should express joy.

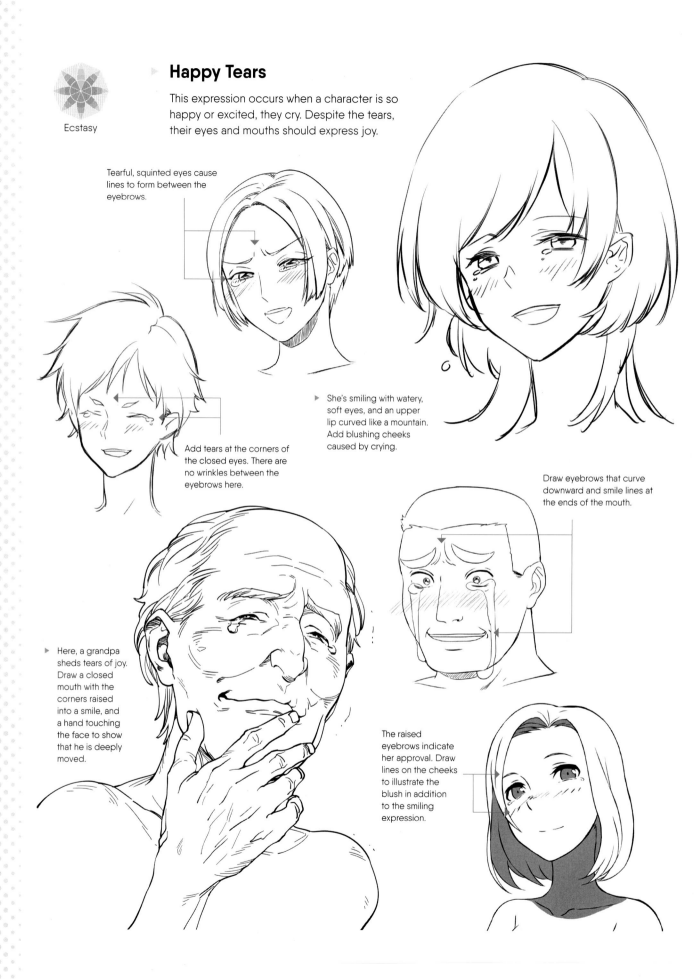

Tearful, squinted eyes cause lines to form between the eyebrows.

Add tears at the corners of the closed eyes. There are no wrinkles between the eyebrows here.

▶ She's smiling with watery, soft eyes, and an upper lip curved like a mountain. Add blushing cheeks caused by crying.

Draw eyebrows that curve downward and smile lines at the ends of the mouth.

▶ Here, a grandpa sheds tears of joy. Draw a closed mouth with the corners raised into a smile, and a hand touching the face to show that he is deeply moved.

The raised eyebrows indicate her approval. Draw lines on the cheeks to illustrate the blush in addition to the smiling expression.

Tears of Disappointment & Frustration

Combine raised, angry eyebrows and a sad mouth distorted by a clenched bottom lip to create a frustrated expression.

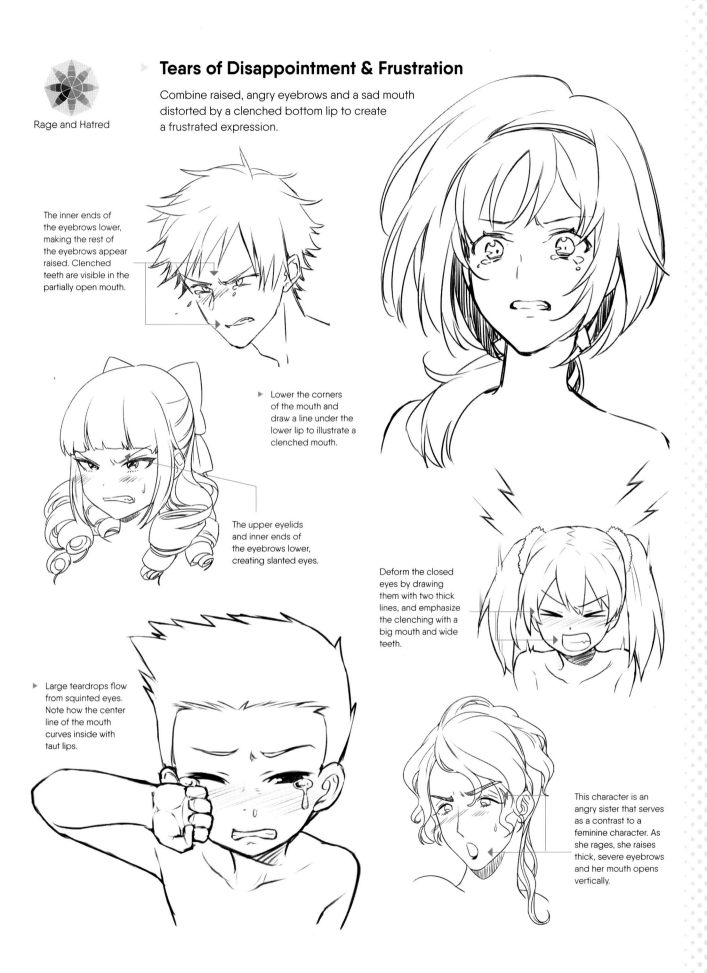

Rage and Hatred

The inner ends of the eyebrows lower, making the rest of the eyebrows appear raised. Clenched teeth are visible in the partially open mouth.

▶ Lower the corners of the mouth and draw a line under the lower lip to illustrate a clenched mouth.

The upper eyelids and inner ends of the eyebrows lower, creating slanted eyes.

Deform the closed eyes by drawing them with two thick lines, and emphasize the clenching with a big mouth and wide teeth.

▶ Large teardrops flow from squinted eyes. Note how the center line of the mouth curves inside with taut lips.

This character is an angry sister that serves as a contrast to a feminine character. As she rages, she raises thick, severe eyebrows and her mouth opens vertically.

Belief & Acceptance

Belief is an emotion similar to joy. Draw a natural smile to illustrate the lack of doubt.

Trust

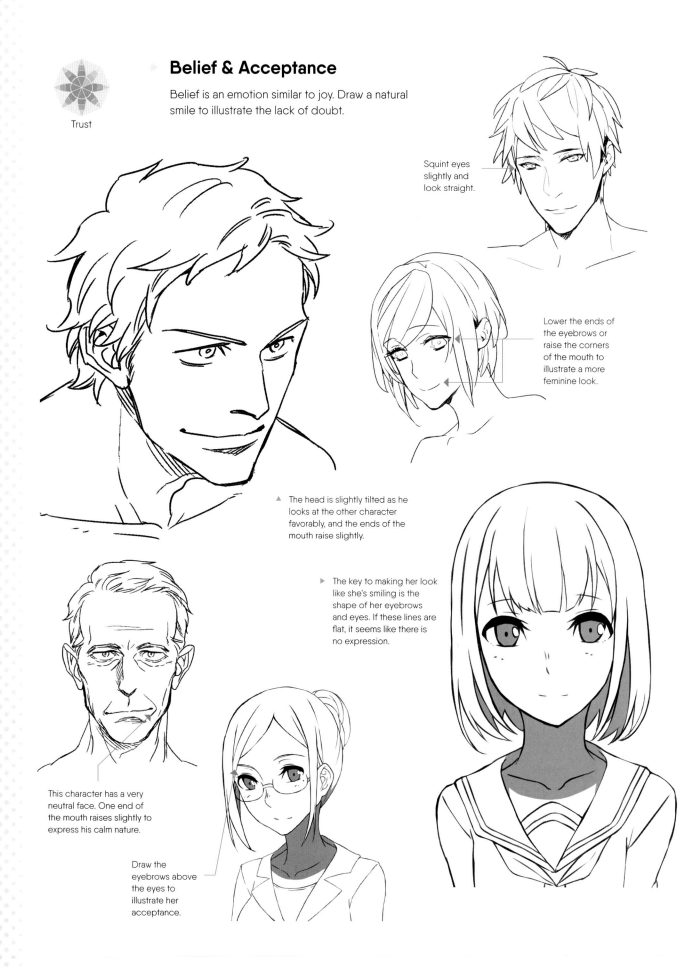

Squint eyes slightly and look straight.

Lower the ends of the eyebrows or raise the corners of the mouth to illustrate a more feminine look.

▲ The head is slightly tilted as he looks at the other character favorably, and the ends of the mouth raise slightly.

▶ The key to making her look like she's smiling is the shape of her eyebrows and eyes. If these lines are flat, it seems like there is no expression.

This character has a very neutral face. One end of the mouth raises slightly to express his calm nature.

Draw the eyebrows above the eyes to illustrate her acceptance.

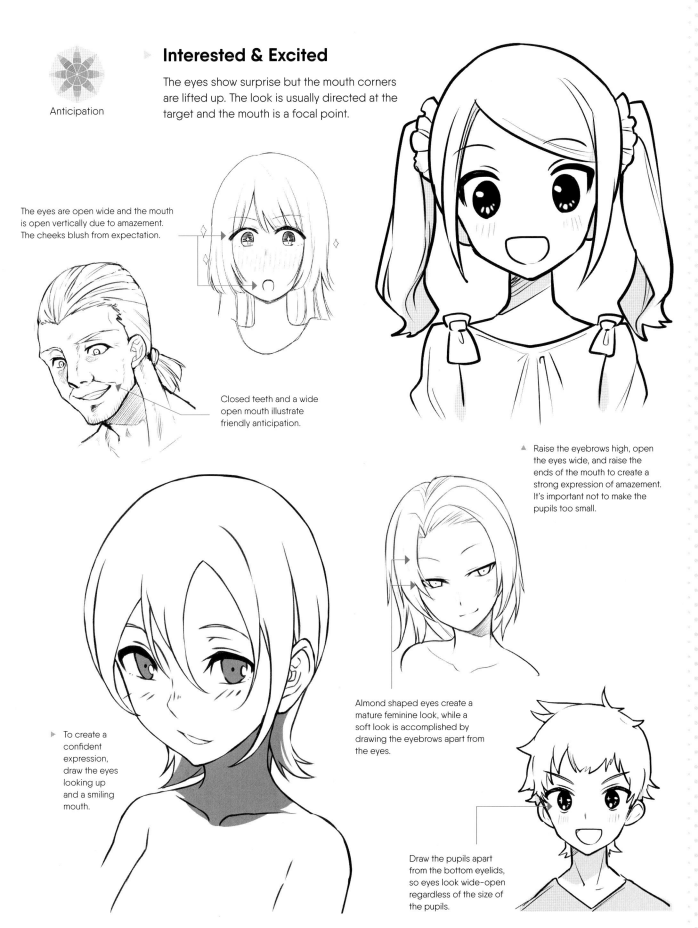

Interested & Excited

The eyes show surprise but the mouth corners are lifted up. The look is usually directed at the target and the mouth is a focal point.

Anticipation

The eyes are open wide and the mouth is open vertically due to amazement. The cheeks blush from expectation.

Closed teeth and a wide open mouth illustrate friendly anticipation.

▲ Raise the eyebrows high, open the eyes wide, and raise the ends of the mouth to create a strong expression of amazement. It's important not to make the pupils too small.

Almond shaped eyes create a mature feminine look, while a soft look is accomplished by drawing the eyebrows apart from the eyes.

▶ To create a confident expression, draw the eyes looking up and a smiling mouth.

Draw the pupils apart from the bottom eyelids, so eyes look wide-open regardless of the size of the pupils.

Trust and
Expectations

Admiration & Respect

Admiration and respect will be clearly evident in a character's eyes—they may be staring or looking up at the object of their affection. Add highlights to the eyes to make them shine and express even more emotion.

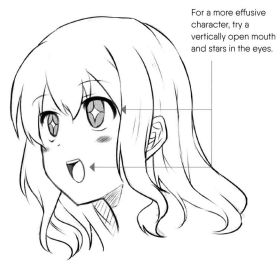

His eyebrows raise while he looks up with admiration and respect for the other person.

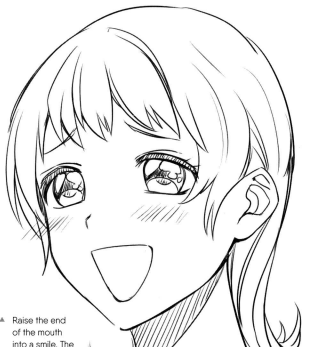

For a more effusive character, try a vertically open mouth and stars in the eyes.

▲ Raise the end of the mouth into a smile. The downward curve of the eyebrows creates a strong feeling of longing.

Blush lines across the cheeks indicate excitement.

The eyebrows and eyes are similar to a surprised expression, while the mouth falls open in awe and reverence.

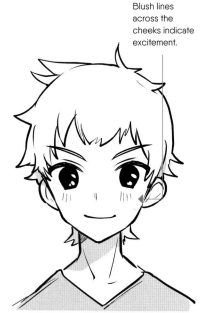

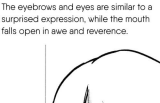

Lift the eyebrows to look with wide-open eyes and show strong interest.

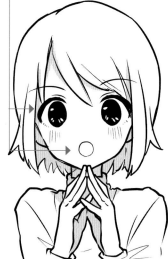

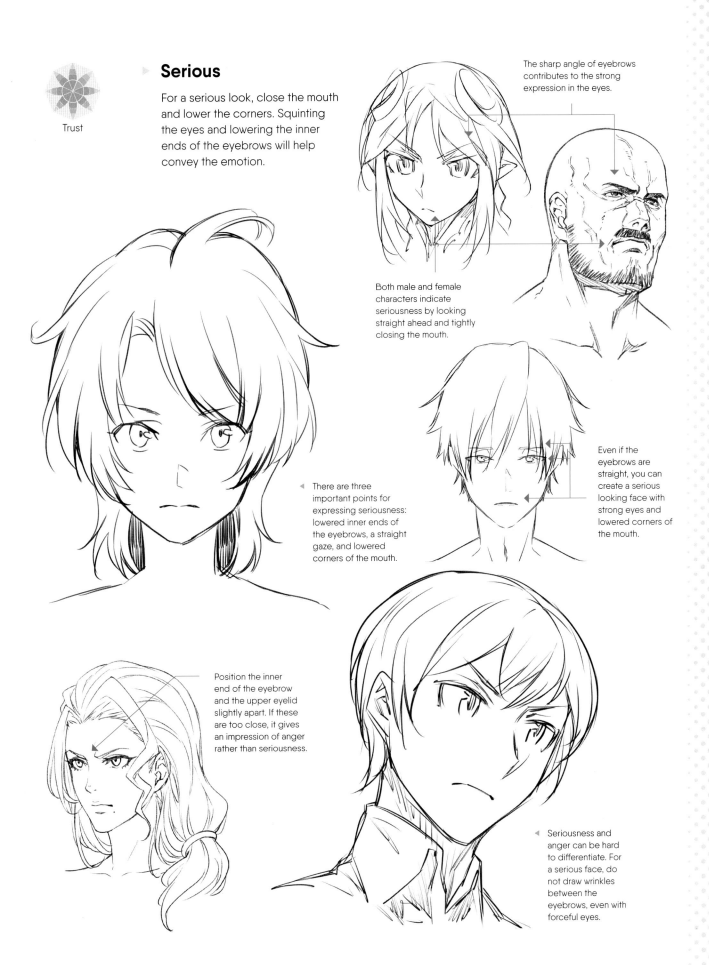

Trust

Serious

For a serious look, close the mouth and lower the corners. Squinting the eyes and lowering the inner ends of the eyebrows will help convey the emotion.

The sharp angle of eyebrows contributes to the strong expression in the eyes.

Both male and female characters indicate seriousness by looking straight ahead and tightly closing the mouth.

There are three important points for expressing seriousness: lowered inner ends of the eyebrows, a straight gaze, and lowered corners of the mouth.

Even if the eyebrows are straight, you can create a serious looking face with strong eyes and lowered corners of the mouth.

Position the inner end of the eyebrow and the upper eyelid slightly apart. If these are too close, it gives an impression of anger rather than seriousness.

Seriousness and anger can be hard to differentiate. For a serious face, do not draw wrinkles between the eyebrows, even with forceful eyes.

Confident

A confident expression comes from trust and joy toward oneself. A smiling mouth is the main feature.

Joy and Trust
Anticipation

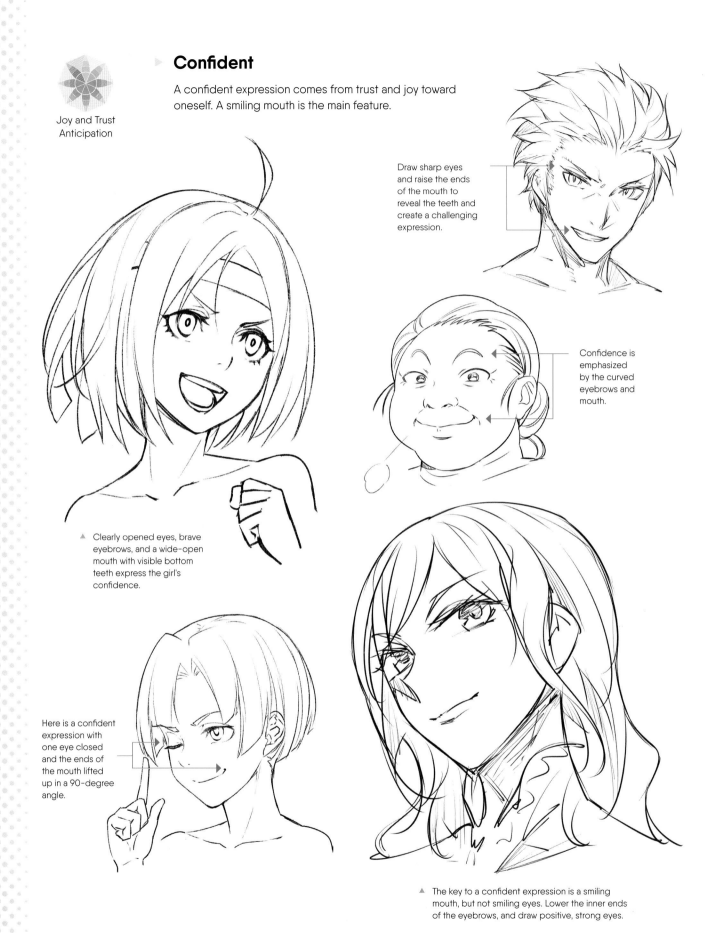

Draw sharp eyes and raise the ends of the mouth to reveal the teeth and create a challenging expression.

Confidence is emphasized by the curved eyebrows and mouth.

▲ Clearly opened eyes, brave eyebrows, and a wide-open mouth with visible bottom teeth express the girl's confidence.

Here is a confident expression with one eye closed and the ends of the mouth lifted up in a 90-degree angle.

▲ The key to a confident expression is a smiling mouth, but not smiling eyes. Lower the inner ends of the eyebrows, and draw positive, strong eyes.

Troubled or Deep in Thought

When we are thinking, we tend to look up or look down and may even support our head with our hands.

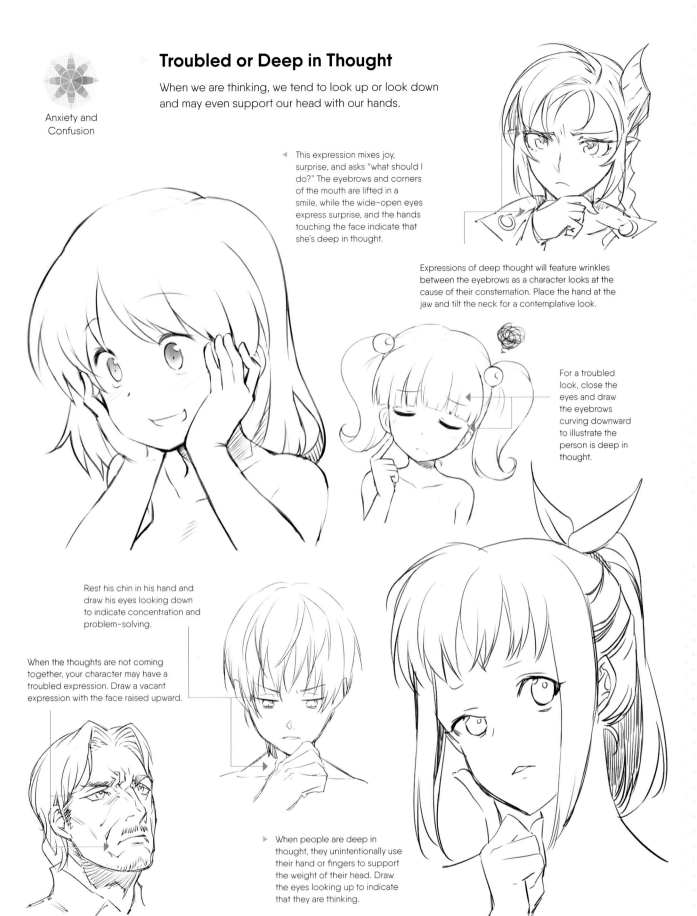

◁ This expression mixes joy, surprise, and asks "what should I do?" The eyebrows and corners of the mouth are lifted in a smile, while the wide-open eyes express surprise, and the hands touching the face indicate that she's deep in thought.

Expressions of deep thought will feature wrinkles between the eyebrows as a character looks at the cause of their consternation. Place the hand at the jaw and tilt the neck for a contemplative look.

For a troubled look, close the eyes and draw the eyebrows curving downward to illustrate the person is deep in thought.

Rest his chin in his hand and draw his eyes looking down to indicate concentration and problem-solving.

When the thoughts are not coming together, your character may have a troubled expression. Draw a vacant expression with the face raised upward.

▷ When people are deep in thought, they unintentionally use their hand or fingers to support the weight of their head. Draw the eyes looking up to indicate that they are thinking.

Fear and
Confusion

▶ Agitated

When facing unexpected circumstances, a person can feel surprised, anxious, and agitated. This expression mixes elements of surprise and fear.

Add wrinkles at the inner ends of the eyebrows to illustrate the troubled feeling. Note the right and left eyebrow shapes are different.

A character may feel anxious when faced with an unexpected turn of events. Their eyes will open wide in surprise.

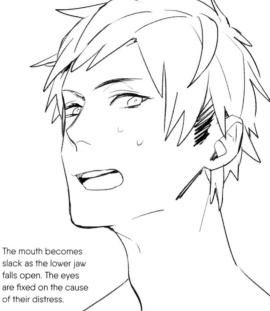

▶ The mouth becomes slack as the lower jaw falls open. The eyes are fixed on the cause of their distress.

Draw a partially opened mouth for a slightly stressful situation.

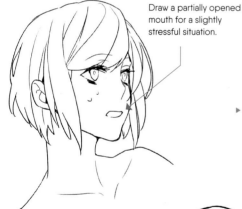

▶ The easiest way to express agitation is to draw sweat on the face. The main characteristic of this expression is wide-open eyes, with the eyes and eyebrows spaced far apart.

Draw a wide-open mouth, inverted eyebrows, and hair that stands on end to emphasize the agitation.

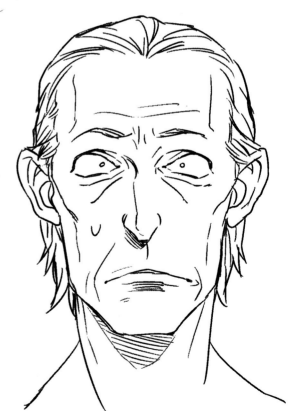

Lying or Evading

The eyes are not focused because they are lying while thinking. Also, the mouth opens because they are trying to talk their way out of a sticky situation.

Fear and Confusion

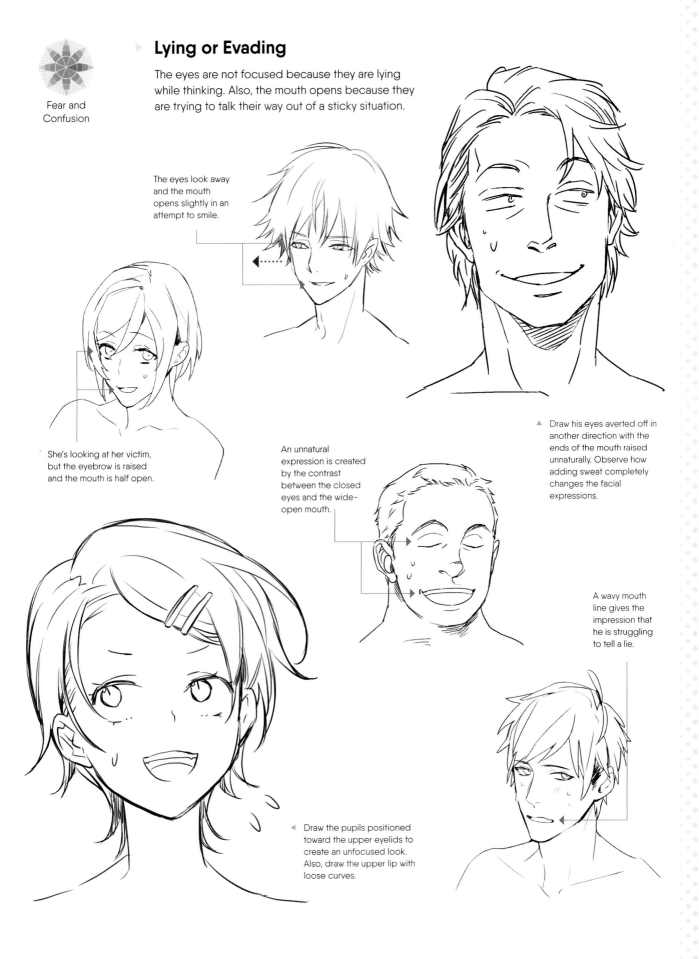

The eyes look away and the mouth opens slightly in an attempt to smile.

She's looking at her victim, but the eyebrow is raised and the mouth is half open.

An unnatural expression is created by the contrast between the closed eyes and the wide-open mouth.

Draw his eyes averted off in another direction with the ends of the mouth raised unnaturally. Observe how adding sweat completely changes the facial expressions.

A wavy mouth line gives the impression that he is struggling to tell a lie.

Draw the pupils positioned toward the upper eyelids to create an unfocused look. Also, draw the upper lip with loose curves.

Acting Tough

A wide-open mouth and raised eyebrows create an assertive looking expression, but wrinkles between the eyebrows indicate that it's all an act.

Add wrinkles at the inner ends of the eyebrows and draw half-opened eyes with lowered eyelids. Raise the corners of the mouth to create a slight smile.

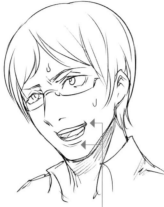

Sharpen the mouth by drawing angled lines at the corners. A strong bottom lip creates wrinkles.

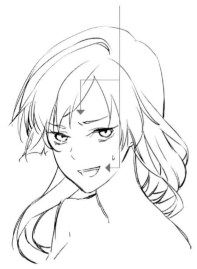

A wobbly smile suggests that he's pretending to be tough. The downward angle of his eyebrows and the slight wrinkles reveal what is really in his heart.

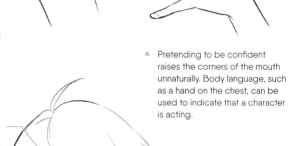

▲ Pretending to be confident raises the corners of the mouth unnaturally. Body language, such as a hand on the chest, can be used to indicate that a character is acting.

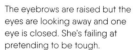

The eyebrows are raised but the eyes are looking away and one eye is closed. She's failing at pretending to be tough.

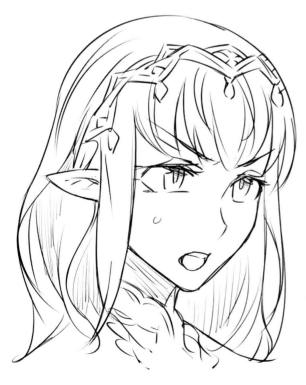

◄ A less tough character can create an expression of bluffing by raising their eyebrows.

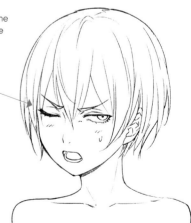

Sulking or in a Bad Mood

Sulking shows a character a little angry, brooding, or moping. Typical behavior is to raise the eyebrows, inflate the cheeks, and stick out the mouth.

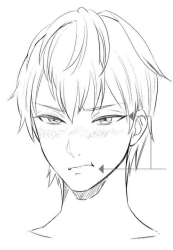

Close the mouth tight, and draw a line under the bottom lip to create a pout. Lower the upper eyelids so the eyes are almost closed.

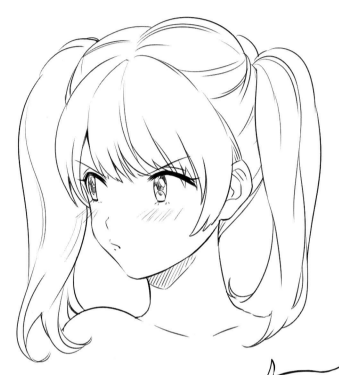

◁ Draw the character looking completely away with raised eyebrows close to the upper eyelids. Sticking out the mouth is also effective for showing anger.

To illustrate a child in a bad mood, add a vertical line on the edge of the mouth to show inflated cheeks.

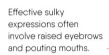

Effective sulky expressions often involve raised eyebrows and pouting mouths.

Angry looking eyes and inflated cheeks can work for a cute girl.

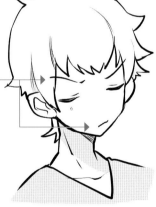

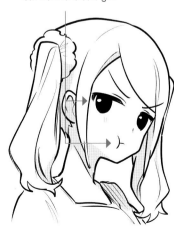

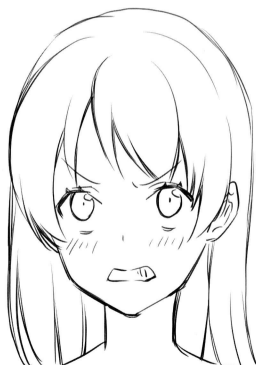

▷ Although her eyebrows are raised in anger, the eyes are looking up, indicating that she is upset with someone she cares about deeply. It is cuter not to lower the ends of the mouth too much.

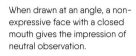

Joy and
Expectations + Fear

Trying to Read Another Person's Mind

When trying to read someone's mind, the shape of the eyebrows changes depending on what kind of feeling the character has toward the other person.

When drawn at an angle, a non-expressive face with a closed mouth gives the impression of neutral observation.

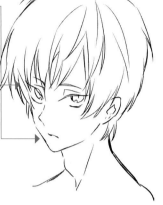

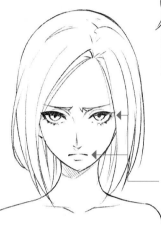

As she stares at the other person, the facial expression becomes serious with lowered eyelids and ends of the mouth, showing a cautious expression.

The eyebrows rise when a character looks at their favorite person—this is especially evident when drawn from a low angle. Draw a small mouth with a pointed tip.

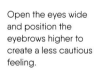

Open the eyes wide and position the eyebrows higher to create a less cautious feeling.

She does not trust the other person, so the eyebrows are not raised much, and the mouth becomes a closed, expressionless shape.

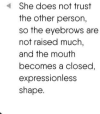

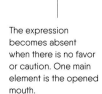

The expression becomes absent when there is no favor or caution. One main element is the opened mouth.

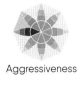

Aggressiveness

Suspicious & Cautious

Anxiety and suspicion create squinted eyes and wrinkles between the eyebrows. This feeling involves aggression so the character does not look away from the target.

The confident suspicious expression is created with half-opened eyes and raised bottom lip.

Raise the eyebrows and close the mouth. She's watching her opponent closely and keeping an eye out for suspicious behavior.

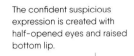

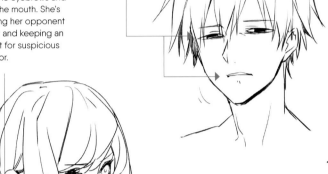

▲ The mouth is tightly closed, while the corners are lowered in suspicion and disgust. Also, one eye is squinted because of doubt.

For a strong suspicious look, squint his eyes but keep them fixed directly on the other person.

For a cautious, anxious expression, draw the eyes looking in the opposite direction of the body. This will create a watchful expression.

◀ This expression contains disgust and anger. Her doubt is clearly visible, and she is alertly watching to see if the other person acts suspicious.

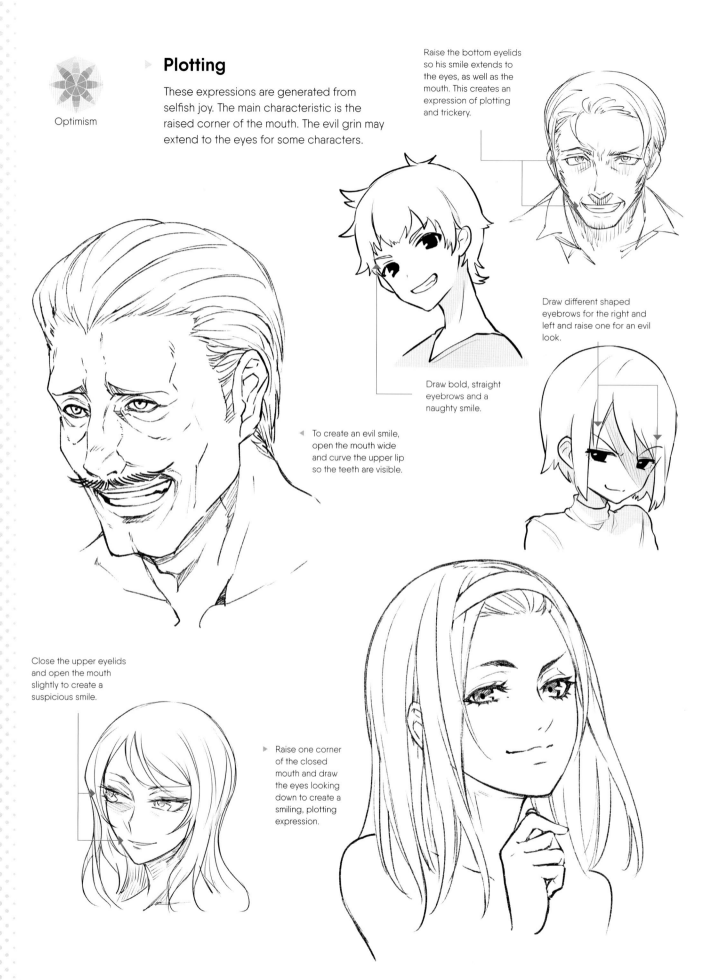

▶ Plotting

These expressions are generated from selfish joy. The main characteristic is the raised corner of the mouth. The evil grin may extend to the eyes for some characters.

Optimism

Raise the bottom eyelids so his smile extends to the eyes, as well as the mouth. This creates an expression of plotting and trickery.

Draw bold, straight eyebrows and a naughty smile.

Draw different shaped eyebrows for the right and left and raise one for an evil look.

◀ To create an evil smile, open the mouth wide and curve the upper lip so the teeth are visible.

Close the upper eyelids and open the mouth slightly to create a suspicious smile.

▶ Raise one corner of the closed mouth and draw the eyes looking down to create a smiling, plotting expression.

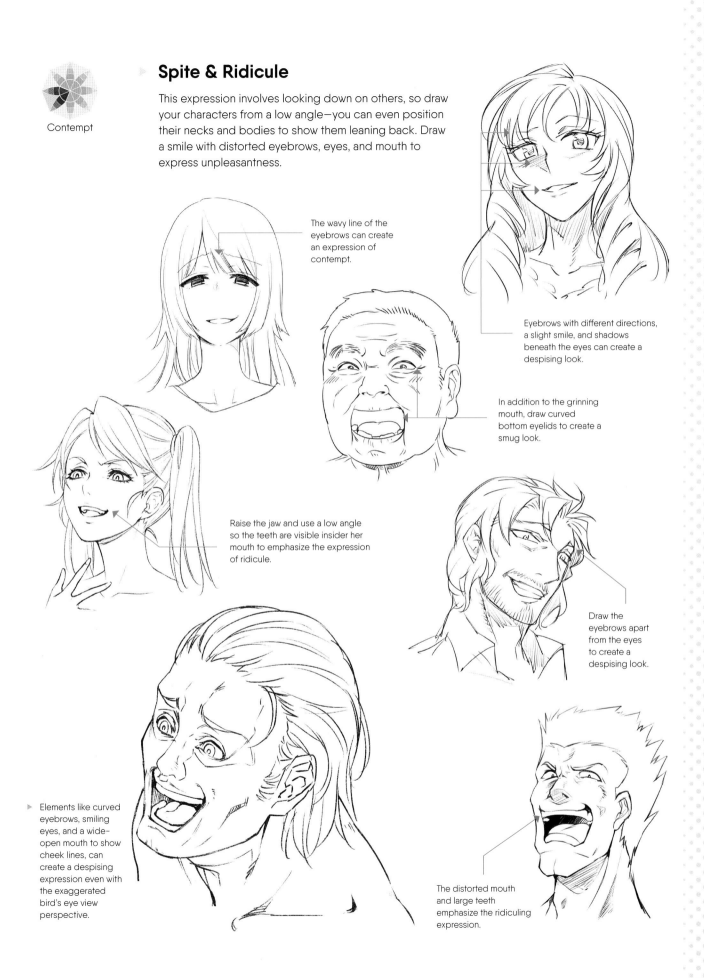

Spite & Ridicule

Contempt

This expression involves looking down on others, so draw your characters from a low angle—you can even position their necks and bodies to show them leaning back. Draw a smile with distorted eyebrows, eyes, and mouth to express unpleasantness.

The wavy line of the eyebrows can create an expression of contempt.

Eyebrows with different directions, a slight smile, and shadows beneath the eyes can create a despising look.

In addition to the grinning mouth, draw curved bottom eyelids to create a smug look.

Raise the jaw and use a low angle so the teeth are visible insider her mouth to emphasize the expression of ridicule.

Draw the eyebrows apart from the eyes to create a despising look.

▶ Elements like curved eyebrows, smiling eyes, and a wide-open mouth to show cheek lines, can create a despising expression even with the exaggerated bird's eye view perspective.

The distorted mouth and large teeth emphasize the ridiculing expression.

EVERYDAY LIFE & GESTURES

Our expressions are not only affected by our emotions, but also by physiological conditions, such as our health and surroundings. Here, we introduce involuntary expressions that occur as automatic reactions to physical stimuli, such as sleepiness or illness, or environmental factors, such as heat or cold.

Serenity

▶ ## Sleepy or Sleeping

When you are sleepy, the eyelids lower naturally to make the eyes close or squint. The mouth either weakly opens halfway or opens widely with a yawn.

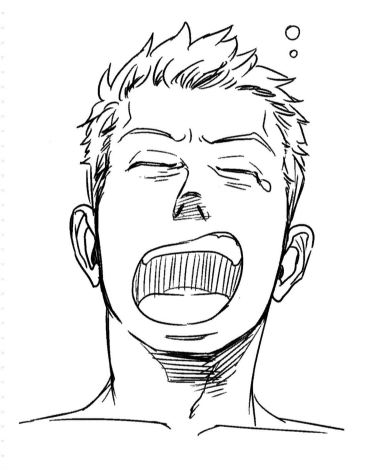

◀ A yawn is a reflexive action to improve the blood circulation by stretching the facial muscles, leaving a wide-open mouth. Tears flow from the corners of the closed eyes and wrinkles form between or under the eyes.

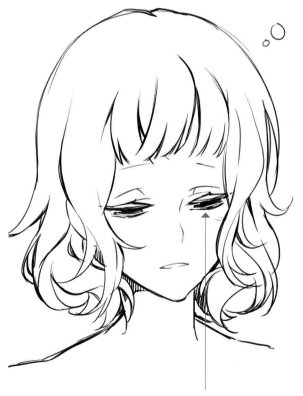

Large pupils create bleary eyes.

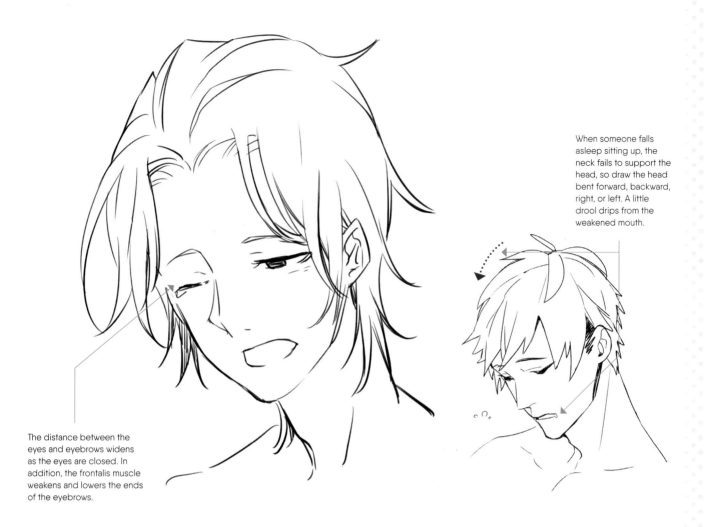

When someone falls asleep sitting up, the neck fails to support the head, so draw the head bent forward, backward, right, or left. A little drool drips from the weakened mouth.

The distance between the eyes and eyebrows widens as the eyes are closed. In addition, the frontalis muscle weakens and lowers the ends of the eyebrows.

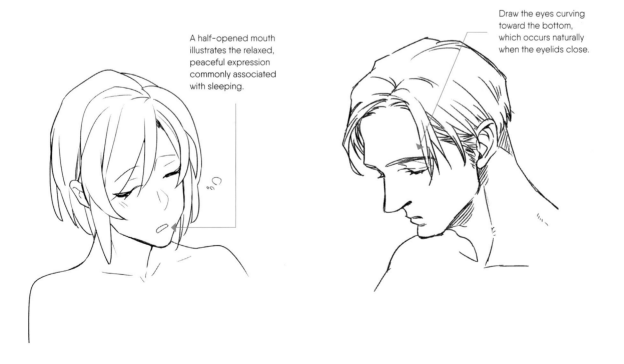

A half-opened mouth illustrates the relaxed, peaceful expression commonly associated with sleeping.

Draw the eyes curving toward the bottom, which occurs naturally when the eyelids close.

Serenity

Half Awake or Absentminded

Dull eyes and a half-opened mouth express exhaustion. Lower the ends of the eyes or eyebrows to capture the unfocused expression.

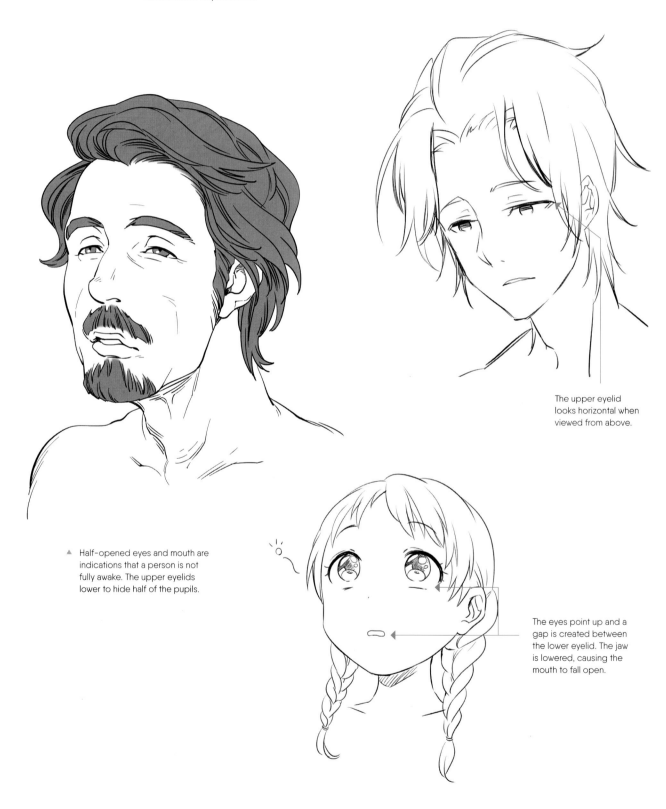

The upper eyelid looks horizontal when viewed from above.

▲ Half-opened eyes and mouth are indications that a person is not fully awake. The upper eyelids lower to hide half of the pupils.

The eyes point up and a gap is created between the lower eyelid. The jaw is lowered, causing the mouth to fall open.

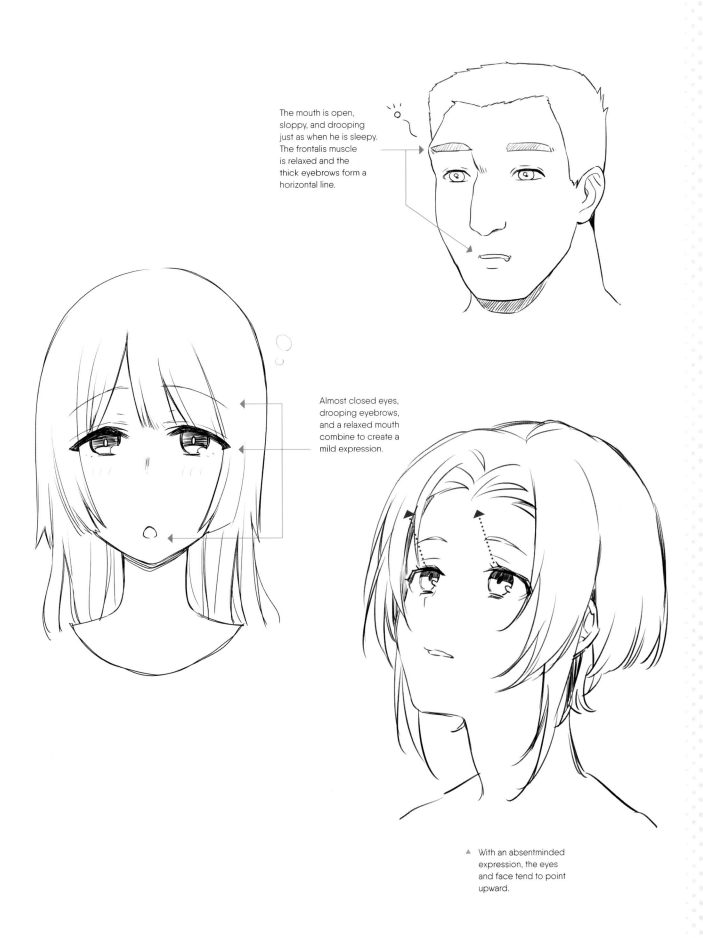

The mouth is open, sloppy, and drooping just as when he is sleepy. The frontalis muscle is relaxed and the thick eyebrows form a horizontal line.

Almost closed eyes, drooping eyebrows, and a relaxed mouth combine to create a mild expression.

▲ With an absentminded expression, the eyes and face tend to point upward.

Hot & Sweltering

Express discomfort by twisting the mouth, or create a stunned expression with lowered eye and mouth ends. Add details, such as drops of sweat running down the face.

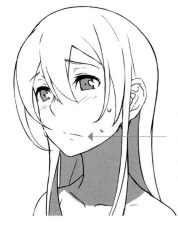

The uncomfortable heat creates an expression of dislike, lowering the ends of a closed mouth.

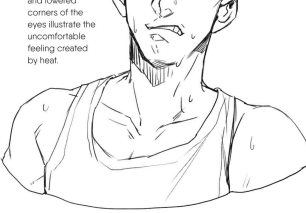

▶ Crooked eyebrows, a biting mouth, and lowered corners of the eyes illustrate the uncomfortable feeling created by heat.

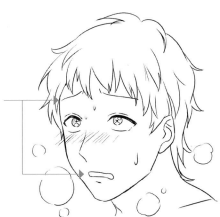

He is short of breath because of the heat. Draw inverted V-shaped eyebrows, a loosely opened mouth, and puffs of air around the head.

Suffocating heat makes breathing difficult, so the mouth is open wide. The eyebrows are distorted with pain and the eyes are closed.

Even if a character doesn't express discomfort openly, you can still show the effects of the heat with subtle details, such as disheveled hair.

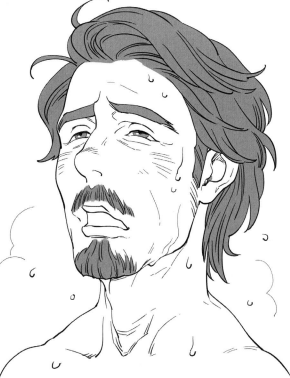

▶ Heat can make people lightheaded, causing their eyes to close and their mouth to hang open. Draw drops of sweat or puffs of steam coming out from the body to illustrate the intensity of the heat.

Cold & Freezing

The whole body becomes stiff when it is cold. The eyes and mouth close tightly, causing wrinkles. Also, the body and teeth shiver due to the cold.

Weary

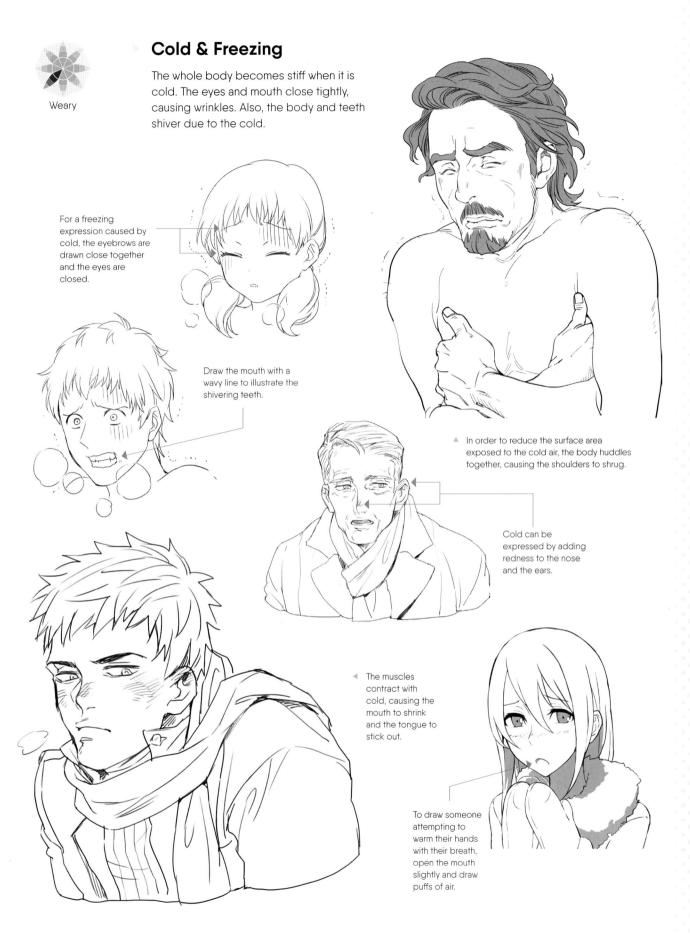

For a freezing expression caused by cold, the eyebrows are drawn close together and the eyes are closed.

Draw the mouth with a wavy line to illustrate the shivering teeth.

In order to reduce the surface area exposed to the cold air, the body huddles together, causing the shoulders to shrug.

Cold can be expressed by adding redness to the nose and the ears.

The muscles contract with cold, causing the mouth to shrink and the tongue to stick out.

To draw someone attempting to warm their hands with their breath, open the mouth slightly and draw puffs of air.

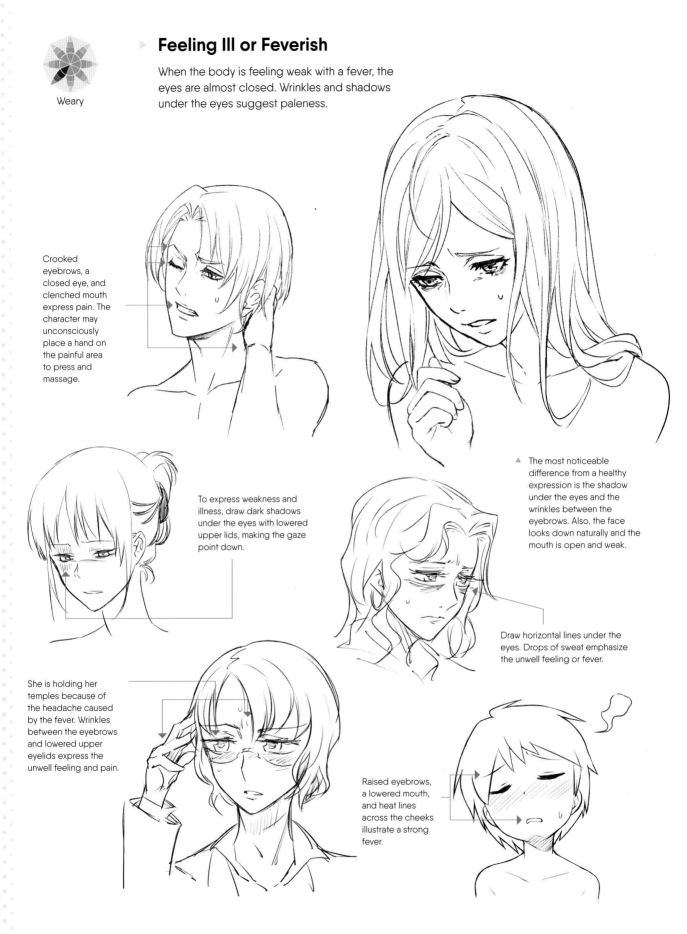

Feeling Ill or Feverish

When the body is feeling weak with a fever, the eyes are almost closed. Wrinkles and shadows under the eyes suggest paleness.

Weary

Crooked eyebrows, a closed eye, and clenched mouth express pain. The character may unconsciously place a hand on the painful area to press and massage.

To express weakness and illness, draw dark shadows under the eyes with lowered upper lids, making the gaze point down.

The most noticeable difference from a healthy expression is the shadow under the eyes and the wrinkles between the eyebrows. Also, the face looks down naturally and the mouth is open and weak.

Draw horizontal lines under the eyes. Drops of sweat emphasize the unwell feeling or fever.

She is holding her temples because of the headache caused by the fever. Wrinkles between the eyebrows and lowered upper eyelids express the unwell feeling and pain.

Raised eyebrows, a lowered mouth, and heat lines across the cheeks illustrate a strong fever.

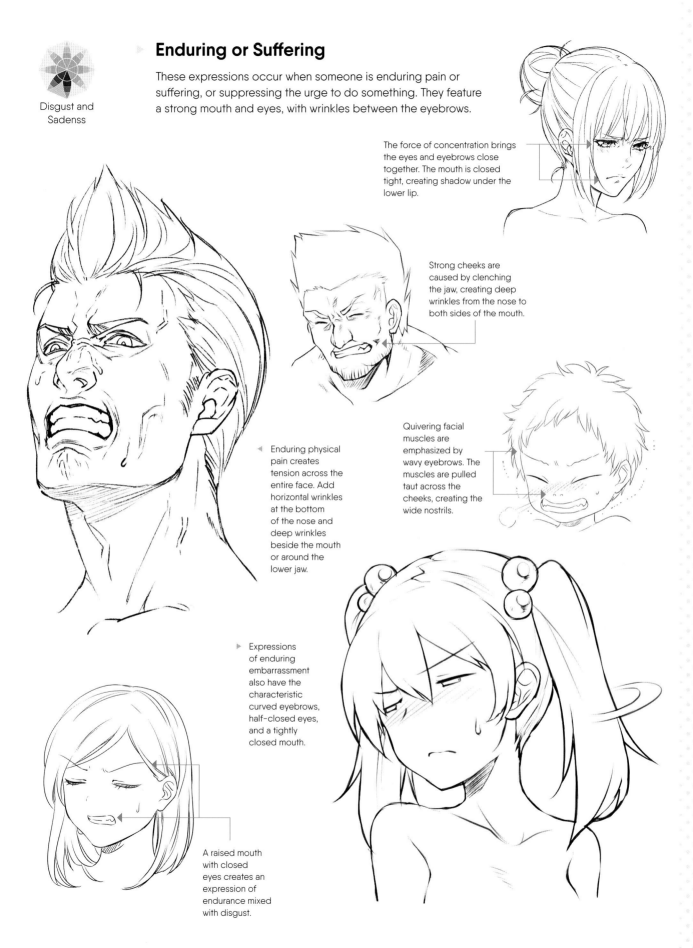

Enduring or Suffering

These expressions occur when someone is enduring pain or suffering, or suppressing the urge to do something. They feature a strong mouth and eyes, with wrinkles between the eyebrows.

The force of concentration brings the eyes and eyebrows close together. The mouth is closed tight, creating shadow under the lower lip.

Strong cheeks are caused by clenching the jaw, creating deep wrinkles from the nose to both sides of the mouth.

Quivering facial muscles are emphasized by wavy eyebrows. The muscles are pulled taut across the cheeks, creating the wide nostrils.

Enduring physical pain creates tension across the entire face. Add horizontal wrinkles at the bottom of the nose and deep wrinkles beside the mouth or around the lower jaw.

Expressions of enduring embarrassment also have the characteristic curved eyebrows, half-closed eyes, and a tightly closed mouth.

A raised mouth with closed eyes creates an expression of endurance mixed with disgust.

EATING

Expressions while eating can vary depending on the food, the way of eating, taste differences, and likes and dislikes. The way someone eats is closely associated with their personality, so understand the focal points in order to change the expressions.

Optimism

▷ **Biting**

Biting into food creates an expression with a wide-open mouth and visible teeth. The expression tends to be bright because of the anticipation for the food.

The teeth are visible when trying to bite off the food. Puffed cheeks indicate that there is food in her mouth.

◁ Biting into hot food causes the face to redden due to the heat. Try closing one eye to show that she is enjoying the food.

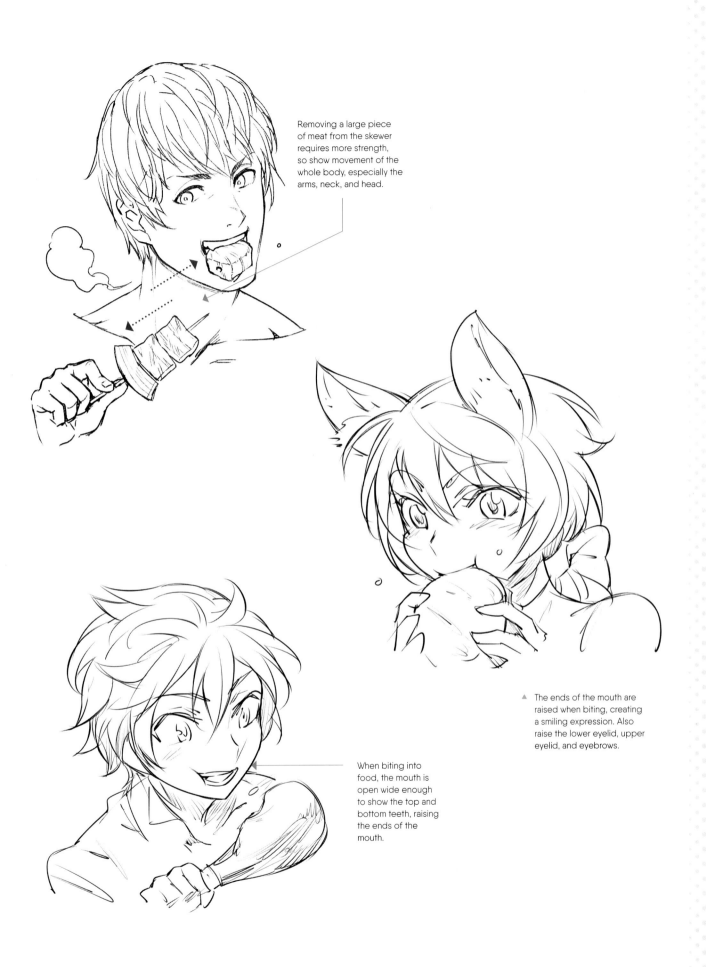

Removing a large piece of meat from the skewer requires more strength, so show movement of the whole body, especially the arms, neck, and head.

The ends of the mouth are raised when biting, creating a smiling expression. Also raise the lower eyelid, upper eyelid, and eyebrows.

When biting into food, the mouth is open wide enough to show the top and bottom teeth, raising the ends of the mouth.

▶ Absorbed in Eating

When we are hungry or the food is delicious, we become absorbed in eating. We look at the food with a focused gaze and stuff it in our mouth.

Optimism

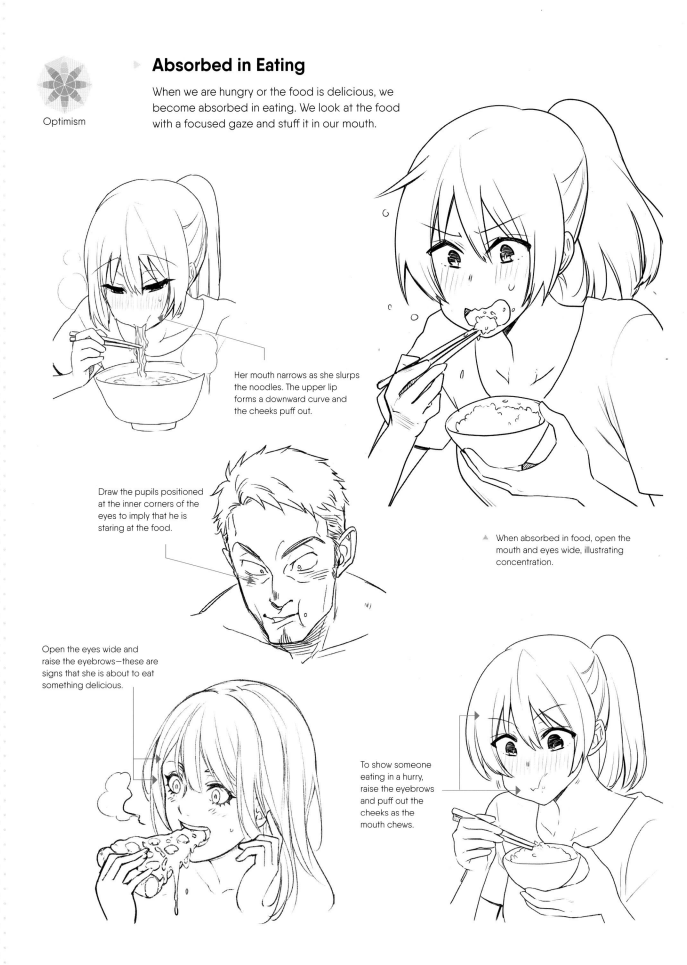

Her mouth narrows as she slurps the noodles. The upper lip forms a downward curve and the cheeks puff out.

Draw the pupils positioned at the inner corners of the eyes to imply that he is staring at the food.

▲ When absorbed in food, open the mouth and eyes wide, illustrating concentration.

Open the eyes wide and raise the eyebrows—these are signs that she is about to eat something delicious.

To show someone eating in a hurry, raise the eyebrows and puff out the cheeks as the mouth chews.

Eating Delicious Food

Smiling, content expressions naturally occur when we eat something tasty. Puff out the cheeks and close the eyes to convey the pleasure of tasting delicious food.

Optimism

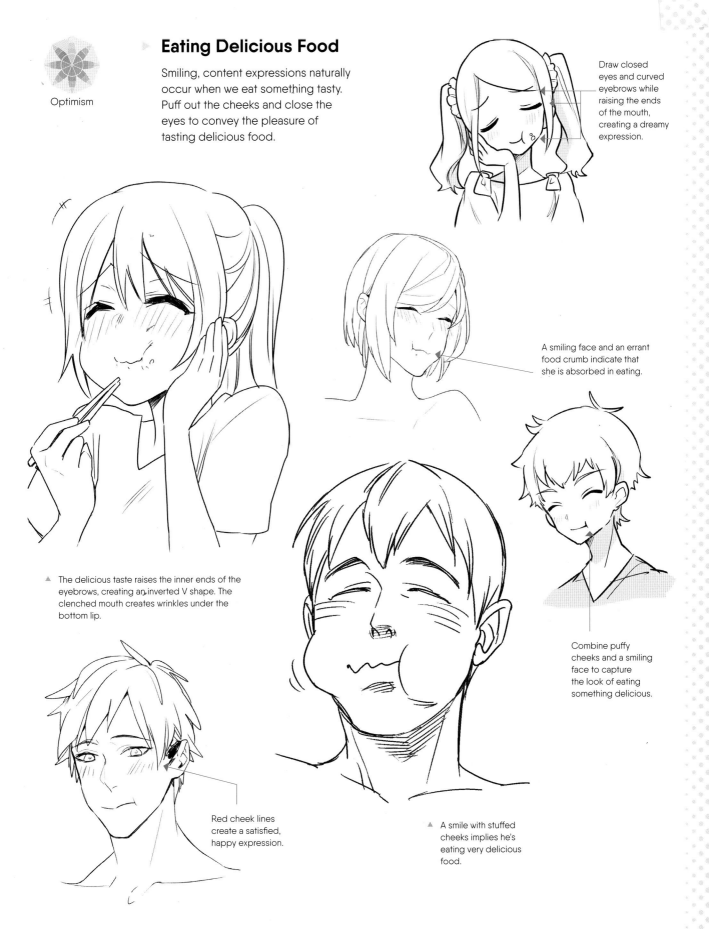

Draw closed eyes and curved eyebrows while raising the ends of the mouth, creating a dreamy expression.

A smiling face and an errant food crumb indicate that she is absorbed in eating.

▲ The delicious taste raises the inner ends of the eyebrows, creating an inverted V shape. The clenched mouth creates wrinkles under the bottom lip.

Combine puffy cheeks and a smiling face to capture the look of eating something delicious.

Red cheek lines create a satisfied, happy expression.

▲ A smile with stuffed cheeks implies he's eating very delicious food.

Remorse

Surprising Taste

Tasting something that is different than what you expect can be a surprise. For example, sour, bitter, or spicy tastes can come as a surprise and cause a knee-jerk reaction.

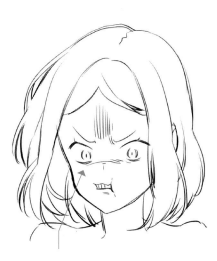

Raised eyebrows and wide-open eyes indicate surprise. Wrinkles form between the eyebrows in reaction to the shocking taste.

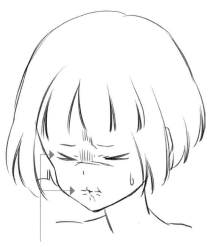

▲ The wavy line of the shoulder, different size of the eyes, and distorted mouth indicate that he's experienced an abnormal taste while eating.

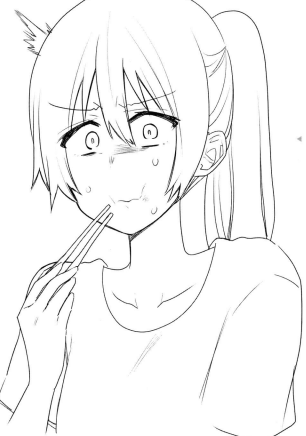

◄ Effect lines drawn around the head, distorted eyebrows and mouth, and small eyes show that she received a surprise.

Eating sour food causes the facial muscles to tense and creates vertical lines between the eyebrows, wrinkles in a spiral around the mouth, and closed eyes.

Remorse

Disgusting Taste

When eating something you don't like or something that's not tasty, the reaction is similar to disgust. This can be conveyed by frowning or sticking the tongue out.

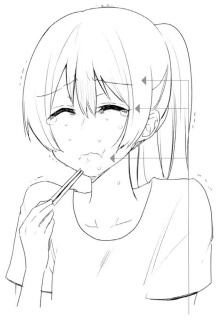

This expression shows enduring the pain with tears in the eyes, sweat on the face, wavy, inverted V-shaped eyebrows and mouth. Clearly, she ate something not tasty.

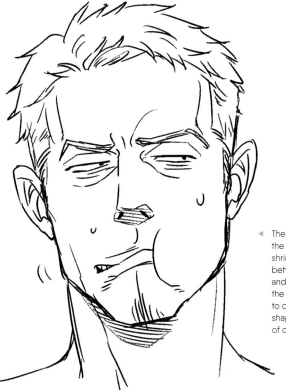

◁ The muscles around the eyebrows and eyes shrink, creating wrinkles between the eyebrows and narrow eyes. Also, the bottom lip is raised to create the same mouth shape as an expression of dislike.

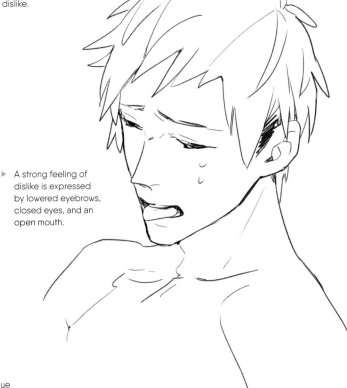

▷ A strong feeling of dislike is expressed by lowered eyebrows, closed eyes, and an open mouth.

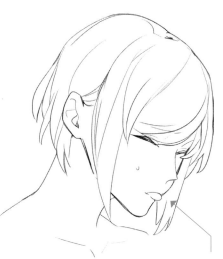

To show disgust and rejection, a character may stick out their tongue and look like they may vomit.

Optimism

▷ Intoxicated

Drinking alcohol creates a red face and loosens the muscles, resulting in relaxed facial expressions. People react differently to alcohol—a character may laugh, cry, or become angry. No matter what the emotion, it is more exaggerated than under normal circumstances.

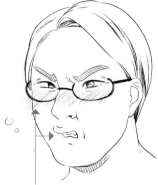

A bright red face indicates intoxication, while the curled lip and raised eyebrows imply that he's angry.

▷ A flushed face and raised bottom eyelids indicate that she's enjoying the effects of alcohol. Her eyes are sparkling and she's smiling as if her inhibitions are lowered.

Being drunk and feeling happy loosens the muscles of the face to make the eyebrows in the shape of an inverted V. The line of the mouth is also wavy.

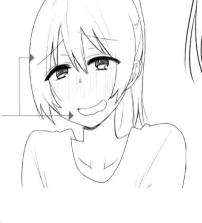

When drunk, cheerful laughter often happens with the eyes closed.

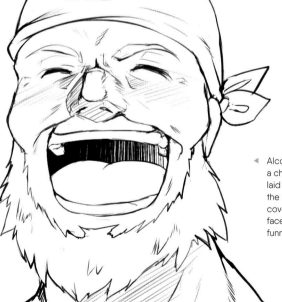

◁ Alcohol can make a character more laid back. Open the mouth wide to cover half of the face, and create funny, big laughs.

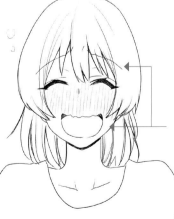

Draw inverted V-shaped eyebrows and a wavy upper lip to capture the feeling of being "happy without reason" when drunk.

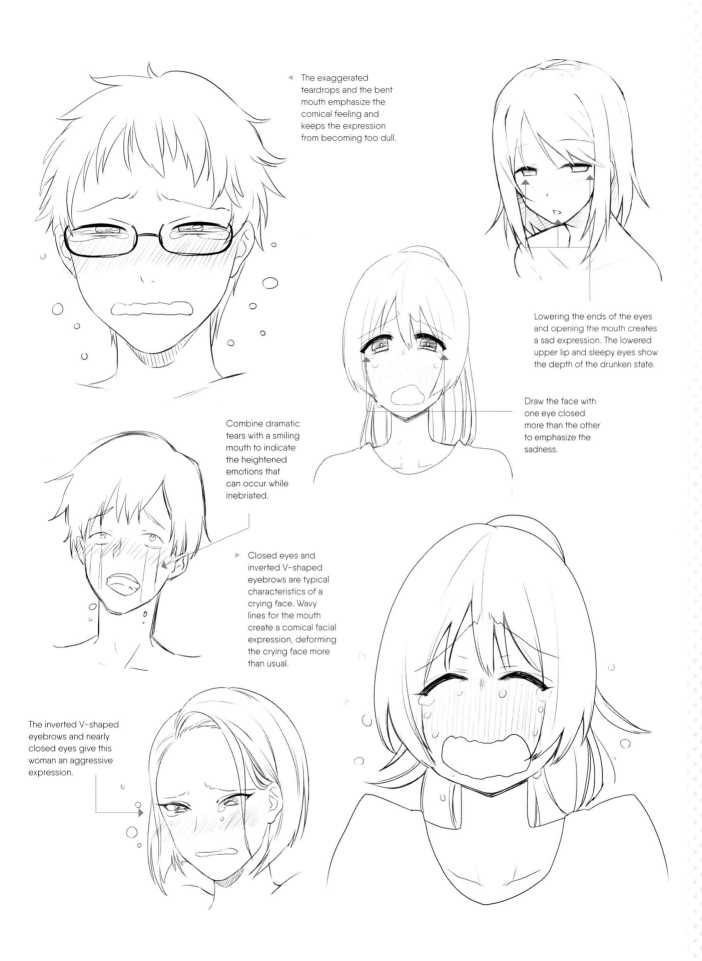

The exaggerated teardrops and the bent mouth emphasize the comical feeling and keeps the expression from becoming too dull.

Lowering the ends of the eyes and opening the mouth creates a sad expression. The lowered upper lip and sleepy eyes show the depth of the drunken state.

Draw the face with one eye closed more than the other to emphasize the sadness.

Combine dramatic tears with a smiling mouth to indicate the heightened emotions that can occur while inebriated.

Closed eyes and inverted V-shaped eyebrows are typical characteristics of a crying face. Wavy lines for the mouth create a comical facial expression, deforming the crying face more than usual.

The inverted V-shaped eyebrows and nearly closed eyes give this woman an aggressive expression.

Lesson 04

FIGHTING

Battle scenes appear often in manga and anime. We rarely encounter these situations in real life, so it helps to practice drawing these expressions and actions.

Aggressiveness

▷ ## Screaming & Shouting

A character may scream at an opponent or shout encouragement at allies. Either way, the expression will feature a wide-open mouth and pupils intently fixed on the target.

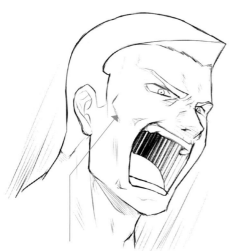

When opening the mouth wide, joints at the jaw are elevated.

When viewed from below, the lower teeth and the tongue are visible.

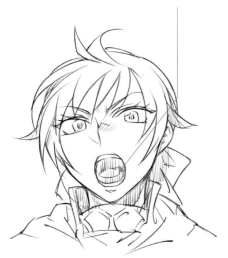

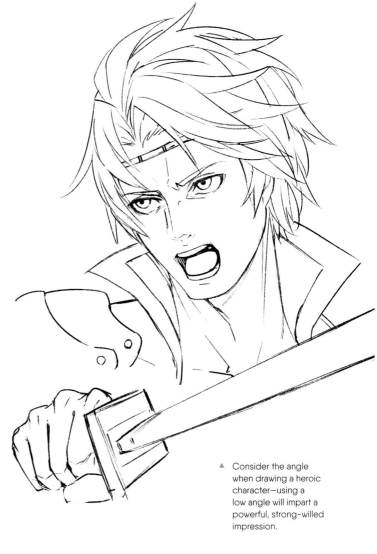

▲ Consider the angle when drawing a heroic character—using a low angle will impart a powerful, strong-willed impression.

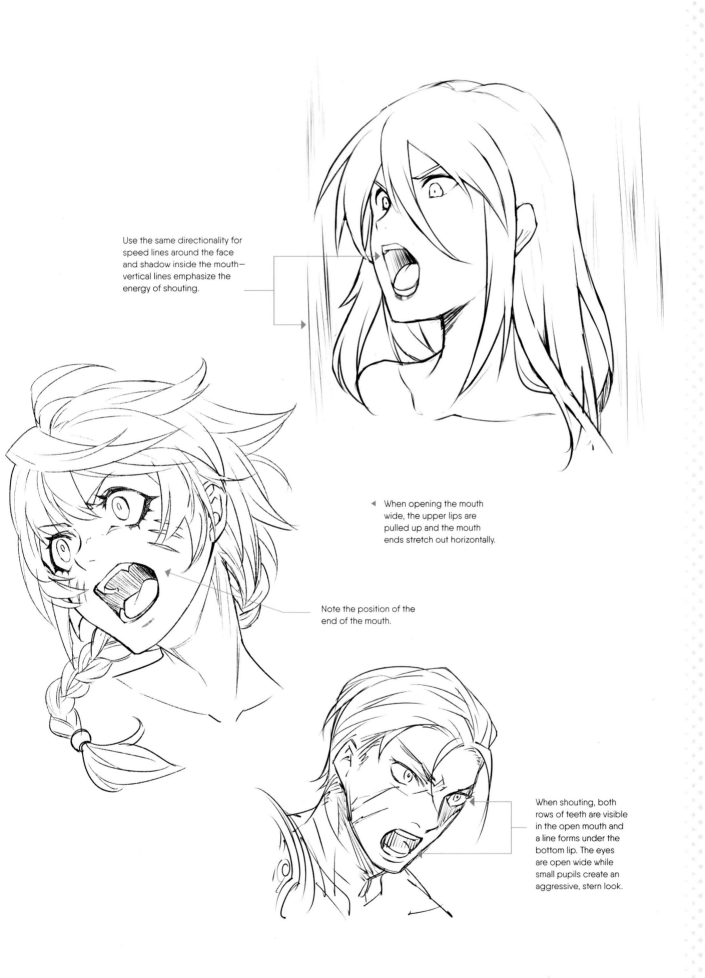

Use the same directionality for speed lines around the face and shadow inside the mouth— vertical lines emphasize the energy of shouting.

◀ When opening the mouth wide, the upper lips are pulled up and the mouth ends stretch out horizontally.

Note the position of the end of the mouth.

When shouting, both rows of teeth are visible in the open mouth and a line forms under the bottom lip. The eyes are open wide while small pupils create an aggressive, stern look.

Casting a Spell

A magical character may harness inner power or call upon the power of nature. The expression will vary depending on the spell or pose, or if a tool is required to summon the power.

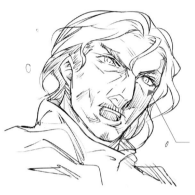

▶ Illustrate the hair being blown back by the magic energy. Then show her shouting with a serious look.

Because he is concentrating, he is looking at the object straight ahead with a serious facial expression.

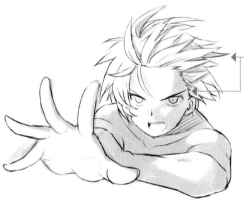

The inner ends of the eyebrows are lowered with the concentration required to release magic, and the expression becomes aggressive, close to shouting. Also, the power is expressed by the shadow of the body and the windblown hair.

In contrast to the calmly closed eyes, the gap between the raised eyebrows and the windblown hair hint at the power this petite girl can bring about.

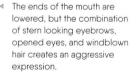

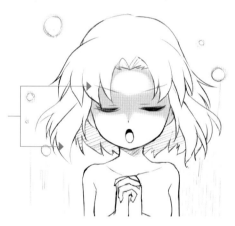

◀ The ends of the mouth are lowered, but the combination of stern looking eyebrows, opened eyes, and windblown hair creates an aggressive expression.

Magic energy is illustrated by orbs of floating light surrounding her. Shadows appear under the eyes as light reflects from the ground.

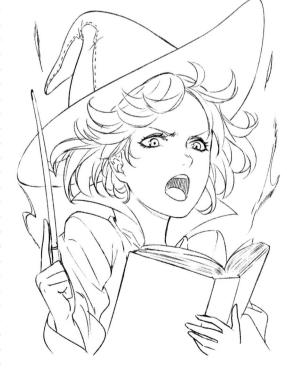

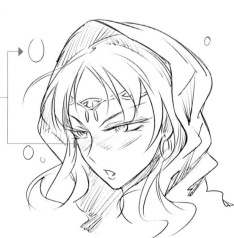

Being Attacked

The face is distorted by pain and shock when hurt. An opened mouth or closed eyes can express the power of the attack.

Remorse

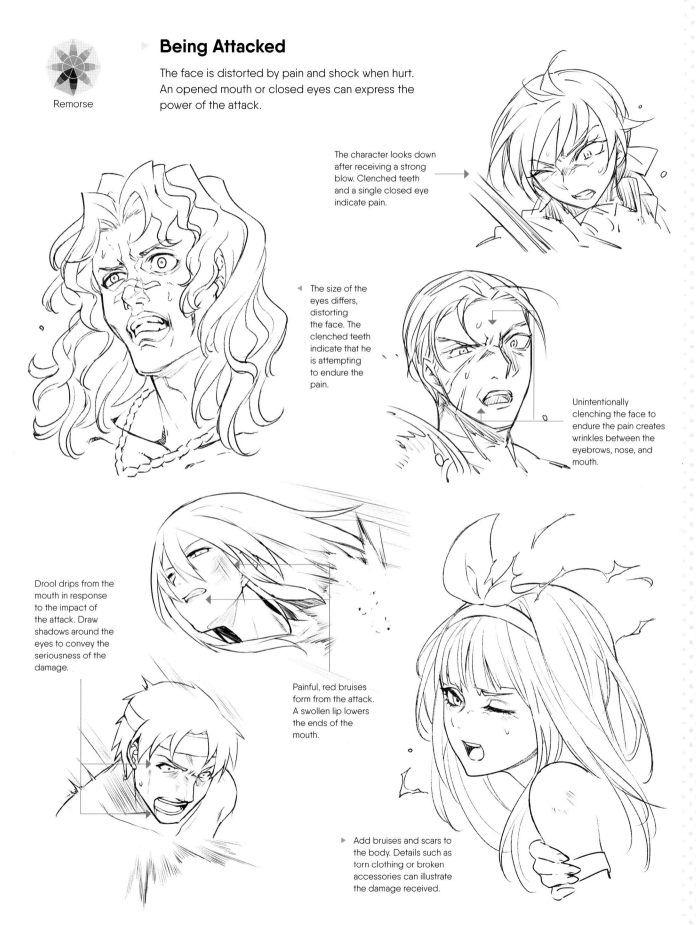

The character looks down after receiving a strong blow. Clenched teeth and a single closed eye indicate pain.

◄ The size of the eyes differs, distorting the face. The clenched teeth indicate that he is attempting to endure the pain.

Unintentionally clenching the face to endure the pain creates wrinkles between the eyebrows, nose, and mouth.

Drool drips from the mouth in response to the impact of the attack. Draw shadows around the eyes to convey the seriousness of the damage.

Painful, red bruises form from the attack. A swollen lip lowers the ends of the mouth.

▶ Add bruises and scars to the body. Details such as torn clothing or broken accessories can illustrate the damage received.

Remorse

Fainting & Collapsing

This expression shows a character unable to battle. The limbs and muscles become loose when someone faints. When conscious, the face may become distorted because of the pain.

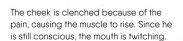

▶ Different from a sleeping state, the painful expression becomes obvious with the inverted V-shaped eyebrows and closed eyes. Also, tilt the head either right or left.

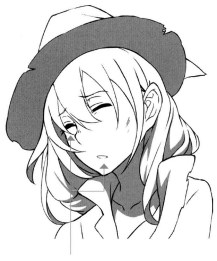

The eyes display a painful expression but the mouth is loose and open slightly.

The cheek is clenched because of the pain, causing the muscle to rise. Since he is still conscious, the mouth is twitching.

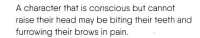

▶ Completely white eyes are a common way to represent that a character has fainted. All the muscles have loosened and the neck is tilted.

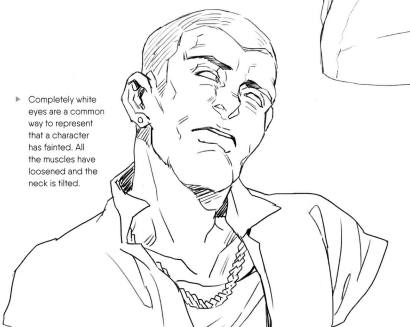

A character that is conscious but cannot raise their head may be biting their teeth and furrowing their brows in pain.

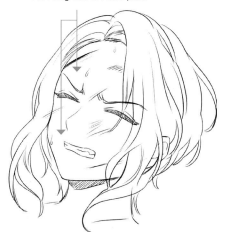

CHAPTER 4
ADDING DETAILS

TYPES OF HAIRSTYLES

Hair is an essential element of drawing manga characters. In this chapter, we'll cover basic hairstyle types, how to draw them, and other characteristics, such as motion and color. First, let's discuss the three general hairstyle types.

▶ **Man**

Short

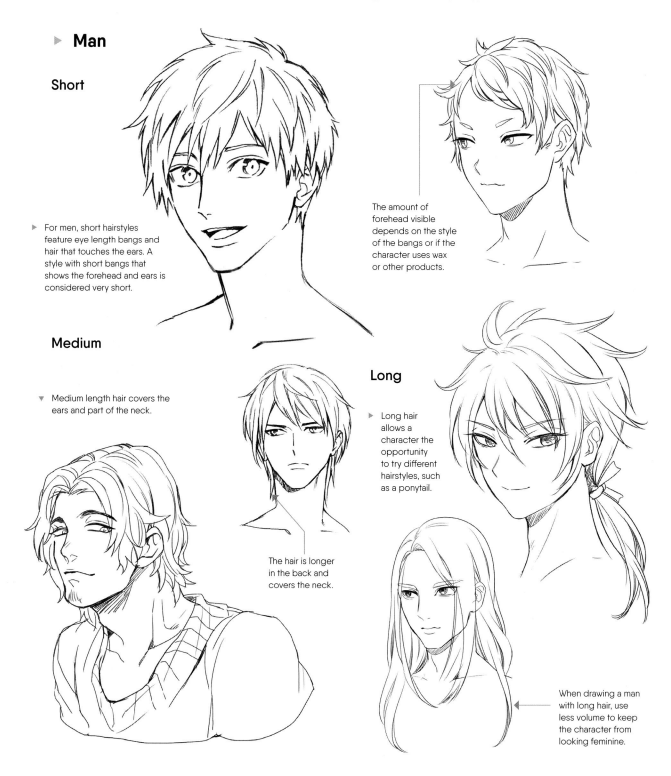

▶ For men, short hairstyles feature eye length bangs and hair that touches the ears. A style with short bangs that shows the forehead and ears is considered very short.

The amount of forehead visible depends on the style of the bangs or if the character uses wax or other products.

Medium

▼ Medium length hair covers the ears and part of the neck.

Long

▶ Long hair allows a character the opportunity to try different hairstyles, such as a ponytail.

The hair is longer in the back and covers the neck.

When drawing a man with long hair, use less volume to keep the character from looking feminine.

Woman

Short

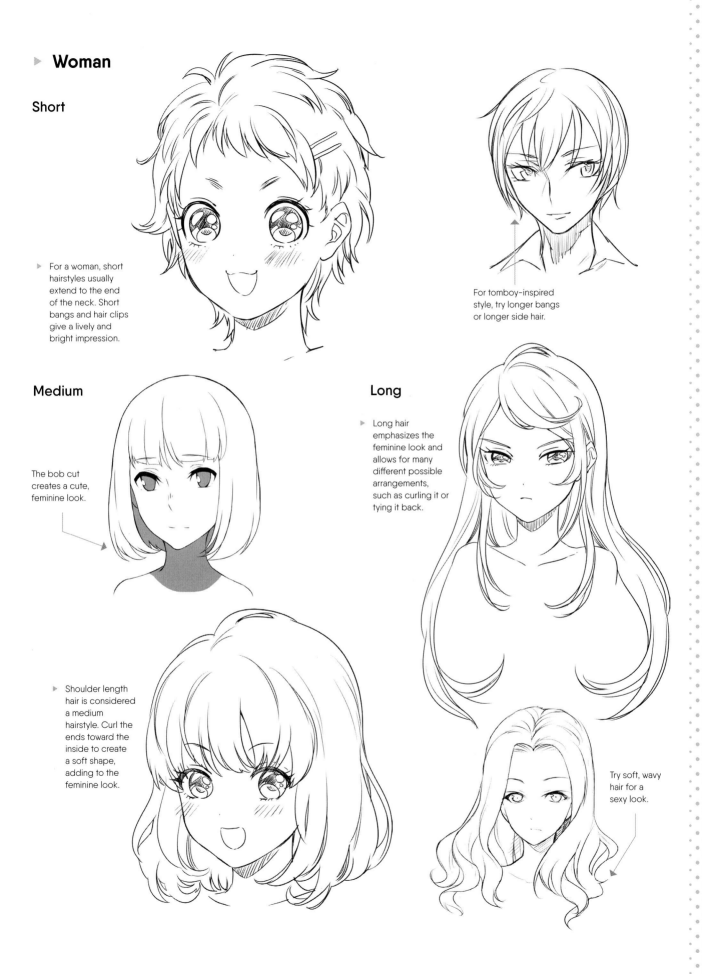

▶ For a woman, short hairstyles usually extend to the end of the neck. Short bangs and hair clips give a lively and bright impression.

For tomboy-inspired style, try longer bangs or longer side hair.

Medium

The bob cut creates a cute, feminine look.

Long

▶ Long hair emphasizes the feminine look and allows for many different possible arrangements, such as curling it or tying it back.

▶ Shoulder length hair is considered a medium hairstyle. Curl the ends toward the inside to create a soft shape, adding to the feminine look.

Try soft, wavy hair for a sexy look.

HOW TO DRAW HAIR

After drawing the facial features, you'll need to add some hair. In this section, we'll explain how to draw a balanced hairstyle for both simple and complicated looks.

▶ Man: Medium

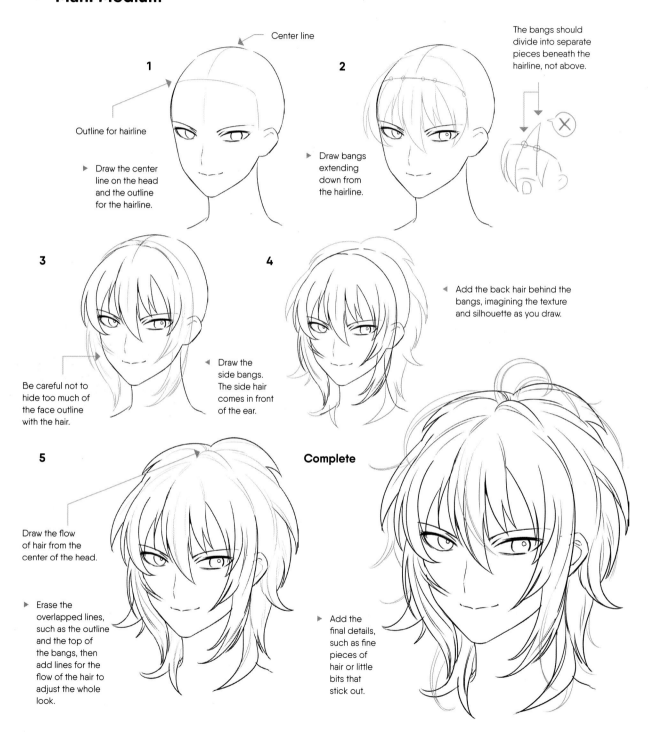

1

Center line

Outline for hairline

▶ Draw the center line on the head and the outline for the hairline.

2

Draw bangs extending down from the hairline.

The bangs should divide into separate pieces beneath the hairline, not above.

3

Be careful not to hide too much of the face outline with the hair.

4

Draw the side bangs. The side hair comes in front of the ear.

◀ Add the back hair behind the bangs, imagining the texture and silhouette as you draw.

5

Draw the flow of hair from the center of the head.

▶ Erase the overlapped lines, such as the outline and the top of the bangs, then add lines for the flow of the hair to adjust the whole look.

Complete

▶ Add the final details, such as fine pieces of hair or little bits that stick out.

Man: Short

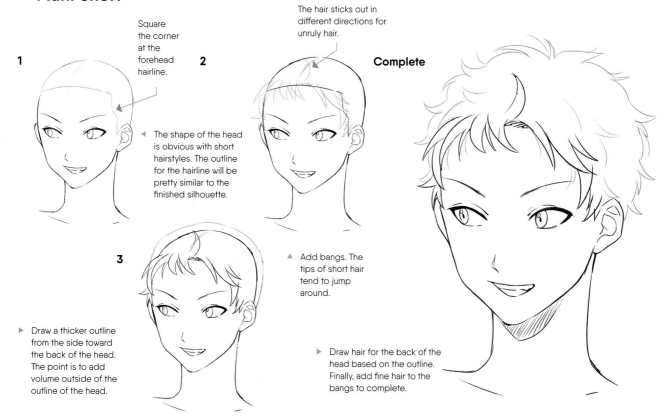

1 Square the corner at the forehead hairline.

◄ The shape of the head is obvious with short hairstyles. The outline for the hairline will be pretty similar to the finished silhouette.

2 The hair sticks out in different directions for unruly hair.

▲ Add bangs. The tips of short hair tend to jump around.

Complete

3

▶ Draw a thicker outline from the side toward the back of the head. The point is to add volume outside of the outline of the head.

▶ Draw hair for the back of the head based on the outline. Finally, add fine hair to the bangs to complete.

Man: Two-Block Haircut

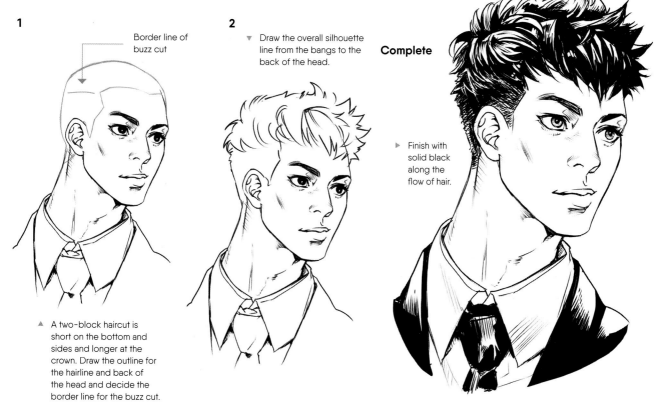

1 Border line of buzz cut

▲ A two-block haircut is short on the bottom and sides and longer at the crown. Draw the outline for the hairline and back of the head and decide the border line for the buzz cut.

2 ▼ Draw the overall silhouette line from the bangs to the back of the head.

Complete

▶ Finish with solid black along the flow of hair.

▸ Woman: Long

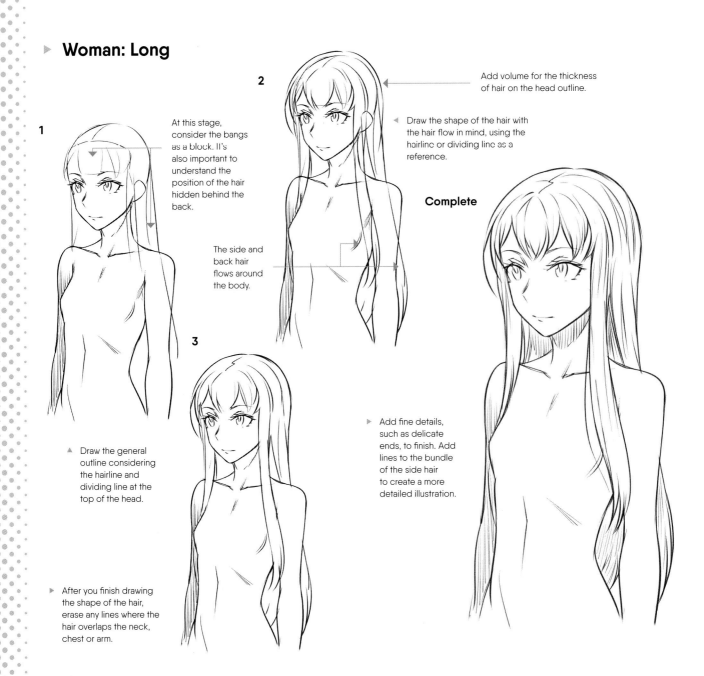

1

At this stage, consider the bangs as a block. It's also important to understand the position of the hair hidden behind the back.

▲ Draw the general outline considering the hairline and dividing line at the top of the head.

▸ After you finish drawing the shape of the hair, erase any lines where the hair overlaps the neck, chest or arm.

2

Add volume for the thickness of hair on the head outline.

◂ Draw the shape of the hair with the hair flow in mind, using the hairline or dividing line as a reference.

The side and back hair flows around the body.

3

▸ Add fine details, such as delicate ends, to finish. Add lines to the bundle of the side hair to create a more detailed illustration.

Complete

Illustration of Hair Strands

Block It Out

Think of the sections of hair as blocks and draw thick outlines. This shape can be used as a general guide.

Divide Into Strands

Add lines along the hair flow to represent individual strands of hair. Divide the ends into smaller sections.

▶ Woman: Pigtails

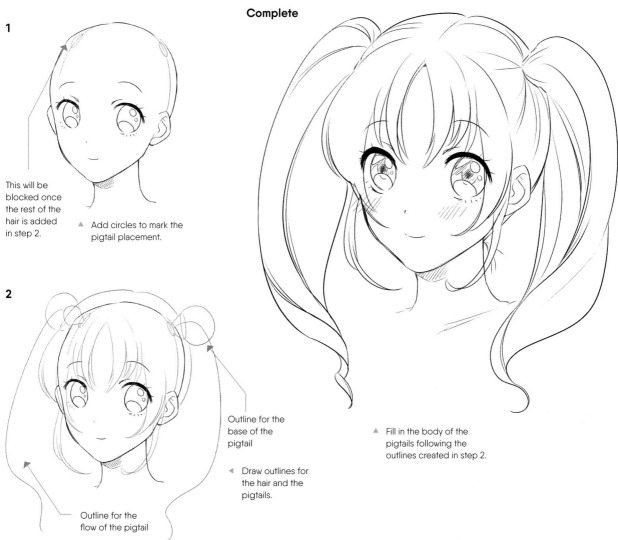

1

This will be blocked once the rest of the hair is added in step 2.

▲ Add circles to mark the pigtail placement.

Complete

▲ Fill in the body of the pigtails following the outlines created in step 2.

2

Outline for the base of the pigtail

◀ Draw outlines for the hair and the pigtails.

Outline for the flow of the pigtail

Pigtail Examples

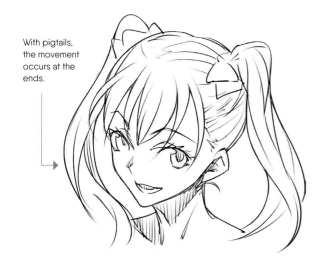

With pigtails, the movement occurs at the ends.

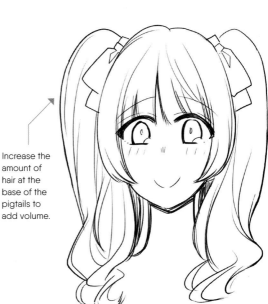

Increase the amount of hair at the base of the pigtails to add volume.

Woman: Curly Hair

1

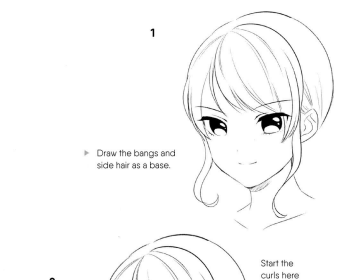

▶ Draw the bangs and side hair as a base.

Start the curls here

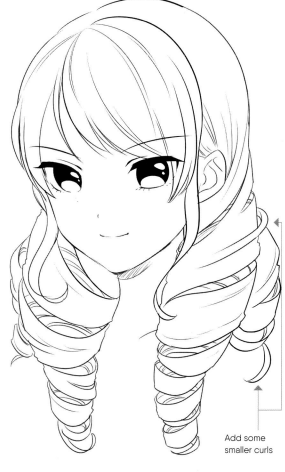

2

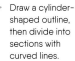
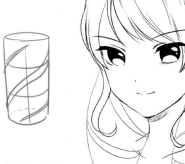

▶ Draw a cylinder-shaped outline, then divide into sections with curved lines.

Add some smaller curls

Curly Hair Examples

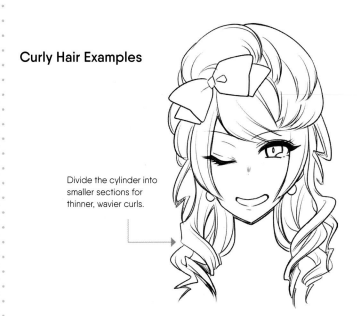

Divide the cylinder into smaller sections for thinner, wavier curls.

Draw smaller, thinner cylinders for more traditional curls.

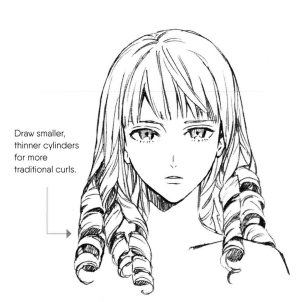

▶ Woman: Braids

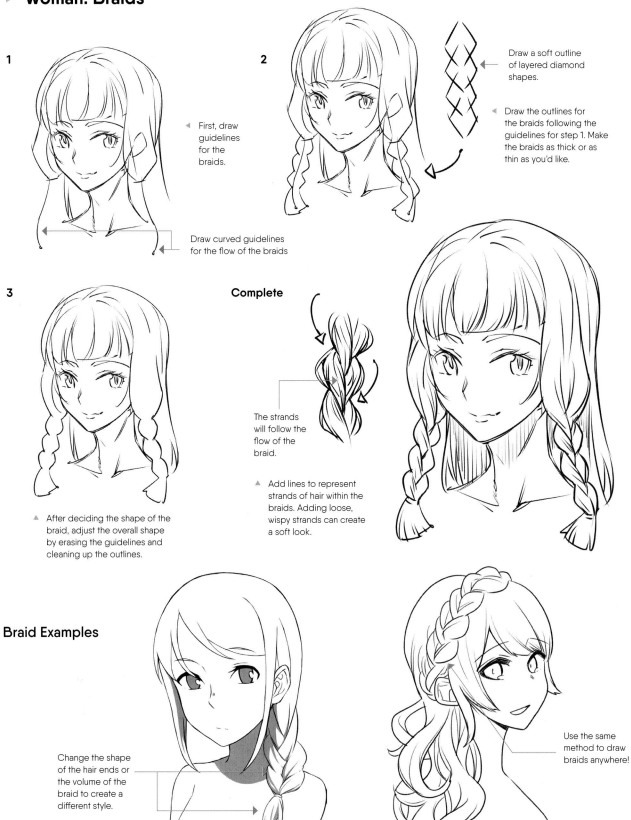

1

◀ First, draw guidelines for the braids.

Draw curved guidelines for the flow of the braids →

2

Draw a soft outline of layered diamond shapes. ◀

◀ Draw the outlines for the braids following the guidelines for step 1. Make the braids as thick or as thin as you'd like.

3

▲ After deciding the shape of the braid, adjust the overall shape by erasing the guidelines and cleaning up the outlines.

Complete

The strands will follow the flow of the braid.

▲ Add lines to represent strands of hair within the braids. Adding loose, wispy strands can create a soft look.

Braid Examples

Change the shape of the hair ends or the volume of the braid to create a different style.

Use the same method to draw braids anywhere!

MALE HAIRSTYLE VARIATIONS

In this section, we'll explore variations of the basic men's hairstyles introduced on page 136. Categorized by length, these variations include both realistic hairstyles, as well as special hairstyles unique to manga.

Short

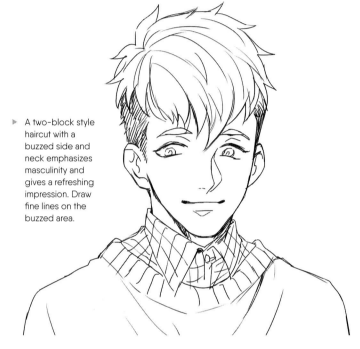

▶ A two-block style haircut with a buzzed side and neck emphasizes masculinity and gives a refreshing impression. Draw fine lines on the buzzed area.

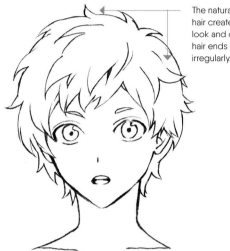

The natural curl of his hair creates a shaggy look and causes the hair ends to stick out irregularly.

To create a manageable, short style, draw hair extending from the whorl and continuing along the shape of the head.

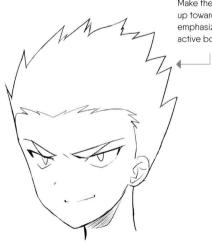

Make the hair stand up toward the back to emphasize the image of an active boy.

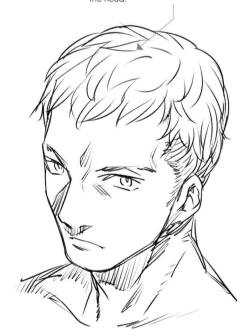

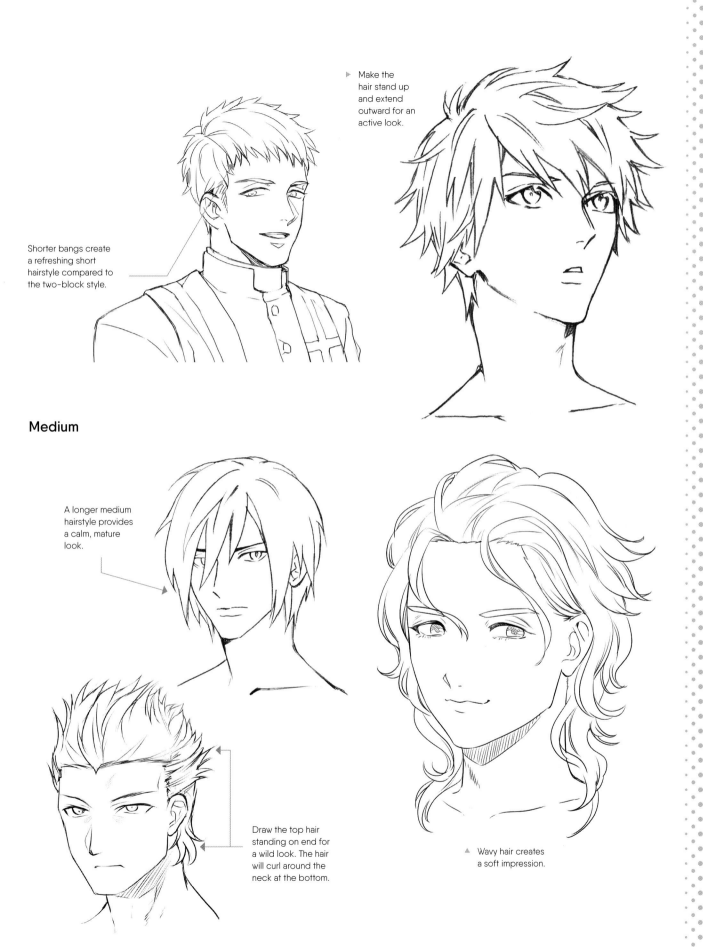

► Make the hair stand up and extend outward for an active look.

Shorter bangs create a refreshing short hairstyle compared to the two-block style.

Medium

A longer medium hairstyle provides a calm, mature look.

Draw the top hair standing on end for a wild look. The hair will curl around the neck at the bottom.

▲ Wavy hair creates a soft impression.

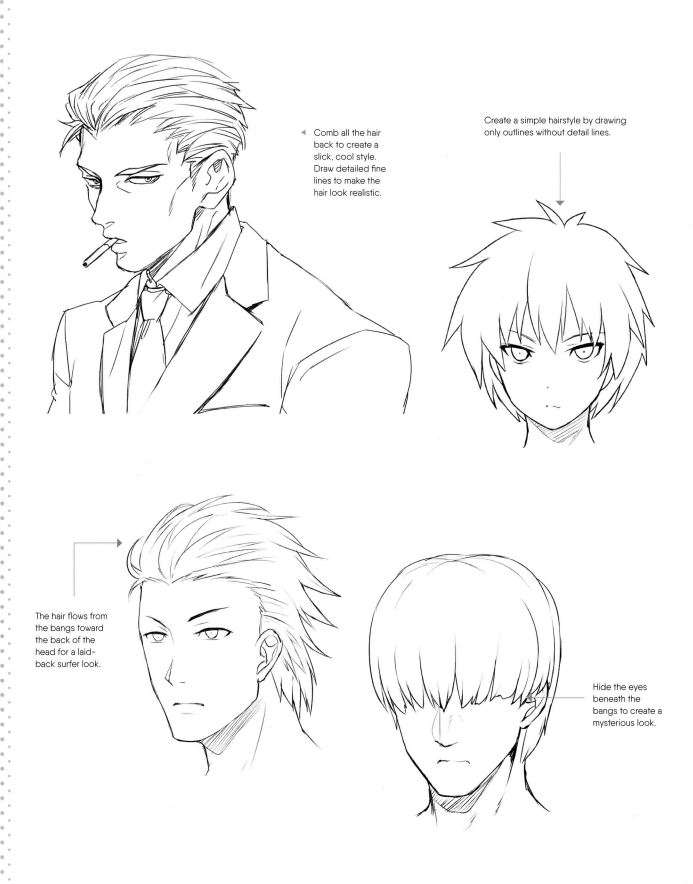

Comb all the hair back to create a slick, cool style. Draw detailed fine lines to make the hair look realistic.

Create a simple hairstyle by drawing only outlines without detail lines.

The hair flows from the bangs toward the back of the head for a laid-back surfer look.

Hide the eyes beneath the bangs to create a mysterious look.

Long

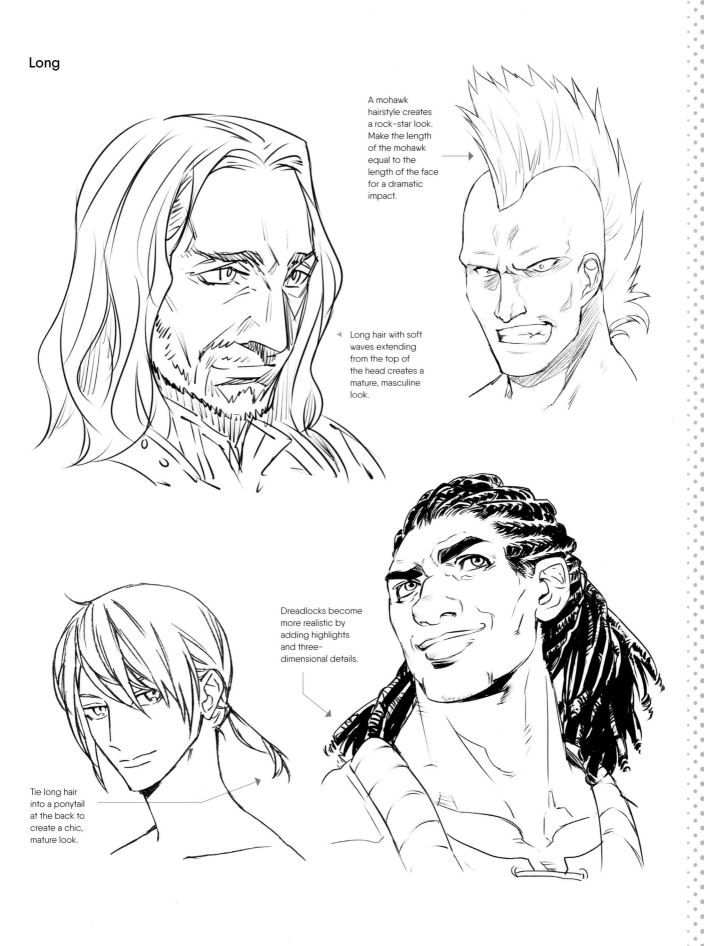

A mohawk hairstyle creates a rock-star look. Make the length of the mohawk equal to the length of the face for a dramatic impact.

Long hair with soft waves extending from the top of the head creates a mature, masculine look.

Dreadlocks become more realistic by adding highlights and three-dimensional details.

Tie long hair into a ponytail at the back to create a chic, mature look.

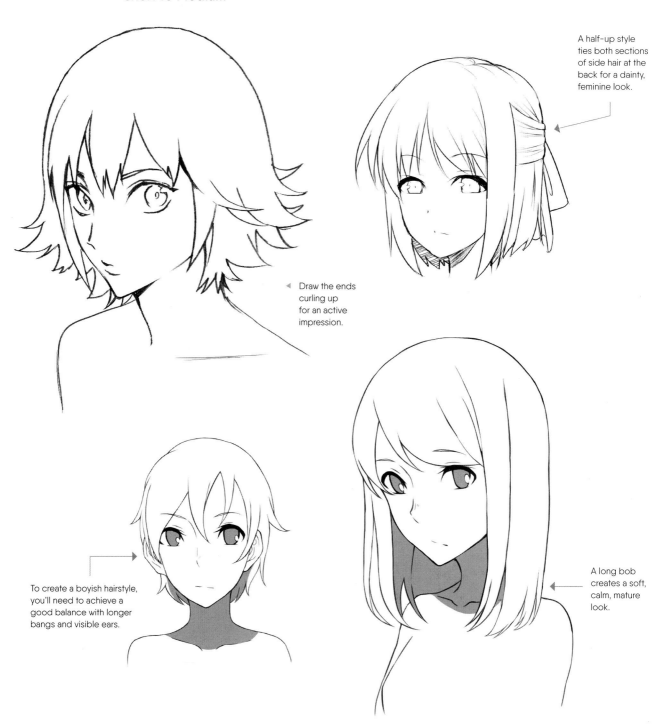

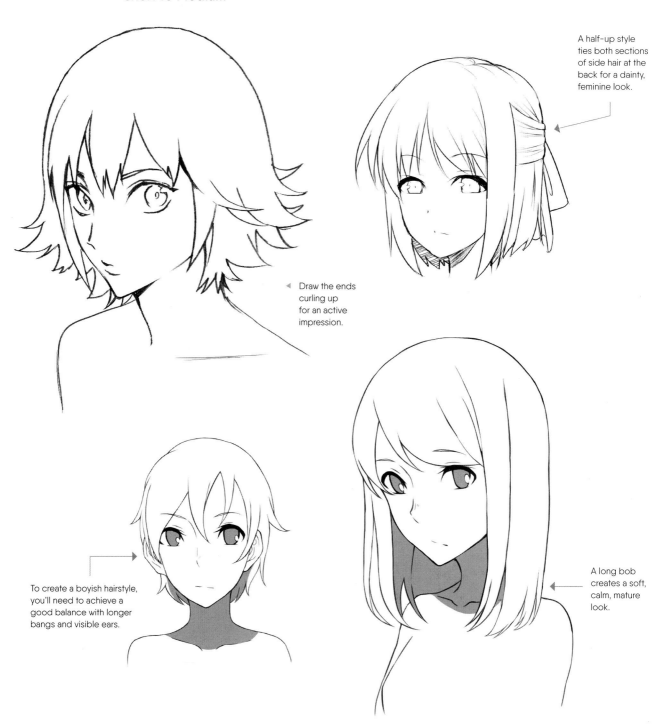

FEMALE HAIRSTYLE VARIATIONS

Lesson 04

Female hairstyles display even more variation than male hairstyles. In addition to the length and texture of the hair, variety can also be displayed through the arrangement—ponytails, buns, braids—the options are nearly endless!

Short to Medium

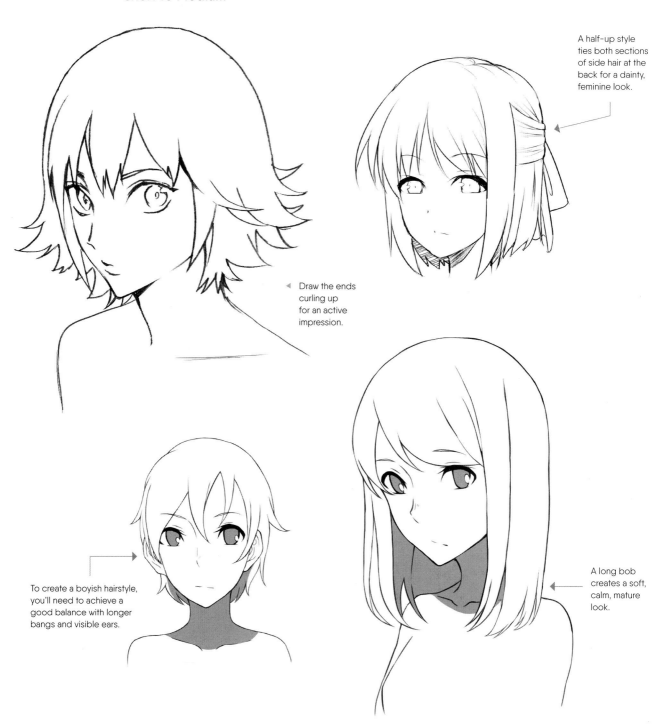

A half-up style ties both sections of side hair at the back for a dainty, feminine look.

Draw the ends curling up for an active impression.

To create a boyish hairstyle, you'll need to achieve a good balance with longer bangs and visible ears.

A long bob creates a soft, calm, mature look.

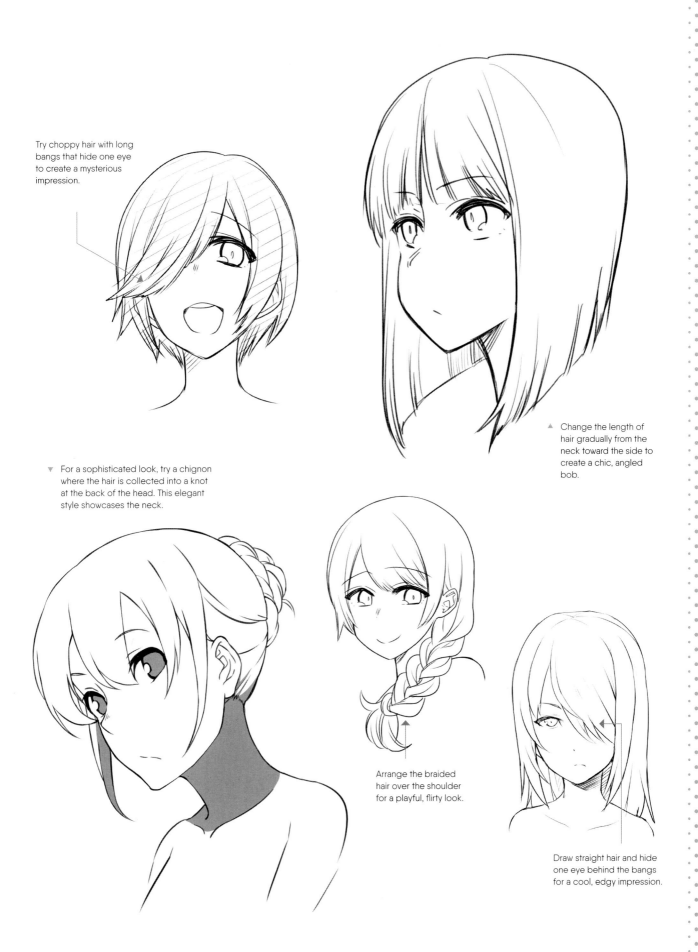

Try choppy hair with long bangs that hide one eye to create a mysterious impression.

△ Change the length of hair gradually from the neck toward the side to create a chic, angled bob.

▽ For a sophisticated look, try a chignon where the hair is collected into a knot at the back of the head. This elegant style showcases the neck.

Arrange the braided hair over the shoulder for a playful, flirty look.

Draw straight hair and hide one eye behind the bangs for a cool, edgy impression.

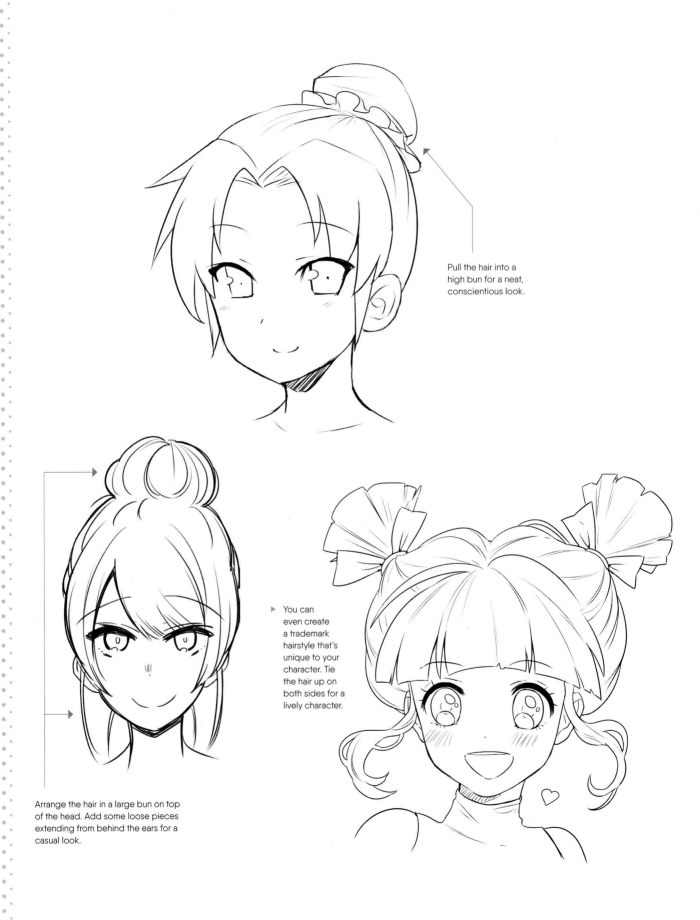

Pull the hair into a
high bun for a neat,
conscientious look.

You can
even create
a trademark
hairstyle that's
unique to your
character. Tie
the hair up on
both sides for a
lively character.

Arrange the hair in a large bun on top
of the head. Add some loose pieces
extending from behind the ears for a
casual look.

Long

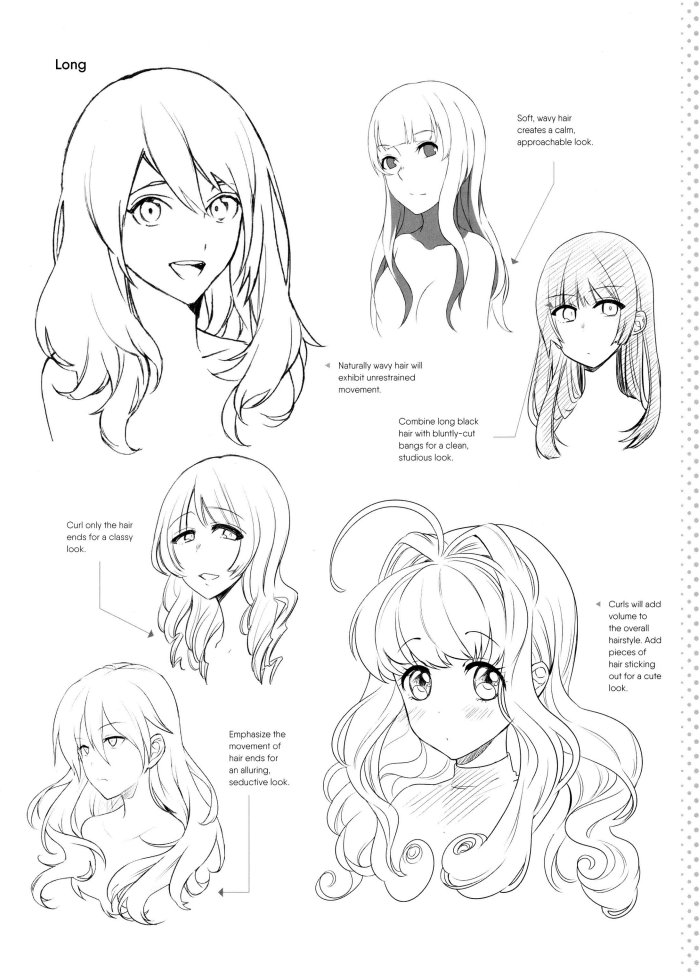

Soft, wavy hair creates a calm, approachable look.

◀ Naturally wavy hair will exhibit unrestrained movement.

Combine long black hair with bluntly-cut bangs for a clean, studious look.

Curl only the hair ends for a classy look.

Curls will add volume to the overall hairstyle. Add pieces of hair sticking out for a cute look.

Emphasize the movement of hair ends for an alluring, seductive look.

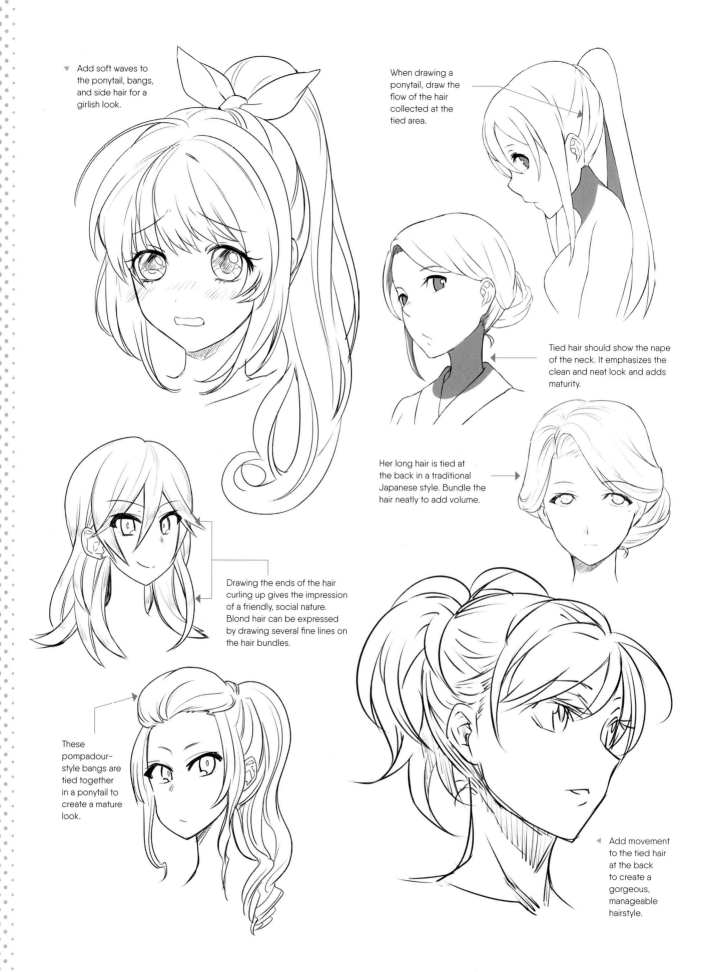

▼ Add soft waves to the ponytail, bangs, and side hair for a girlish look.

When drawing a ponytail, draw the flow of the hair collected at the tied area.

Tied hair should show the nape of the neck. It emphasizes the clean and neat look and adds maturity.

Her long hair is tied at the back in a traditional Japanese style. Bundle the hair neatly to add volume.

Drawing the ends of the hair curling up gives the impression of a friendly, social nature. Blond hair can be expressed by drawing several fine lines on the hair bundles.

These pompadour-style bangs are tied together in a ponytail to create a mature look.

◄ Add movement to the tied hair at the back to create a gorgeous, manageable hairstyle.

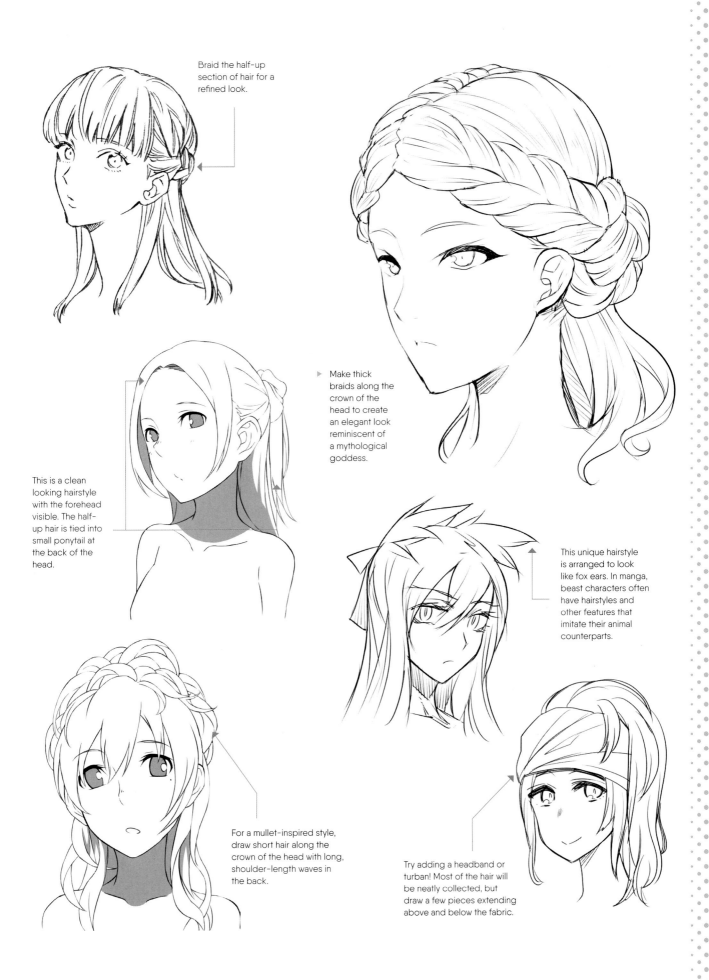

Braid the half-up section of hair for a refined look.

Make thick braids along the crown of the head to create an elegant look reminiscent of a mythological goddess.

This is a clean looking hairstyle with the forehead visible. The half-up hair is tied into small ponytail at the back of the head.

This unique hairstyle is arranged to look like fox ears. In manga, beast characters often have hairstyles and other features that imitate their animal counterparts.

For a mullet-inspired style, draw short hair along the crown of the head with long, shoulder-length waves in the back.

Try adding a headband or turban! Most of the hair will be neatly collected, but draw a few pieces extending above and below the fabric.

Lesson 05

ILLUSTRATING HAIR COLOR

Even with black and white illustrations, hair color and texture can be expressed through lines and shading. It's important to keep hair color in mind to differentiate the characters within your story.

Blond Hair

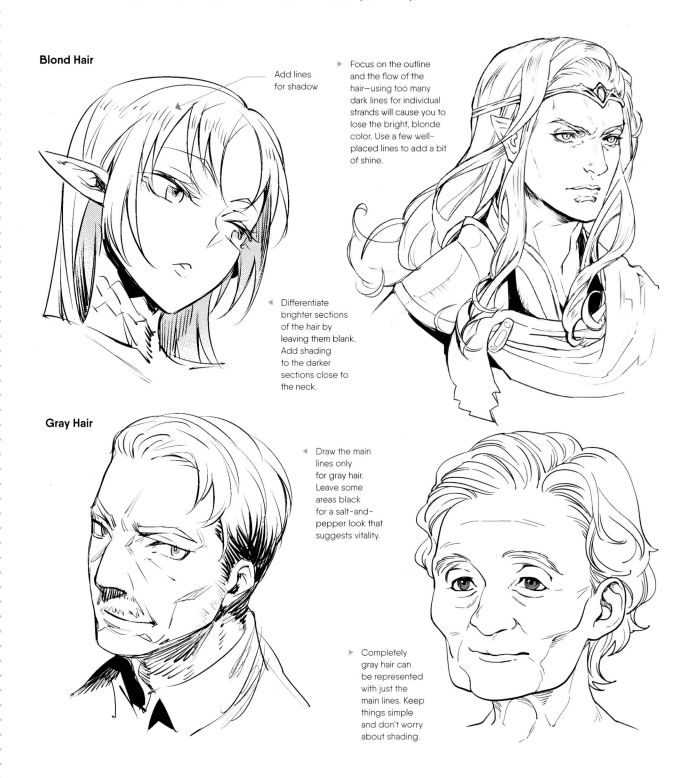

Add lines for shadow

► Focus on the outline and the flow of the hair—using too many dark lines for individual strands will cause you to lose the bright, blonde color. Use a few well-placed lines to add a bit of shine.

◄ Differentiate brighter sections of the hair by leaving them blank. Add shading to the darker sections close to the neck.

Gray Hair

◄ Draw the main lines only for gray hair. Leave some areas black for a salt-and-pepper look that suggests vitality.

► Completely gray hair can be represented with just the main lines. Keep things simple and don't worry about shading.

Red Hair

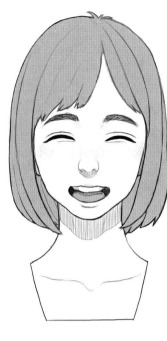

Black Hair

▲ Add dark tone all over the hair to illustrate the colored hair.

▲ In black and white illustrations, dark gray shading works well to represent red hair. The key to capturing different hair colors is saturation—light gray can be used to represent brown hair.

▲ Black hair is represented by solid sections of color. Don't forget to include white highlights for realistic dimension. The healthier the hair, the more shiny highlights you'll see.

Silver Hair

▶ Add light shading to the areas where the hair is concentrated or in shadow to create a metallic look.

Dyed Gray Hair

▶ For hair that's been dyed gray, focus on the outline, following the same process used to illustrate blonde hair. For areas in shadow, draw fine lines or add a light-colored tone.

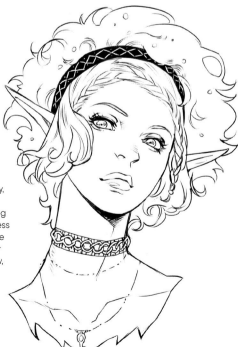

EXPRESSING EMOTIONS THROUGH HAIR

Lesson 06

In addition to facial expressions, the emotions of characters can also be expressed through the movement of their hair. In this section, we'll focus on some of the most common emotions, such as happiness and anger. Use this guide as a reference as you draw.

▶ Happy

The hair fans out softly to match her lighthearted expression.

The head tilts with laughter, causing the hair to stick out in different directions.

▶ Angry & Irritated

▽ Fanned back or floating hair is commonly used to represent rage in cartoon drawings. For example, a character may be so mad that their hair stands on end. With this emotion, the hair is spread out in different directions.

Her hair defies gravity, illustrating a fierce rage.

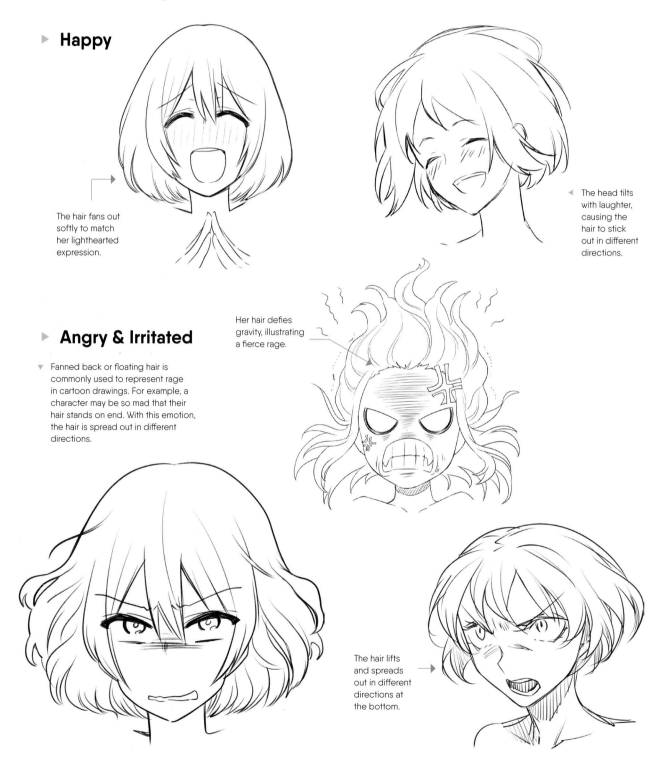

The hair lifts and spreads out in different directions at the bottom.

154 DRAWING ANIME FACES AND FEELINGS

Surprised

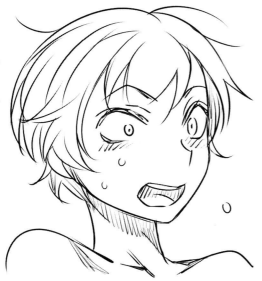

The hair raises because of the impact of the surprise. With this expression, the hair will stick out wildly.

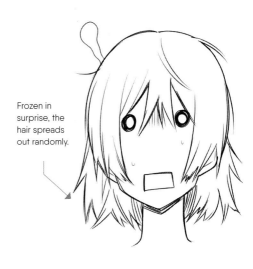

Frozen in surprise, the hair spreads out randomly.

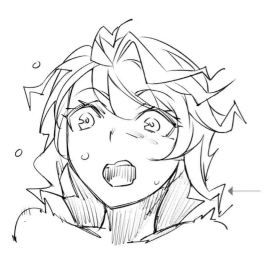

The shocked feeling is illustrated by the bold, angular chunks of hair that stick out in all directions.

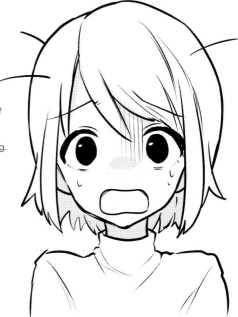

A few strands of hair jump out to emphasize the surprised feeling.

Disappointed & Depressed

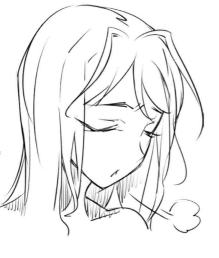

The hair ends point down to show the feeling of disappointment and depression. A few strands of hair limply hang along the side of the face.

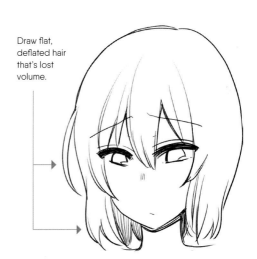

Draw flat, deflated hair that's lost volume.

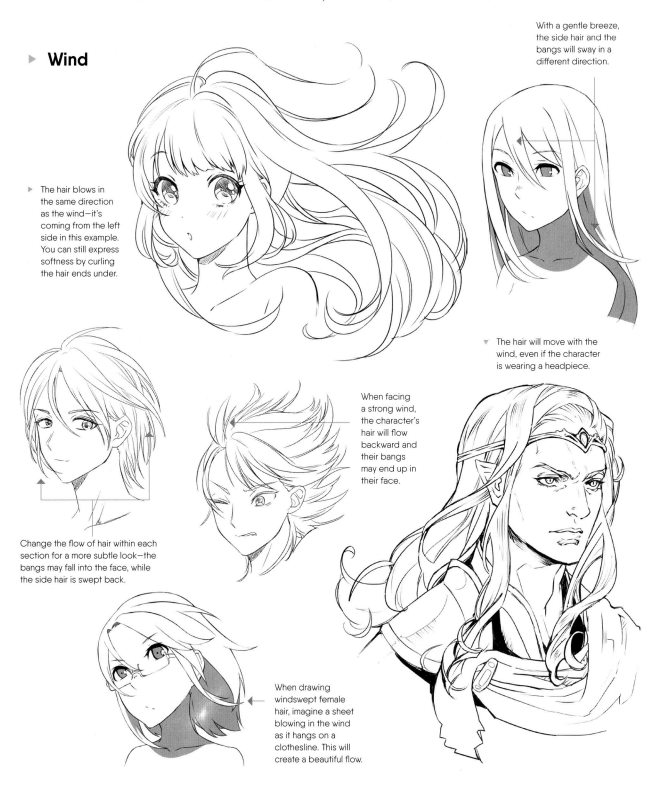

THE MOVEMENT OF HAIR

The movement of hair is an important element for expressing the emotion of characters and creating their vibrant look. Here, we will explore the impact that nature, such as wind or water, and body movement, such as exercise, has on hair.

► **Wind**

With a gentle breeze, the side hair and the bangs will sway in a different direction.

► The hair blows in the same direction as the wind—it's coming from the left side in this example. You can still express softness by curling the hair ends under.

▼ The hair will move with the wind, even if the character is wearing a headpiece.

When facing a strong wind, the character's hair will flow backward and their bangs may end up in their face.

Change the flow of hair within each section for a more subtle look—the bangs may fall into the face, while the side hair is swept back.

When drawing windswept female hair, imagine a sheet blowing in the wind as it hangs on a clothesline. This will create a beautiful flow.

Body Movement

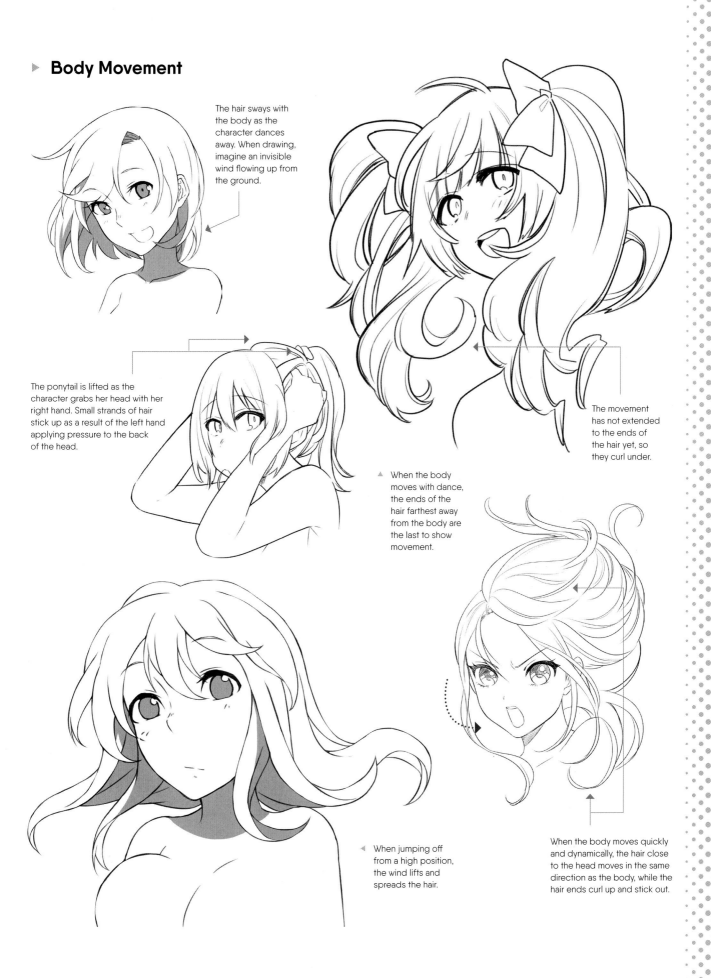

The hair sways with the body as the character dances away. When drawing, imagine an invisible wind flowing up from the ground.

The ponytail is lifted as the character grabs her head with her right hand. Small strands of hair stick up as a result of the left hand applying pressure to the back of the head.

The movement has not extended to the ends of the hair yet, so they curl under.

▲ When the body moves with dance, the ends of the hair farthest away from the body are the last to show movement.

◄ When jumping off from a high position, the wind lifts and spreads the hair.

When the body moves quickly and dynamically, the hair close to the head moves in the same direction as the body, while the hair ends curl up and stick out.

▶ Body Movement

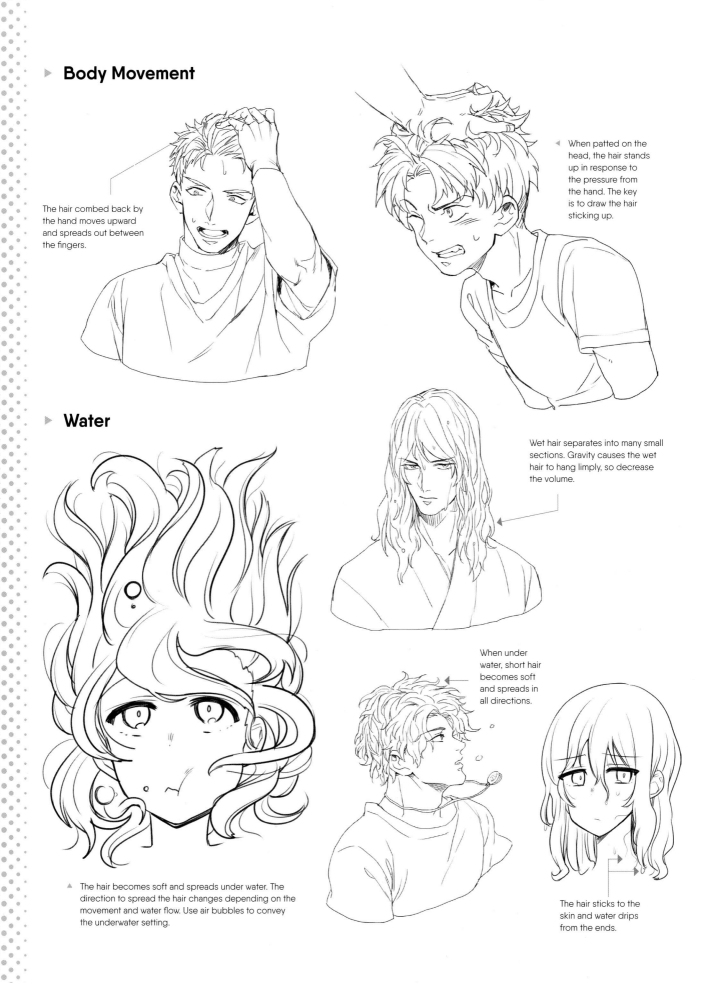

The hair combed back by the hand moves upward and spreads out between the fingers.

◀ When patted on the head, the hair stands up in response to the pressure from the hand. The key is to draw the hair sticking up.

▶ Water

Wet hair separates into many small sections. Gravity causes the wet hair to hang limply, so decrease the volume.

When under water, short hair becomes soft and spreads in all directions.

▲ The hair becomes soft and spreads under water. The direction to spread the hair changes depending on the movement and water flow. Use air bubbles to convey the underwater setting.

The hair sticks to the skin and water drips from the ends.

ARTIST INDEX

Hiromu
Cover, pages 7-8, 10, 13, 16, 32-33, 39-40, 42-45, 48-53, 56, 60, 62, 64-65, 68-70, 75, 77-80, 82-85, 87-89, 101-102, 106, 108, 110-11, 118-122, 128-131

▸ www.shibaction.tumblr.com
▸ www.pixiv.net/member.php?id=125048

Sakurako Aoi
Pages 20-22, 47-51, 56-57, 61-62 64-65, 70-71, 73-74, 81-82, 84, 88-89, 92, 94-95, 97-99, 103, 105, 107-111, 114-117, 120, 126, 128-129, 156

▸ www.blue0cherry.tumblr.com

Atsuki Ogino
Pages 9, 12, 18-21, 23, 42-43, 45-47, 51, 53-56, 59, 61-63, 67, 69-72, 75, 77-79, 81-84, 86-87, 89, 92, 95, 97, 100, 102, 107, 111, 115-117, 119, 126-127, 132, 134-137, 139-140, 143-144, 147-150, 154, 156-157

▸ www.oginoatsuki.moo.jp

Gufu
Pages 10, 13, 40, 42-43, 46, 48-50, 54, 56-58, 61, 64-65, 69, 72-74, 76, 80-81, 85-86, 153

▸ www.pixiv.net/member.php?id=3074618

Shina
Pages 9-10, 34, 38, 41-42, 45-49, 51, 53, 55-58, 61, 63, 65-69, 72-74, 77, 80-81, 83-84, 87, 101-103, 106, 108, 110-111, 118, 120-121, 128-131, 133, 135, 138-139, 141-142, 144-145, 152-155

▸ www.pixiv.net/member.php?id=63636

Naako
Pages 10, 13, 22, 44, 54, 57, 64, 73, 85, 133-134, 140, 142-147, 149, 151

Nagioka
Pages 8, 18-19, 40, 42-44, 46, 48, 50-51, 53, 56, 58-61, 64, 66-67, 70, 74-80, 82-83, 85, 87, 91, 96, 98-99, 116-117, 132, 135, 141, 146-151, 156-157

▸ www.pixiv.net/member.php?id=211254

Mimura

Pages 9, 13, 16, 36, 41, 44, 50, 52, 58, 60, 64, 68, 74, 76, 80, 85, 93-94, 98, 104-105, 109, 112-113, 122-125

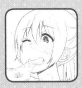

Inca of the Dead

Cover, pages 7-8, 10, 13, 16, 32-33, 39-40, 42-45, 48-53, 56, 60, 62, 64-65, 68-70, 75, 77-80, 82-85, 87-89, 101-102, 106, 108, 110-11, 118-122, 128-131

▶ www.pixiv.net/member.php?id=156737

Kasukazu

Pages 8, 13, 18-21, ,23, 35, 41, 47, 54, 58, 61, 66, 68, 74, 76, 84-85, 91, 95, 97, 99-100, 103, 111, 118-119, 126-131, 135, 142-151

▶ www.pixiv.net/member.php?id=251906

ShiSei

Pages 13, 18-21, 39, 41, 44, 53, 55-56, 59, 66, 70, 77-78, 81-82, 116-117, 132, 134, 142-144, 158

▶ www.zesnoe.tumblr.com

Fumi Takamura

Pages 40, 43, 51-52, 56, 60, 66, 68, 72, 74, 80, 84, 93-94, 98, 104-105, 109, 112-113, 123, 125

▶ www.moira-takamu.com

Yasukata Nakama

Pages 7-8, 13-16, 24-31, 37, 52, 55-56, 70, 72, 87-88, 137, 144-145, 152-153, 156

▶ www.nakama-yasukata.tumblr.com

Nanna Fujimi

Pages 10, 12, 43, 44, 48, 52, 59, 63-64, 67, 75-76, 80, 82, 90-91, 94, 99-100, 104, 107, 110, 123, 155

▶ www.pixiv.net/member.php?id=3230062

Mamemo Mozu

Pages 8-9, 12-13, 16-21, 39-41, 45, 47-48, 50, 59, 61, 66, 70-71, 76, 78-79, 83, 86, 90-92, 114-117, 152